D0351942

SKI THE rockies

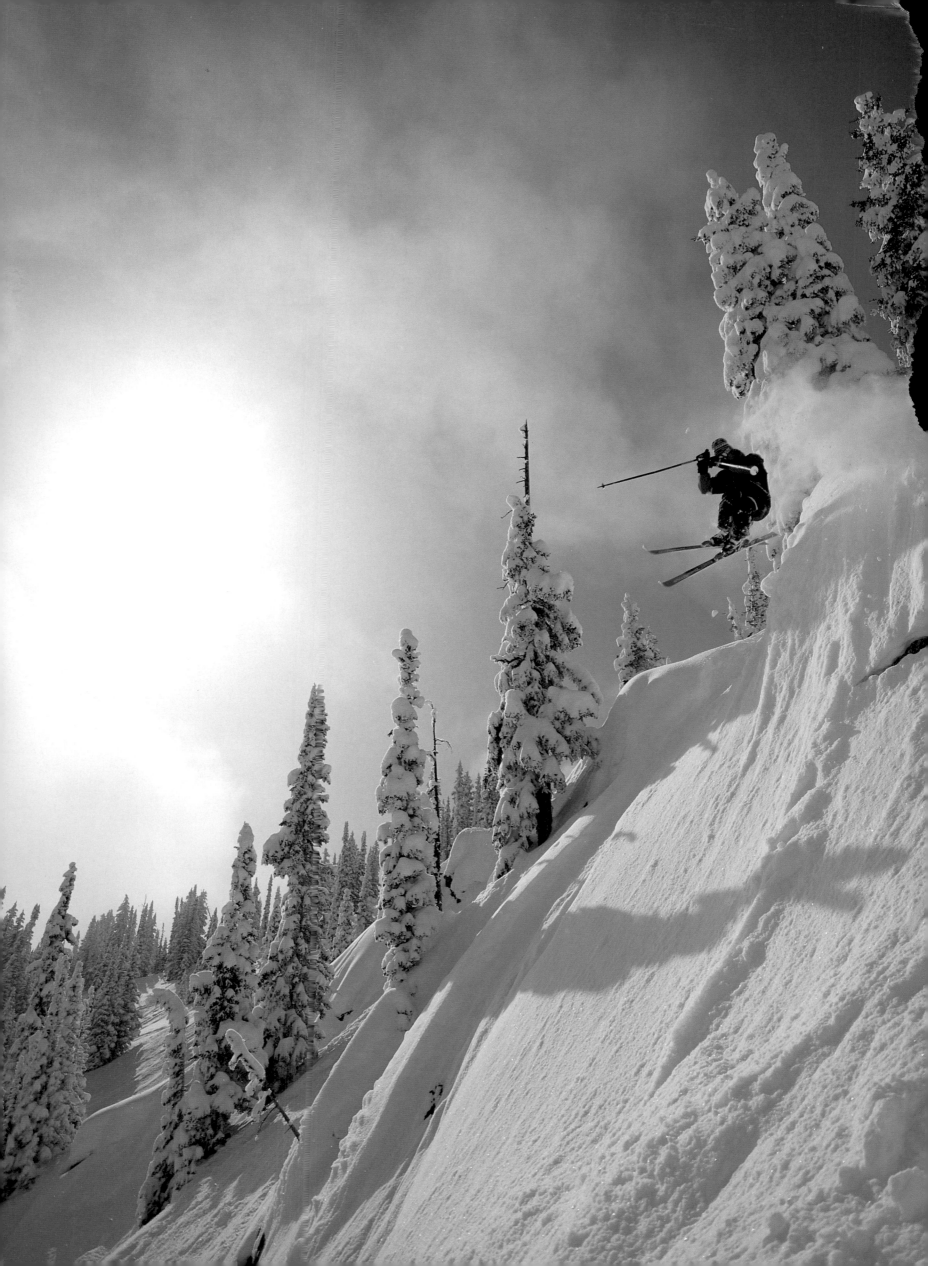

MARC MUENCH

ski
THE
rockies

text ▲ PETER SHELTON

foreword ▲ STEVE COHEN

✖ GRAPHIC ARTS CENTER PUBLISHING™

To my wife, Stefanie, and our children, Trevor and Skyler.

With loving anticipation of skiing the Rockies together.

MARC MUENCH

International Standard Book Number 1-55868-196-5

Library of Congress catalog number 94-75559

Photographs © MCMXCIV by Marc Muench

Text and captions © MCMXCIV by Peter Shelton

Published by Graphic Arts Center Publishing Company

P.O. Box 10306 • Portland, Oregon 97210 • 503/226-2402

All rights reserved. No part of this book

may be copied by any means, including artistic renderings,

without permission of the Publisher.

President • Charles M. Hopkins

Editor-in-Chief • Douglas A. Pfeiffer

Managing Editor • Jean Andrews

Designer • Bonnie Muench

Production Manager • Richard L. Owsiany

Cartography • Ortelius Design

Book Manufacturing • Lincoln & Allen Co.

Printed in the United States of America

Second Printing

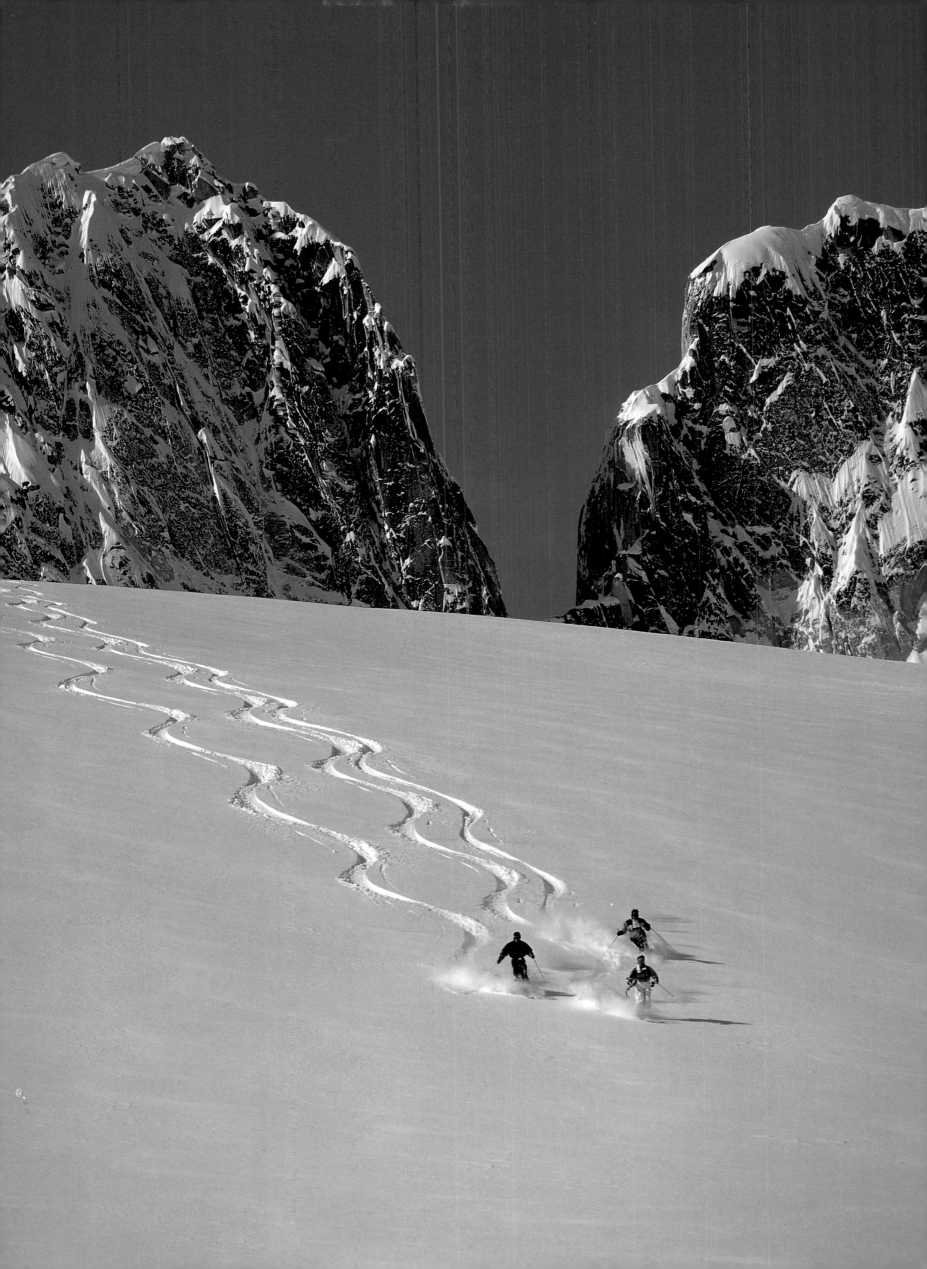

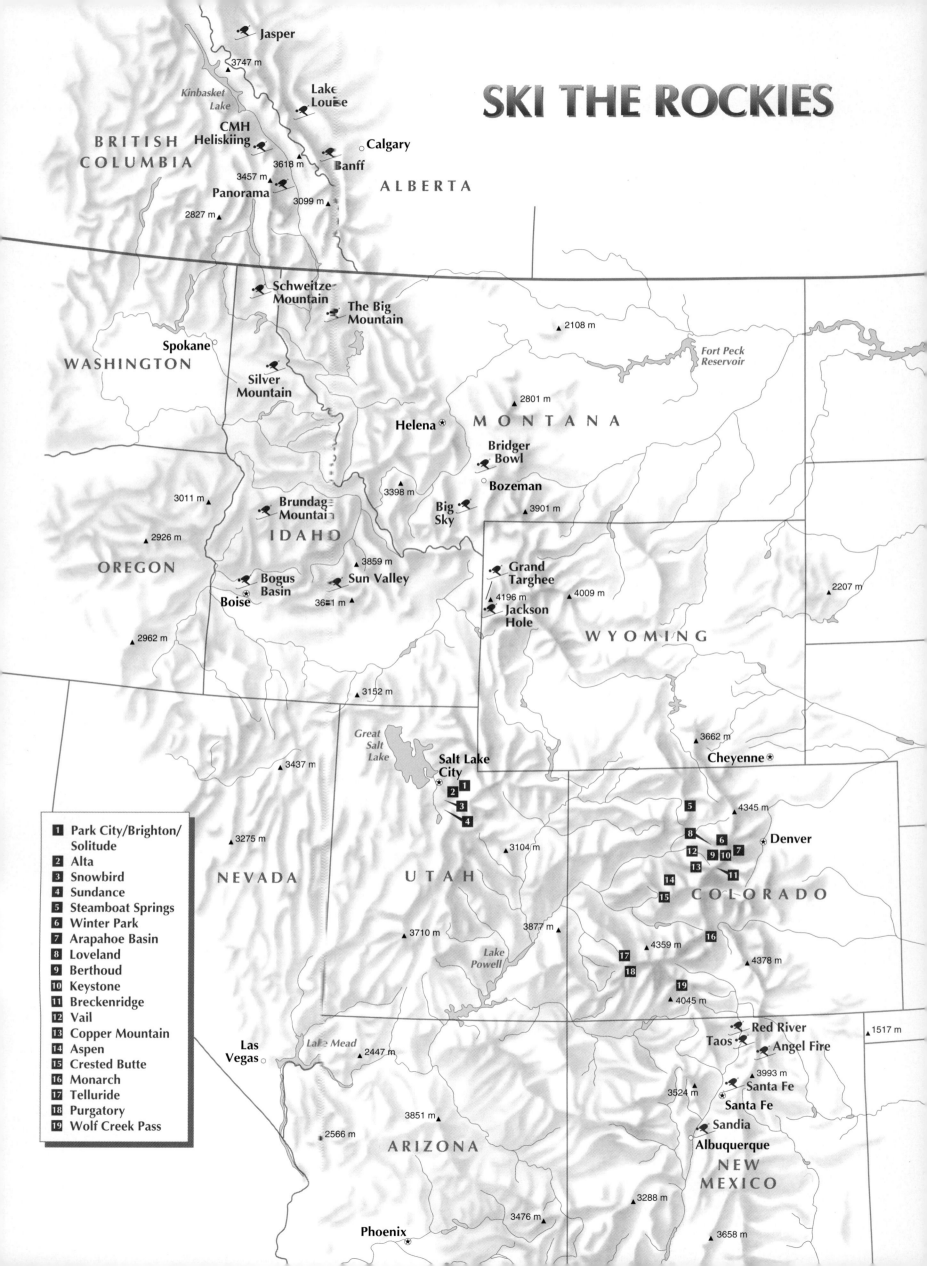

SKI THE ROCKIES

Jasper ▲ 3747 m

Kinbasket Lake

Lake Louise

BRITISH COLUMBIA

CMH Heliskiing
3618 m ▲

○ **Calgary**

3457 m ▲

Banff

ALBERTA

Panorama
3099 m ▲

2827 m ▲

Schweitze Mountain

The Big Mountain

▲ 2108 m

Fort Peck Reservoir

○ **Spokane**

WASHINGTON

Silver Mountain

▲ 2801 m

Helena ✪

MONTANA

Bridger Bowl

○ **Bozeman**

3398 m ▲

3011 m ▲

Brundage Mountain

IDAHO

Big Sky

▲ 3901 m

2926 m ▲

OREGON

3859 m ▲

Sun Valley

Bogus Basin

Boise ✪

36=1 m ▲

Grand Targhee
4196 m ▲

▲ 4009 m

▲ 2207 m

Jackson Hole

2962 m ▲

WYOMING

3152 m ▲

3437 m ▲

Great Salt Lake

3662 m ▲

Cheyenne ✪

Salt Lake City ✪

1
2 **1**
3

5

▲ 4345 m

3104 m ▲

8

6 ✪ **Denver**

12

9 10 7

13

11

14

15 **COLORADO**

NEVADA

UTAH

3710 m ▲

3877 m ▲

16

Lake Powell

17 4359 m ▲

18 ▲ 4378 m

19

▲ 4045 m

Las Vegas ○

Lake Mead

2447 m ▲

2566 m

Red River

▲ 1517 m

Taos

Angel Fire

3993 m ▲

Santa Fe

3524 m ▲ **Santa Fe** ✪

3851 m ▲

ARIZONA

Sandia

Albuquerque

NEW MEXICO

3288 m ▲

Phoenix

3476 m ▲

3658 m ▲

FOREWORD

Fittingly, I first met Peter Shelton deep in the Rocky Mountains. The Purcell Range of British Columbia Canada, to be exact. We were both on assignment to write about a heli-skiing operation based out of the Panorama Ski Resort. Peter, a former ski school director, was an expert deep powder skier; I was a floundering easterner more at home on hard, packed snow.

During our week together, Peter graciously taught me new skiing skills, but, more importantly, helped nurture in me a new sense of the power and beauty of mountains.

Peter grew up in a skiing family in coastal California, but from birth, it seems, his soul was truly of the raised earth. He respects and reveres the mountains—their history (both natural and manmade), geology, flora, and fauna—unlike any other person I have known.

Peter, you must understand, never skis *on* a mountain; he skis *with* it. He doesn't seek to "tame" or "conquer" the mountain with his skis as much as he caresses and embraces its folded flanks. His approach lets him pierce an invisible barrier of mountain discovery. You will find many of his secrets shared in this book.

Marc Muench and I are relatively new acquaintances. Like an increasing number of modern friendships, ours is one that has been conducted over phone lines. But even more than through our conversations and data exchanges, I have come to know Marc by pouring through the hundreds of images he has submitted to *Ski Magazine* over the last few years.

Marc has a unique sense of perspective and a reverence for the mountains and the sport. His landscapes are sensual and colorful. His action photographs capture skiers in the mountain playgrounds, lending a satisfying sense of perspective. Rare is the Muench shot that sends a skier hurtling toward the camera lens with no sense of place.

Marc's father David is an award-winning outdoor photographer, so it was clear the younger Muench was blessed with shooter's genes right from birth. Still, Marc did not become serious about his photography until after college. His natural talents developed rapidly and he quickly realized that outdoor photography was the ideal way to enjoy his passion for outdoor sports and still earn a living

Unlike Peter, Marc came relatively late to skiing. He remembers "high school road trips [from his home in Santa Barbara, California] to Mammoth Mountain, California, where we slept in my friend's father's station wagon in parking lots to save money."

For SKI THE ROCKIES, Marc road-tripped up and down the spine of the Rockies on a three-winter odyssey that spanned more than half a year of real time. He spent 175 days actually shooting photographs—and a full month waiting for good weather. And his itinerary was truly peripatetic.

"The best photos are taken during or after storms," he says, "so I'd check all the weather reports and follow the storm tracks off the Pacific. If they went south, I went south. If they went north, I headed north."

Along the way, Marc fell in love—with the Rockies. "The Rockies," he says, "have striking terrain with all the variety one could want; they get a sinful amount of snow and contain some of the most spectacular scenery found anywhere."

If you enjoy and appreciate the images and words in this book as much as I have, you will probably need two copies—a "show" copy for your coffee-table and a personal edition that will grow dog-eared and scrappy from repeated visits to vicariously "Ski the Rockies."

Steve Cohen
Editor of *Ski Magazine*

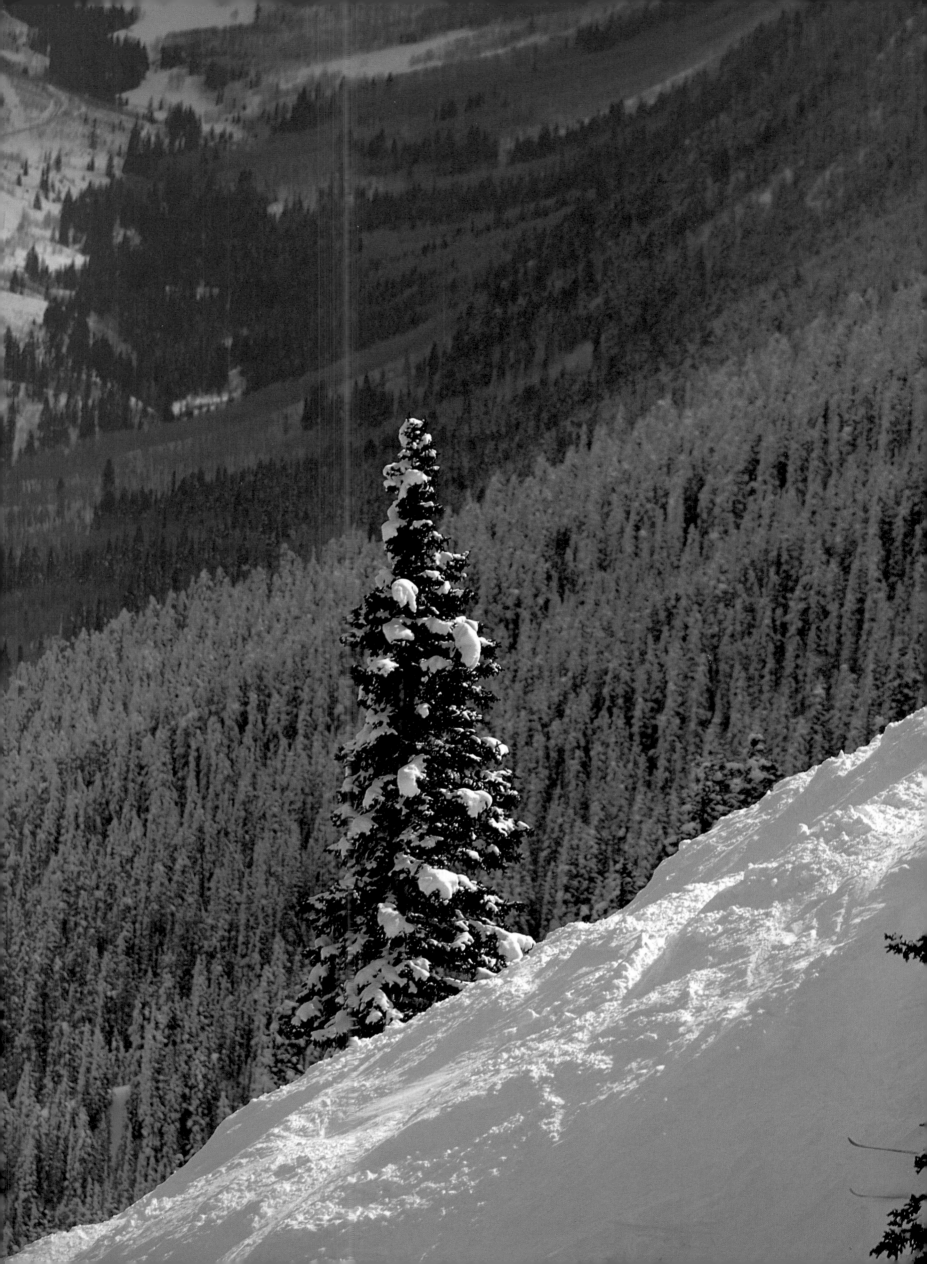

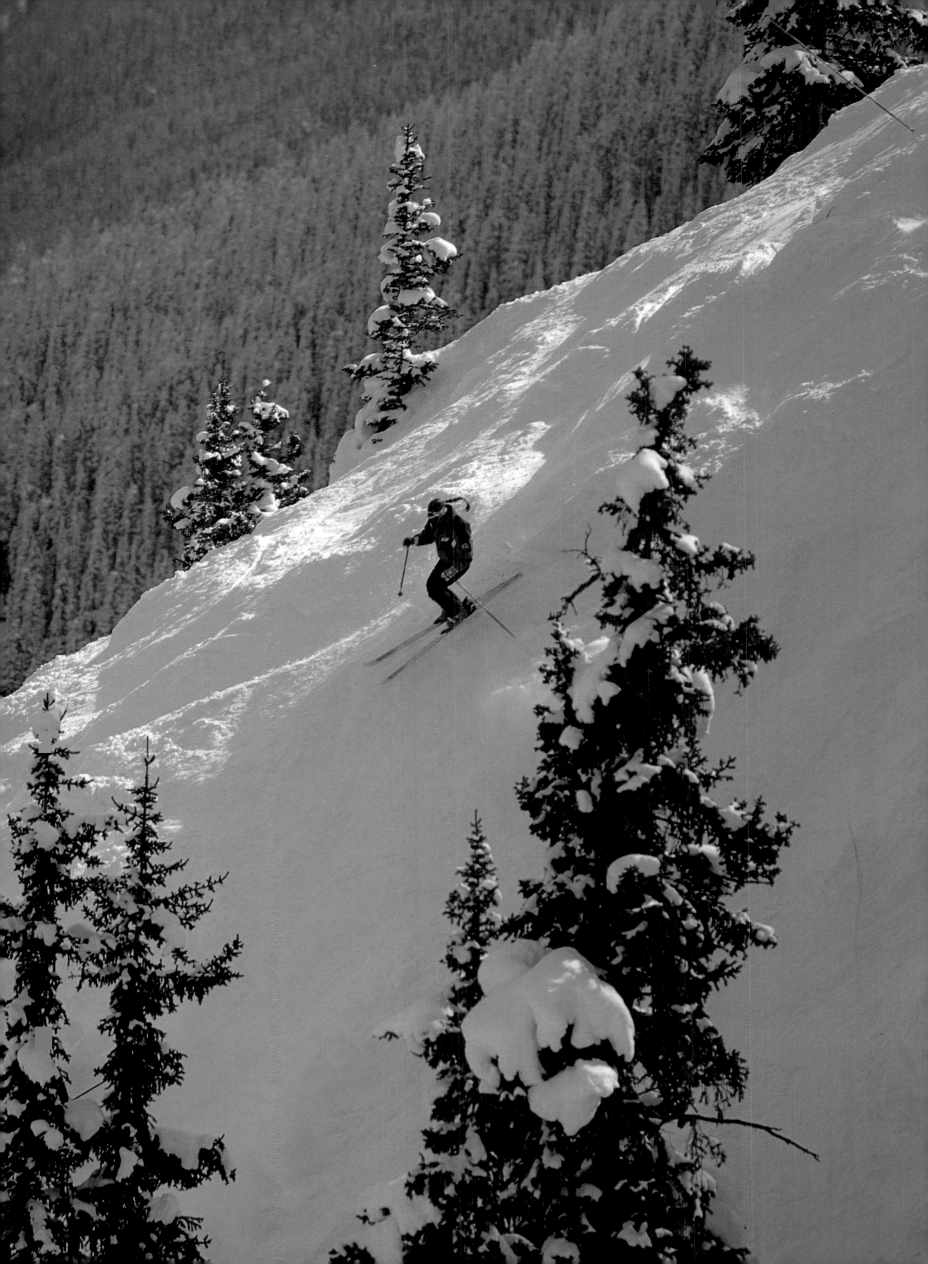

CONTENTS

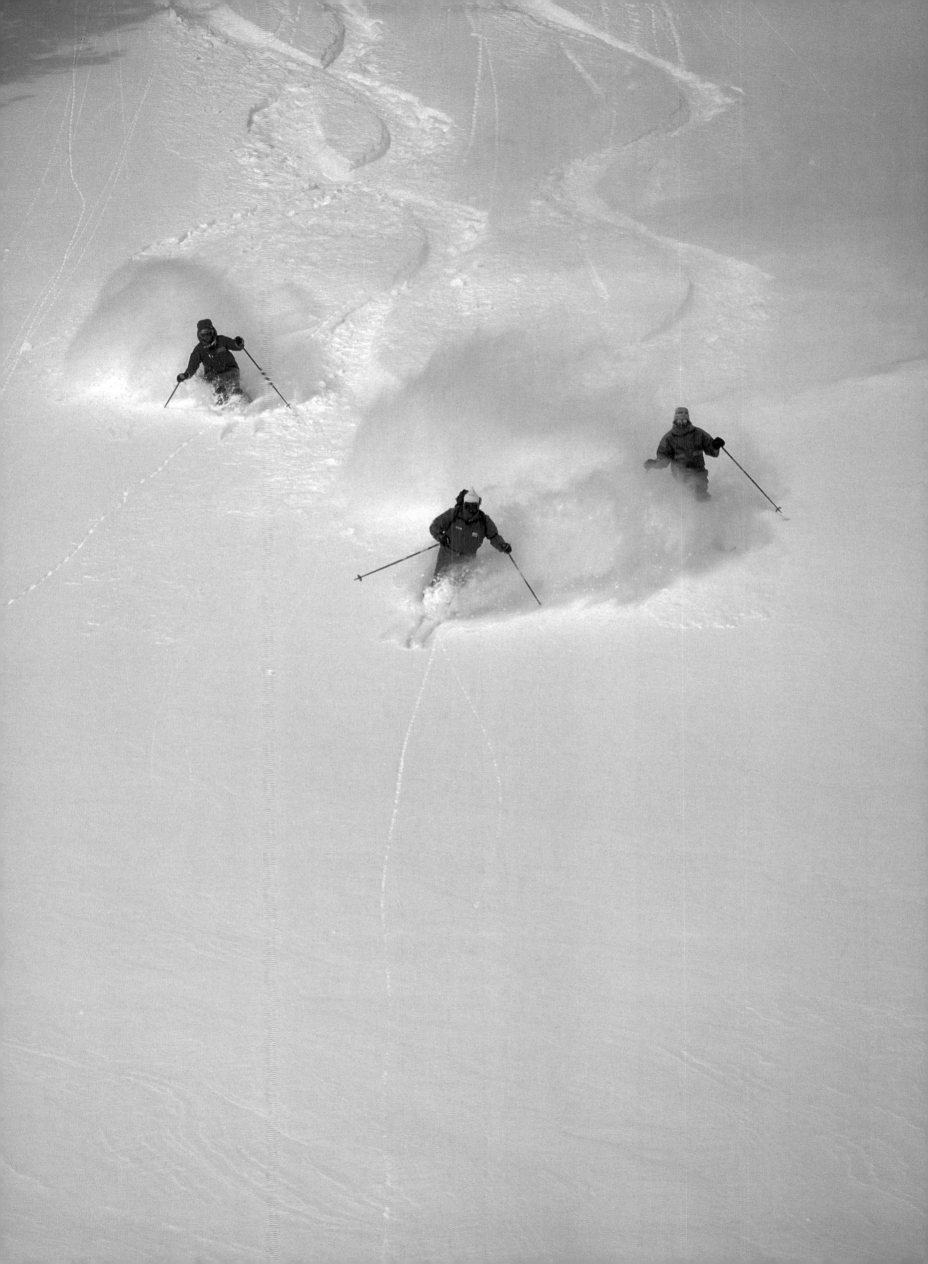

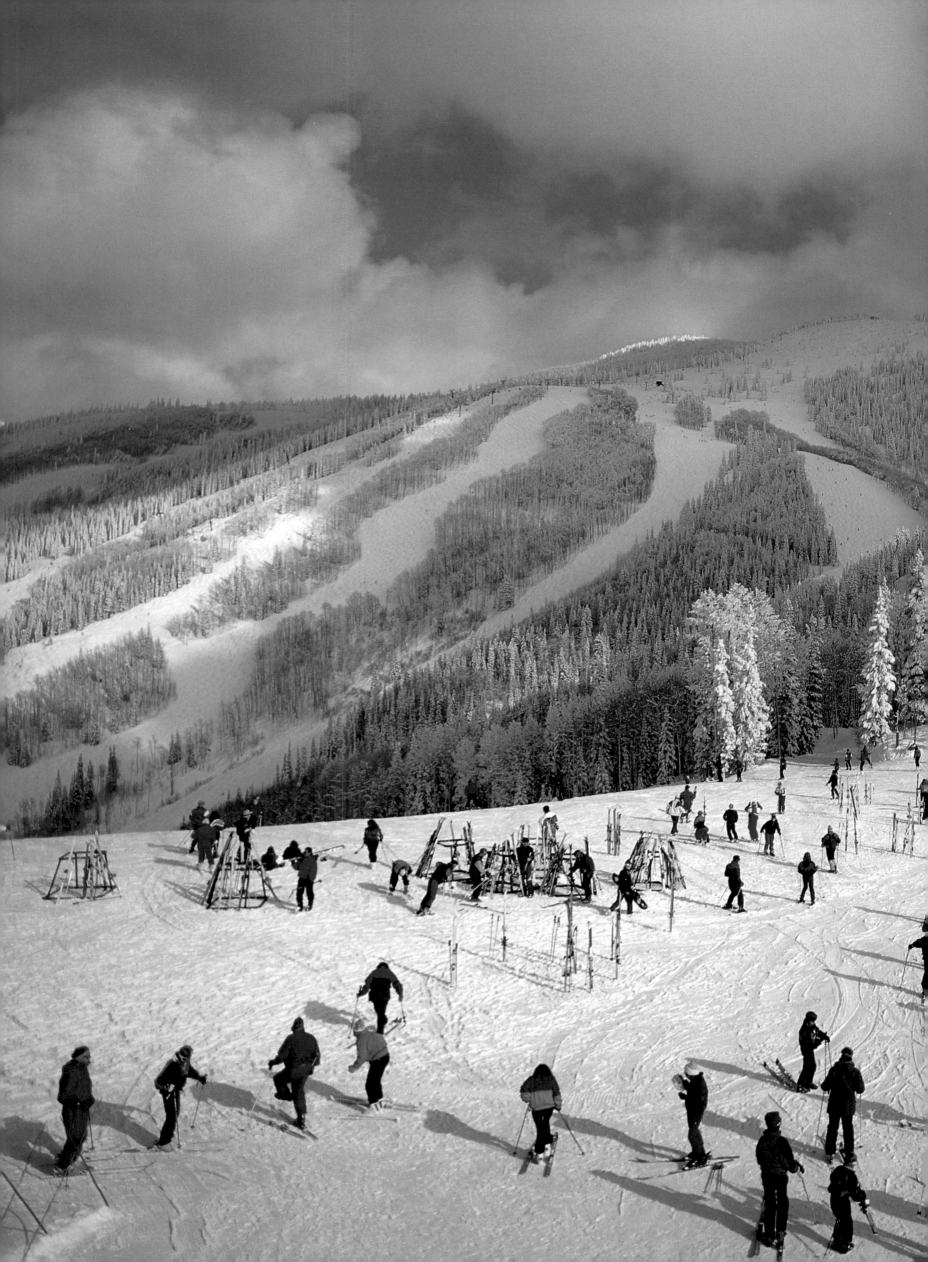

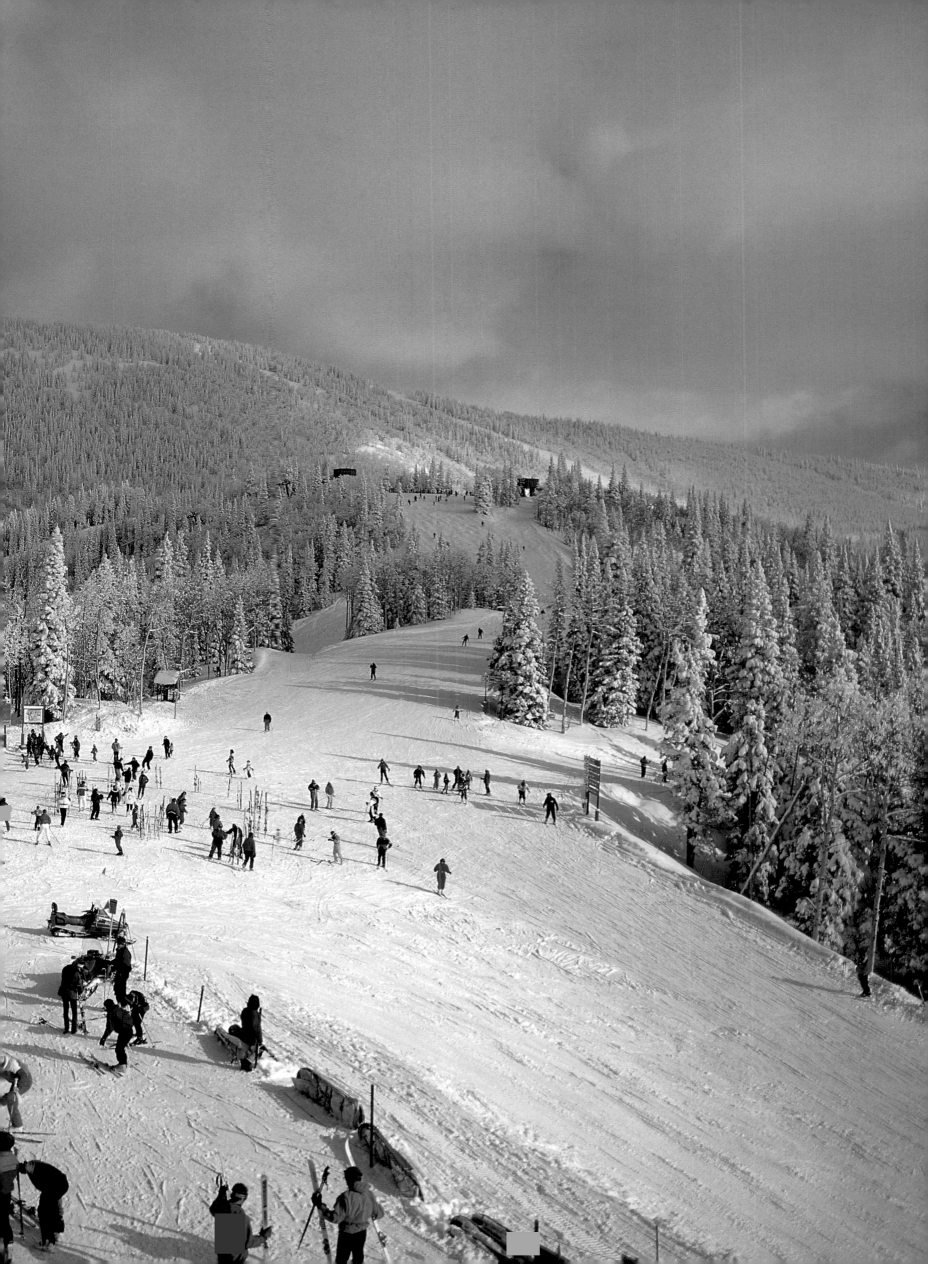

SUN VALLEY SERENADE

I woke up on the train with the sun glancing off endless, snow-covered fields. The metal wheels tapped out their clickity rhythm; the Idaho potato farms gave way to sagebrush plains then to the blazing white foothills of the Pioneer Mountains, cut here and there by meandering clear streams. One of the streams was Ernest Hemingway's favorite, Silver Creek, where large, haughty rainbow trout tested Papa's dry fly technique.

At fourteen years old in 1963, I knew nothing about *The Sun Also Rises*. I knew only that it was dawn, twelve hours after my parents had deposited me on the Union Pacific coach in Los Angeles, and that the train was now winding its way up the Big Wood River, through Hailey and Ketchum, out of the Great Basin desert and into the Rockies at last, to Sun Valley.

Trains are an integral part of Sun Valley's story. In 1935, Union Pacific board chairman Averell Harriman wanted to increase passenger traffic to the West, and decided that a European-style, winter destination resort would be the ticket. So he hired an Austrian count, Felix Schaffgotsch, to scour the mountains for the perfect location, with the caveat that it be accessible by rail.

Count Schaffgotsch spent the winter of 1935 to 1936 on tour with his knickers and six pairs of hickory skis. He rejected Washington's Mount Rainier because all the surrounding land was publicly owned. He nixed Oregon's Mount Hood as too wet. Aspen flunked because its elevation at eight thousand feet was considered too high for strenuous alpine exercise. Jackson Hole was deemed inaccessible.

The good count was about to return east a failure, when a UP representative in Idaho wired him to come take a look at the area around Ketchum, an isolated sheep and cattle ranching town with a dwindling population of 270 souls. Schaffgotsch arrived on a day much like mine, with the sun dazzling the rounded, nearly treeless slopes. Very little wind found its way through the protective ring of the Pioneer Range, the Boulder Range and the spiky, distant Sawtooths. Because of the proximity to the desert and the long, dry route storms took in getting there, the snow Schaffgotsch found was too dry to make good snowballs; it was mostly air, the better to float down on skis.

It was perfect, and Harriman wasted no time implementing his plan. By New Year's Eve 1936 the luxurious Sun Valley Lodge had already hosted champagne banquets for the likes of Sam Goldwyn, Errol Flynn and Claudette Colbert. Guests twirled around the glorious ice rink and swam in a glass-enclosed, circular pool under the stars. And even more amazing for skiers, Harriman had built the world's first chair lift, engineered by a designer of conveyor systems for loading banana boats in Central America. Just replace the banana hook with a single chair—including safety bar and a blanket for your lap—and up the mountain you go!

Sun Valley made skiing glamorous. The Rockies, which up to that point boasted only a smattering of WPA rope tows, were suddenly mentioned in the same winter breath with St. Moritz and Gstaad. Hemingway settled into a second-story suite in the Lodge to work on *For Whom The Bell Tolls*. Hollywood came to ski and be seen. Clark Gable. Ingrid Bergman. Gary Cooper. Sonja Henie. Jimmy Stewart. Marilyn Monroe. They even made movies there. Henie and John Payne starred in the 1941 romance, *Sun Valley Serenade*. Another famous resident, a former mistress of gangster Bugsy Siegel named Virginia Hill, fell in love and later ran off with one of Sun Valley's handsomest ski instructors, Austrian Hans Hauser.

Most ski teachers in those days were Austrian, dashing and fun-loving in their Tyrolian hats and natty, boiled-wool jackets. By the time of my first visit, the embroidered jackets were history, but the core of the school was still Austrian. My ski instructor for the six days of my package week was named Leo. He had blond hair and brilliant teeth and spoke with a charming accent. Everyone in my class was in love with him— the girls on spring break for their reasons, I because of his elegant, apparently effortless style. With legs and feet tight together, he would traverse the hill, then set his edges, hop his ski tails up off the snow and into a swooping arc across the fall line. I wanted, more than anything, to ski like Leo.

For the first two days he led us back and forth across the naked, utterly treeless expanse of Dollar Mountain, Sun Valley's original hill and still its best novice terrain. From there, we graduated to the big mountain, Baldy, a mile down the road with the old town of Ketchum hunkered at its base. Baldy was the real thing, much steeper and longer than Dollar, with runs through the evergreens that seemed to go on forever. On one of our last days, I had skied the entire serpentine length of Warm Springs run, three miles and over three thousand vertical feet, without falling, thereby earning the Sun Valley Two-Star pin and—even more precious—rare praise from Leo.

In the evenings, guests packed into the gemütlichkeit of the Ram Bar for accordions and beer or to the Duchin Room in the Lodge, where big bands lit up the night through the 1940s and 1950s (and still do today). I had to content myself with bowling in the basement alley or reading in one of the overstuffed arm chairs before the fire. I could never keep my eyes open for very long. The sun and altitude and vigorous skiing conspired against even the most provocative prose.

I dreamed of floating down the mountain like Leo. Around the Rockies, lots of ski towns dreamed they could somehow

replicate Sun Valley's success. Aspen bloomed, albeit more slowly, after the war; Taos in the 1950s; Jackson Hole and Vail and Big Sky in the 1960s. They all owed at least part of their vision to the original, Sun Valley.

Elsewhere in Idaho, smaller areas popped up to serve local skiers: Bogus Basin outside Boise, Schweitzer Mountain Resort in the big timber country of Idaho's panhandle, Jackass Ski Bowl (later renamed Silver Mountain) near the Montana border in the silver-rich Coeur d'Alene Range. Schweitzer and Silver Mountain have made the commitment recently to becoming true ski destinations, with investment in new lifts, hotels, and marketing. But Sun Valley is still the queen, although until quite recently, an aging and somewhat neglected monarch.

When I last visited, in the winter of 1994, I drove down from the north, over Galena Summit in the moonlight. A recent storm had blanketed the peaks, and the fresh snow so brilliantly reflected the moonlight, I could have driven without headlights. Ketchum glowed like a prone Christmas tree, the colored lights washing up the valley sides. The tiny evergreens I remembered had grown so, the Lodge and its famous pool—once isolated in a treeless sheep meadow—were all but invisible. I knew I would not see the train. Union Pacific never did make money on the project, Averell Harriman's attention turned to politics, and the resort had long ago been sold.

Everyone agrees that the current owner, Earl Holding, has brought Sun Valley to prominence again with five new, high-speed quad lifts; gracious new restaurants on the mountain; and a state-of-the-art computerized snowmaking system that blankets much of Baldy, top-to-bottom, whether or not nature cooperates. It seems the locals stretched the truth a bit that day in 1936. When Count Schaffgotsch, up to his knees, asked if it was always so snowy in Ketchum, his guides said, "Oh my yes. In fact, it is usually much snowier than this!" Of course, Sun Valley does have its wet years. But it also suffers dry ones, more than its share in the 1970s and 1980s. With an average of 280 days a year of sunshine the name is apt. Every major Rockies ski area now boasts at least some artificial snowmaking, to guarantee skiing by Christmas and to guard against dry spells. Sun Valley once again leads the way.

I skied Warm Springs in a reprise of my pin-garnering descent thirty years previous. It was better groomed than before, smooth as linen, but just as long as I remembered—

so long it has three names on the map: Warm Springs Face, Mid Warm Springs and Lower Warm Springs. The biggest difference was, at the bottom I hopped on the Challenger high-speed lift and charged straight back to the top, thirty-one hundred vertical feet in ten minutes.

You can exhaust yourself in half a day skiing Baldy now. And a good many people try, bombing down the Warm Springs and Seattle Ridge groomed pistes on long, quiet skis designed to go fast. (Sun Valley's list of racing greats includes Gretchen Fraser, gold and silver medalist at the 1948 Olympics; 1984 silver medalist Christin Cooper; and 1994 silver medalist, Picabo Street.) Others, often the younger, hot-skiing locals, can be seen bouncing down classic mogul lines with names like Exhibit on, Holiday, and—the steepest run on the mountain—Inhibition. Still others prefer the wide-open spaces of the bowls: Christmas Bowl, Easter Bowl, Lookout Bowl, and so on.

Below me as I rode the Christmas lift, I spied silver-maned Bobby Burns slinking through powder remnants. The inventor of The Ski, a popular ski brand in the 1970s, he has a heliski lodge named for him up in the Canadian Rockies. I saw other stars that day. Catching my breath at the bottom of Limelight, I chatted with Adi Erber, Arnold Schwartzenegger's instructor when the muscled one is in town. Adi is Austrian, with a cleft chin and a big smile, "Mr. Schmooth," according to Arnold.

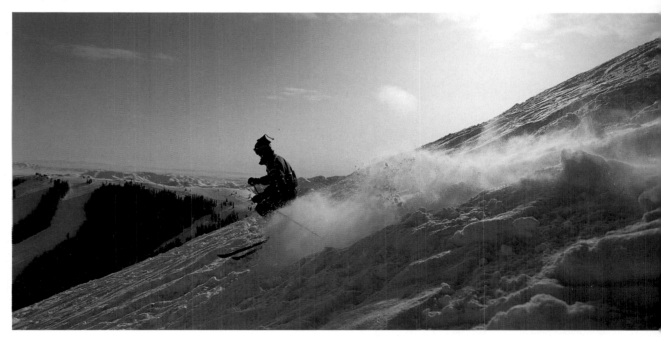

Christmas present, Christmas Bowl, Sun Valley

A new Hollywood generation has discovered Sun Valley: Bruce Willis and Demi Moore, Arnold, Margaux Hemingway. Margaux has real roots here. Papa loved the big mountains.

I skied Baldy's Hemingway on my last run down, tried to really carve the shapes, stay in balance as the river rushed up to meet me. It reminded me of a line from Papa's short story, "Cross Country Snow," where Nick Adams, after a run in the Alps, tells a friend: "There's nothing can touch skiing, is there?"

16 \ *High atop the mountain, Seattle Ridge*

Lodge presides over a Great Basin sunrise.

17 \ *The first chairlift in the world chugged up*

Dollar Mountain, the gentle face of Sun Valley, in

1936. Across the valley, Mount Baldy, the big hill,

hovers over the former sheep town of Ketchum.

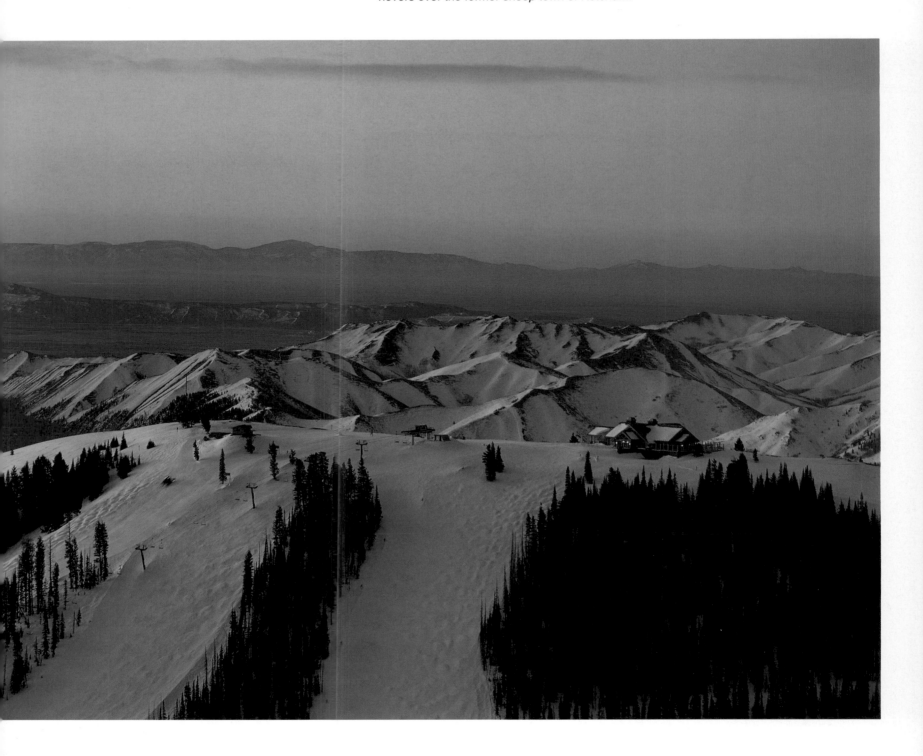

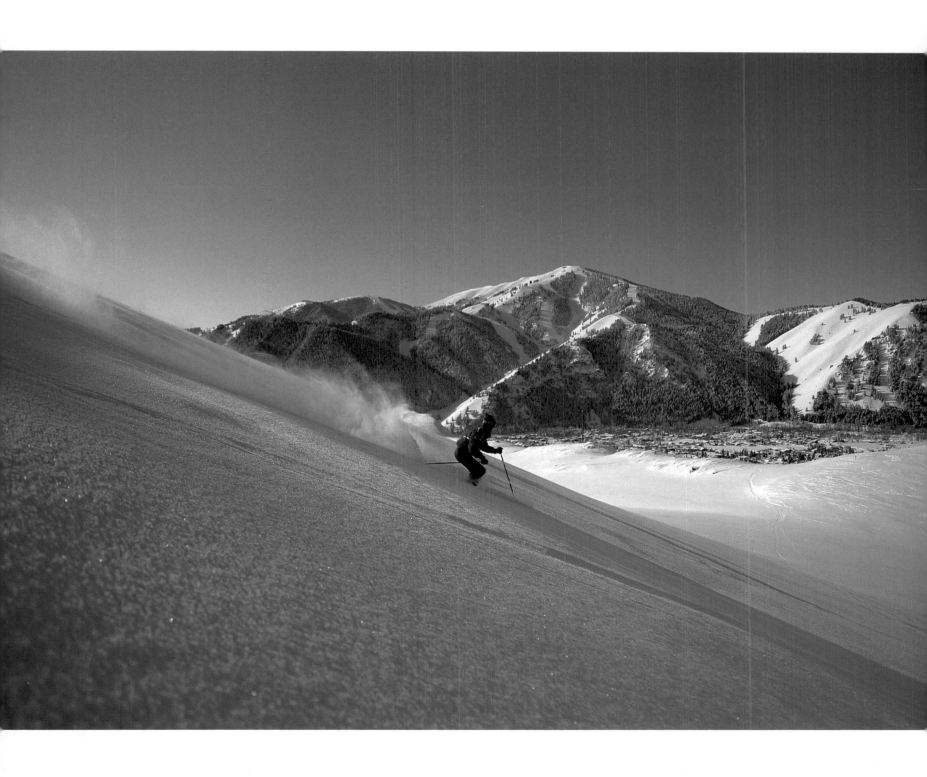

18 \ *Built in 1936 by railroad magnate Averell*

Harriman, the Sun Valley Lodge put Idaho on

the world ski map with St. Moritz and Gstaad.

19 \ *Cross-country skiers stride through Big Wood*

River valley, one of Hemingway's favorite trout streams.

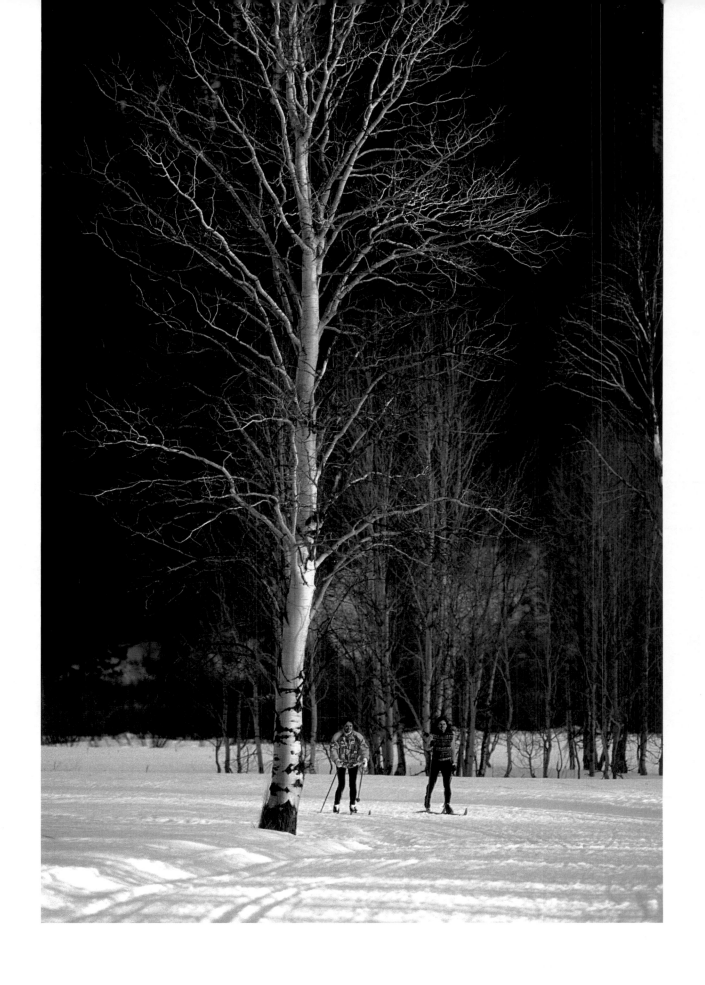

20-21 \ *With the recent addition of a sixteen-*

million-dollar, top-to-bottom, computerized

snowmaking system, Sun Valley is now

able to generate cruising skiing like this on

Seattle Pidge, even without Nature's help.

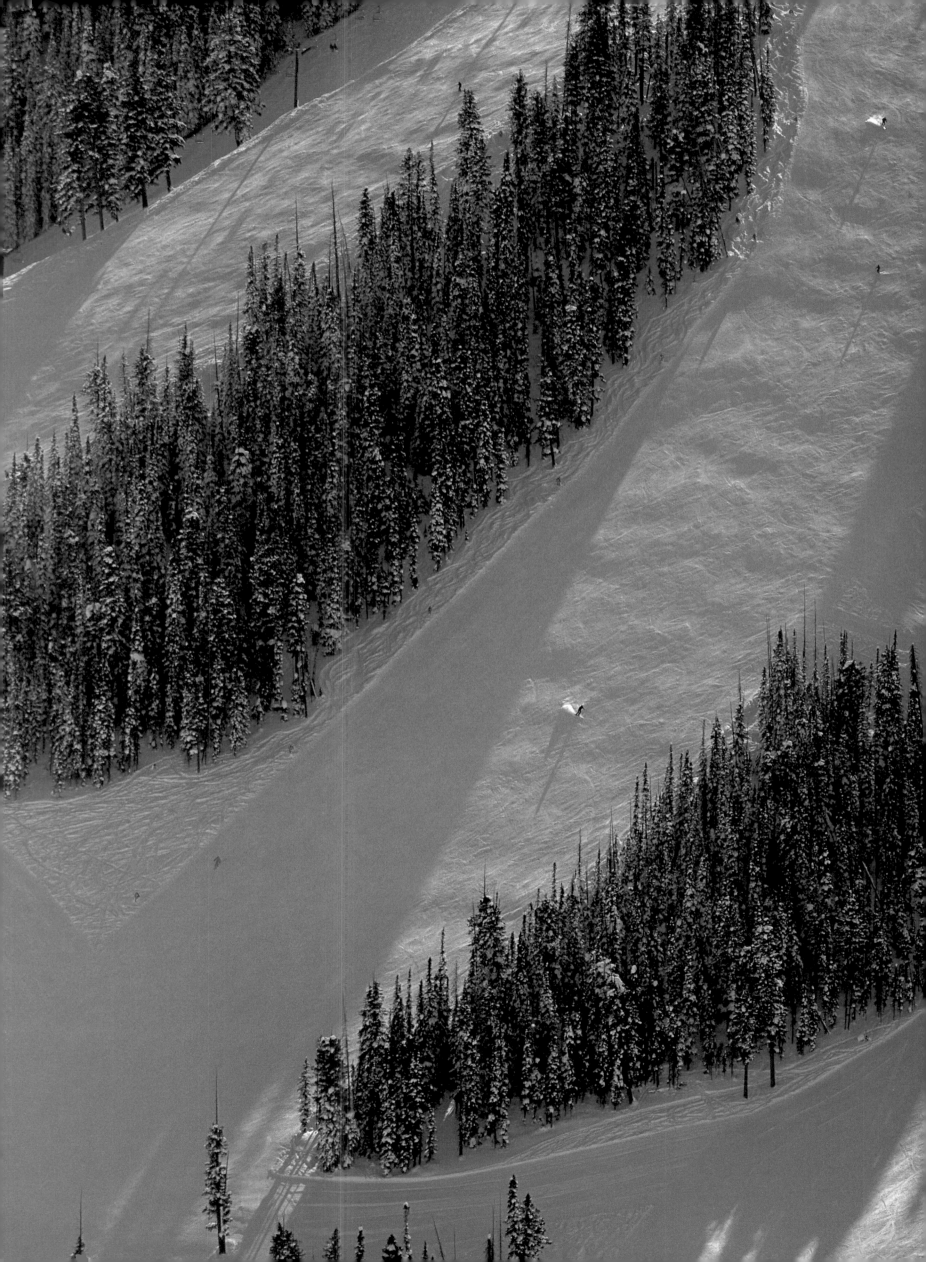

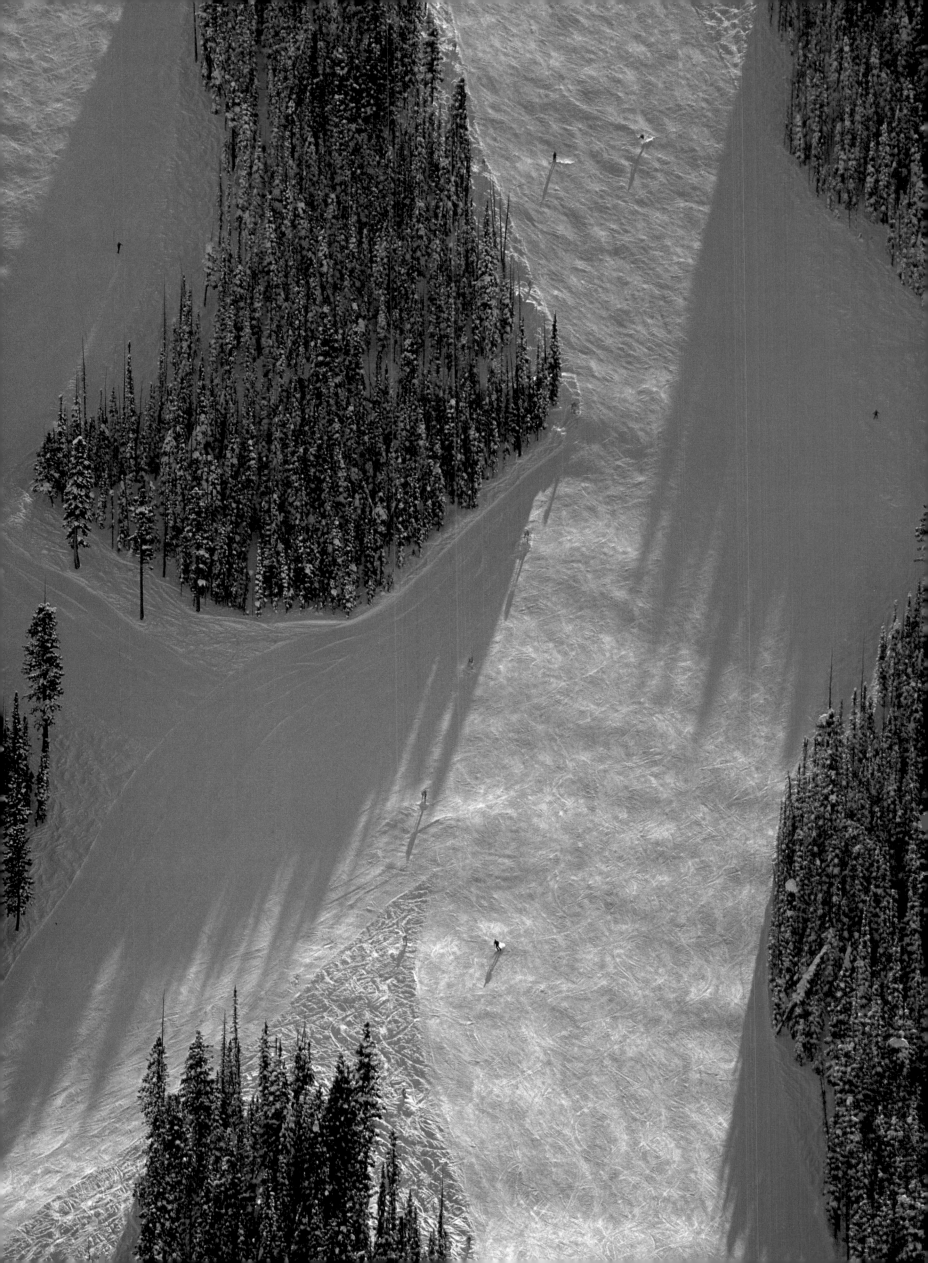

22　　*Warm Springs Lodge looks into the*

sun, up the Warm Springs trail, thirty-

one hundred feet to Baldy's summit.

23　　*The once-upon-a-time sheep*

town of Ketchum spreads its chic

blanket of lights across the valley.

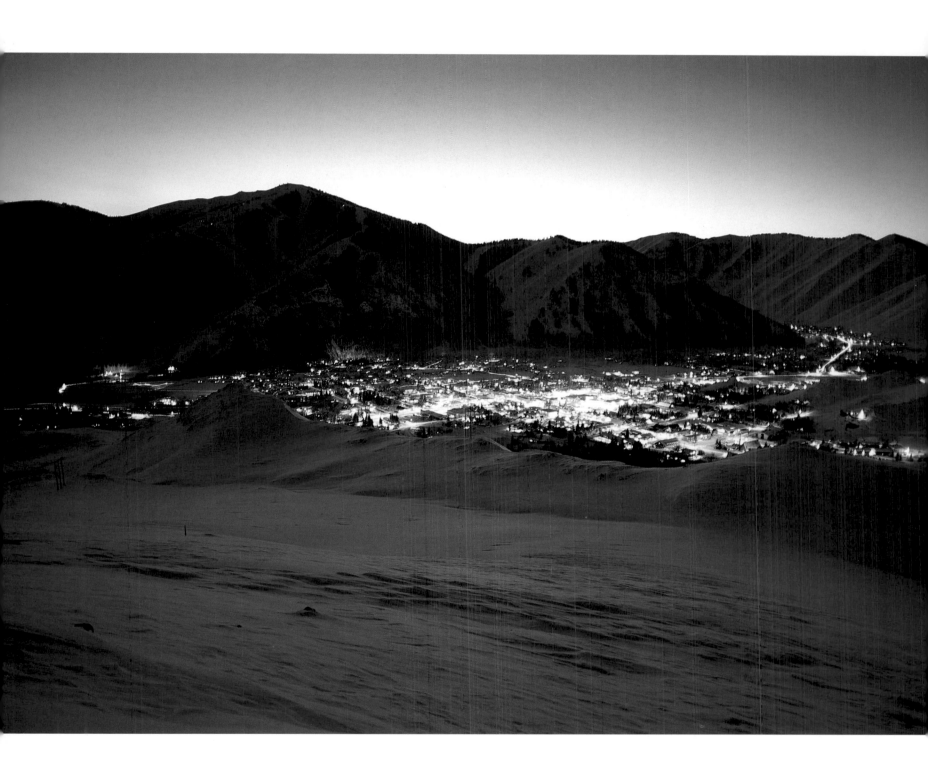

IT'S AN ALTA DAY TODAY

Alf Engen had gathered some of his oldest friends together at Alta to mark the area's fiftieth anniversary, and his own somewhat reluctant retirement after forty years as ski school director. They would provide their own entertainment: a demonstration of ski techniques from across the years, a living history, starting with the venerable telemark turn invented a hundred years ago in Alf's native Norway, and schussing right up to the latest PSIA (Professional Ski Instructors of America) teaching theories. It was to be called "Skiing As I Remember, by Alf Engen."

Rainer Kolb had made the drive down from Sun Valley. Pepi Stiegler came from Jackson Hole. Junior and Maxine Bounous popped up the canyon road a mile from their base in Snowbird. Stein Eriksen was to come from his home in Park City just across the ridgeline, but the heavy snow kept him off the road.

That was the problem: snow hung like a curtain everywhere you turned, drifting straight down and accumulating at a rate of about an inch an hour. Some in the gathering suggested that perhaps the ski demonstration should be postponed because of the weather, but the eighty-year-old Engen dismissed the idea. "It's an Alta day today," he said with an elfin twinkle. This is Alta weather; the show will go on.

Snow is the defining element at Alta, perched high at the end of Little Cottonwood Canyon in Utah's Wasatch Range. No one knows exactly why it snows so much at Alta. But it does, an average of five hundred inches per year for the last fifty years. That is forty-one feet a season. A single storm in January 1965 dumped 105 inches of snow on the roof of the Alta Lodge. And the snow pouring down is not just any snow, it is usually low-density fluff on the order of 8 to 11 percent water. Melt a quart of it, and you get a sip. The crystals are large and airy. Hundreds of them can balance on an aspen twig. Sometimes the snow is only 4 or 5 percent water. This stuff you can scoop up in your hand and blow away like so many dandelion feathers.

Snow like this makes skiing easy. When it is packed down by the big rollers, ski edges slice it like sharp knives in butter. There are no scraping or chattering sounds. Only silence. And when there is a blanket of new powder on the slopes here, skiing becomes something else entirely, something like a falling dream. The snow turns to whipped cream, time slows to a crawl, and gravity lets you down the mountain as if you were royalty, with hushed tones and a sublime gentleness.

Alf "discovered" Alta in 1935 from his CCC post in Big Cottonwood Canyon just over the ridge to the north. From Catherine's Pass, which straddles the two canyons, he could see almost the entire Wasatch Range. Tall and blade-thin, it stretched barely a hundred miles from near the Idaho border to its southern terminus at Mount Nebo above Provo. The valley of the Salt Lake was only five miles away but a full seven thousand vertical feet below. Storms traversed the thousand miles of Great Basin desert to the west, climbing and cooling as they came, then slammed into the Wasatch Front. They funneled up the glaciated canyons east of the lake where most of Utah's ski areas now cluster—Alta, Snowbird, Brighton, Solitude, Park City—and poured snow on the peaks. Alf looked at the sensuous, womanly shapes snow made and dreamed a ski area.

America's second chair lift, after Sun Valley's, rattled up into Alta's Collins Basin in the winter of 1938. It was constructed of parts from an old mine tram. A newly formed grass-roots organization called the Salt Lake Winter Recreation Association ran the lift, and charged a buck and a half for the all-day ticket. By the time I first skied Alta in 1968, the price still had not gone up commensurately with the rest of the ski world. As I recall, the full-day pass was five dollars. Today, it is still about fifteen years behind the times. Alta does not accept credit cards; it does not advertise (it has no need to), and it does not offer discounts—even for children. The official line goes: "We don't sell a children's ticket because here everybody pays children's prices." Joe Quinney, one of the guiding lights of the SLWRA, is reputed to have told his successors from his deathbed, "Take what you need to make a living, *but keep the price down.*"

I remember in 1968 packing lunches of peanut butter, banana, and honey sandwiches and driving forty minutes from my friend's house in Salt Lake City up the canyon and into the Alta parking lot. It was a low-ceiling, low-visibility day, so we only sprung for the half-day ticket, at $3.50 each. By the time we reached the top of the second chair, the Germania lift, sun was beginning to burn through the clouds. We noticed a ski patrolman turning a sign from CLOSED to OPEN, and decided to follow him up and over the ridge separating Alta's two main basins. On the Sugarloaf side, we faced into the emerging sun. Clouds tore themselves to wisps at our feet, and the snow—a new foot had fallen overnight—sparkled like a copper sea.

Neither of us had much experience in powder. In fact, my few forays off the track in the California Sierra had always led to gluelike frustration. But this dazzling, unmarked canvas drew us in. My friend said, you first, so I eased over the lip, stemmed tentatively, and dropped in. Another stem, a little speed, and the snow began to kick up around me. My skis rose and fell like dolphins playing a placid cove. Now snow curved in a wave up my legs and chest and washed over my shoulders like white silk scarves. Cold snow pricked my cheeks and tapped a message on my goggles. I am certain it was not pretty, my tracks more closely resembling the mark of Zorro than sinuous S's. But I blazed inside, giddy, hooked, in love forever.

All this snow, over the years, has created as many problems as it has powder converts. Back in the late 1800s, when Alta flourished briefly as a silver camp, avalanches ripped through the miners' shacks almost as fast as they could build them. Every tree in the valley was cut for mine timbers, exacerbating an already fearsome problem. (Ironically, this relative dearth of forest today contributes to the expansive, European feel to the terrain.) According to newspaper accounts, at least seventy-four miners were killed in snowslides from 1872 to 1911.

When the skiers came, some way had to be found to protect them from snowslides, both on the slopes and on the road through the canyon. At first, a snow ranger blared a warning through loud speakers when slide danger was deemed high enough to close the mountain. Guests were "interlodged," required to stay inside until the all-clear. But the system was anything but scientific. Nobody really knew why snow cut loose down a mountainside or how to predict when it might happen.

Two pioneers of snow science Monty Atwater and Ed LaChapelle, used Alta as their laboratory in the years following World War II. LaChapelle studied snow crystals, their formation in the air and their metamorphoses inside the snow pack. Atwater studied the mechanisms of release and pioneered the use of artillery to shoot down avalanches before they become a problem. Today, whenever a foot or more of new snow has fallen, ski patrol gunners at both Alta and Snowbird are up before dawn manning their howitzers. They load the thirty-pound shells from concrete bunkers below the gun mounts, dial in the coordinates of the start zones they wish to shoot, huddle close—and with the road closed and the guests safely interlodged—blast a fiery tongue of orange into the night. Mostly, they shoot across the highway at big avalanche paths on Mount Superior and Flagstaff Peak. On the ski hill itself, teams of patrollers take specific routes and lob smaller bombs, hand charges, into known start zones high on the ridges. Depending on the amount and density of the new snow, their "big bangs" may induce dozens of slides or none at all. There is still a lot of mystery to the science.

When the canyon and the hill are bombed and safe, roadblocks come down and lifts roll. Powder addicts scramble to be the first to their own favorite places: Sun Spot, Lone Pine, Devil's Castle, Alf's High Rustler, Eddie's High Nowhere—the last named for ski instructor Eddie Morris who in the 1960s laid

down the first truly modern, slow-motion, alpha-wave powder turns, the kind then known as the Alta Machine Track.

Most deep snow techniques in use today were invented or refined here, beginning with Alf's discovery in the late 1940s that the steadiest, best platform for skiing deep snow was a two-footed stance, not the single-ski weighting that worked on hard snow. Alf, his brother Sverre, and Dick Durrance—America's first ski Olympian (Garmish 1936)—practiced this "Double Dipsy" on High Rustler, the horn-shaped, thousand-foot pitch soaring directly above the Alta Lodge. "Ya, sure, by gosh it worked," Alf crooned in his soft Norwegian lilt. "We just skied it silky smooth, pretty much like the path of water."

Other inventions for three-dimensional snow included the Alta Bounce, pouncing down, then bringing the skis up to the surface to begin a turn; the Alta Start, wherein the skis' tails are kicked into the snow at the top of a run allowing for a start straight in the fall line; and the Ready Hand, an aggressive use of hands and poles (from Alf's early days as a boxer), the better to unweight and maneuver the skis in heavy snow.

Happily for the spectators at Alta's fiftieth, the snow stopped just in time for Alf's skiing history lesson. Demonstrators, some dressed in skirts and wool jackets with pole baskets as big as LPs, waltzed down the hill doing the Arlberg technique. Or the French Ruade, the "horse kick." Reverse shoulder.

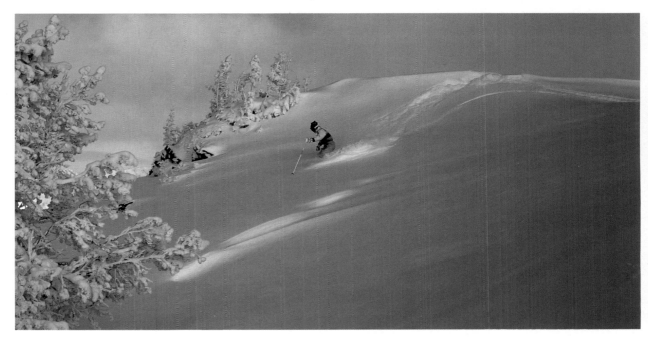

Deep snow defines the ethos at Alta.

Wedeln. Hop christies. Each advance leads to the fluid composite that is modern skiing. The last to ski was a bunch of Alta's tiniest kids, in bright suits, not much bigger than the balloons they carried. They could have been the great grandchildren of the first people Alf taught to ski. The P.A. announcer read from the script, "In each of us a child still exists." Alf's eyes filled with tears, and his friends closed in around him, as the sky closed up and once more commenced to snow.

26 Castles in the air: The

Devil's Castle region of Alta.

27 Utah's license plate is snow-

white with a skier at the top and the

words, "Greatest Snow on Earth" scrawled

across the bottom. No idle boast—it is true.

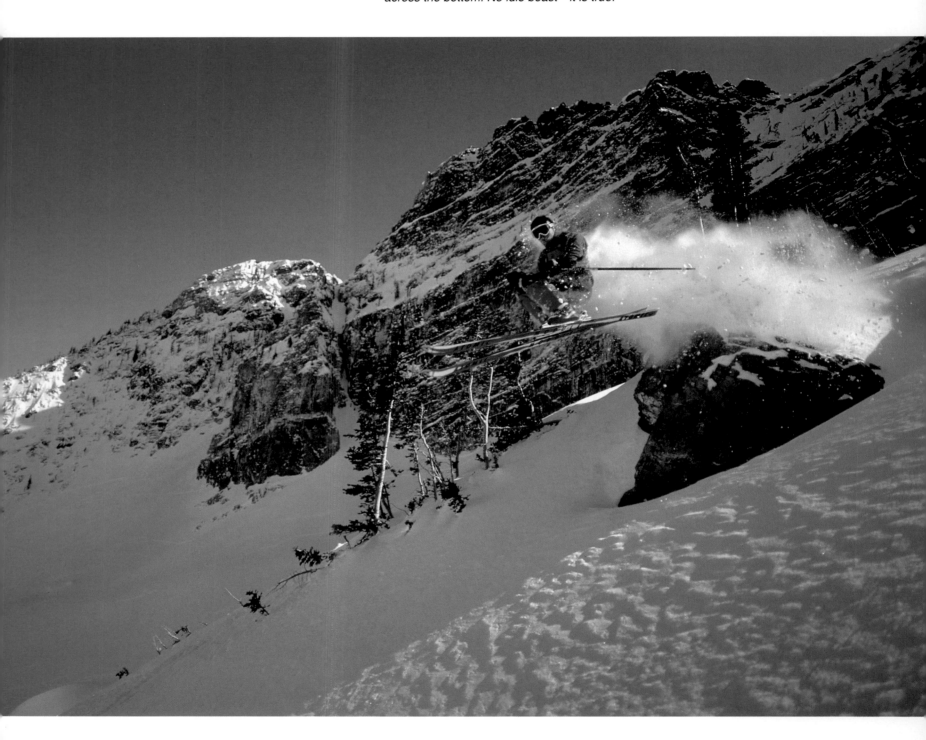

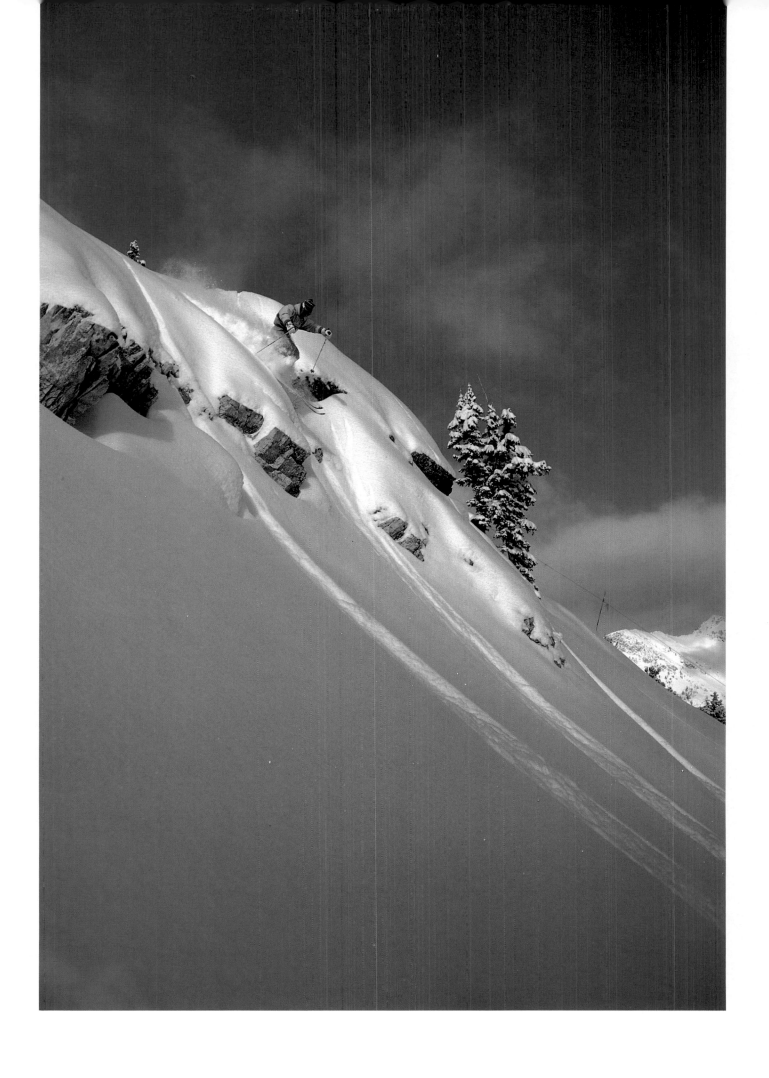

28-29 \ *Northern Utah's Wasatch Range could*

scarcely have been more perfectly designed

for skiing: tall (up to eleven thousand feet)

but not too tall; steep but not cliffy; forested

just enough; and perfectly situated to gather

in those powder-laden Great Basin storms.

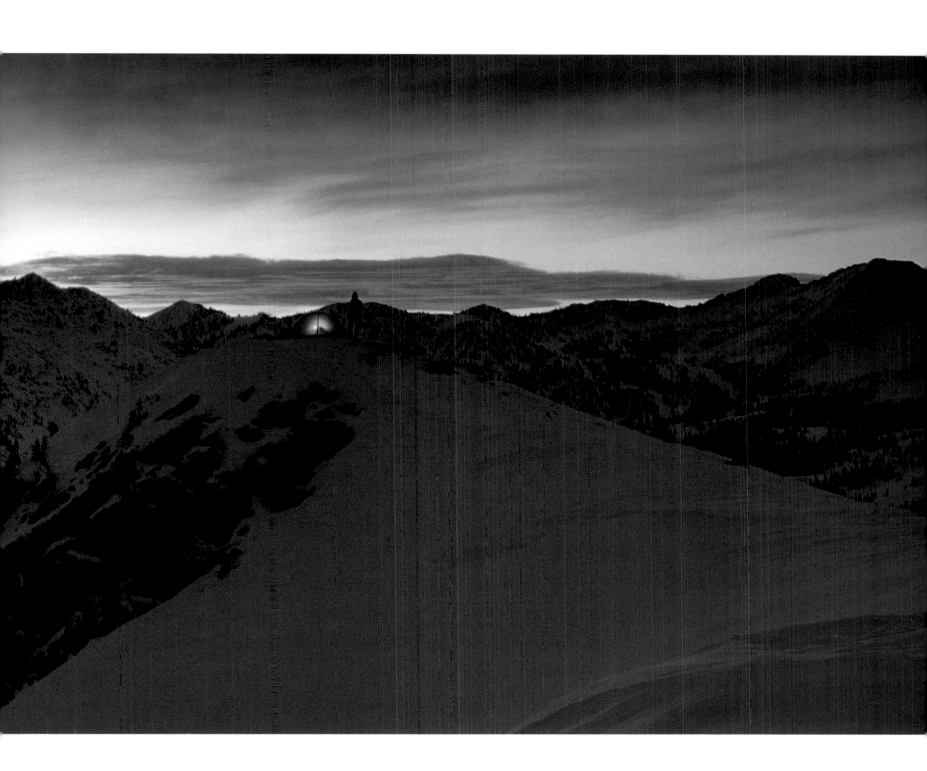

30 \ *The world's second chair lift,*

after Sun Valley's, ascended the slopes of

Alta's Collins Basin during the winter of 1938.

31 \ *Today, skiers frolic in the deep snow,*

thanks, in part, to the powder techniques

pioneered at Alta in the 1940s and 1950s.

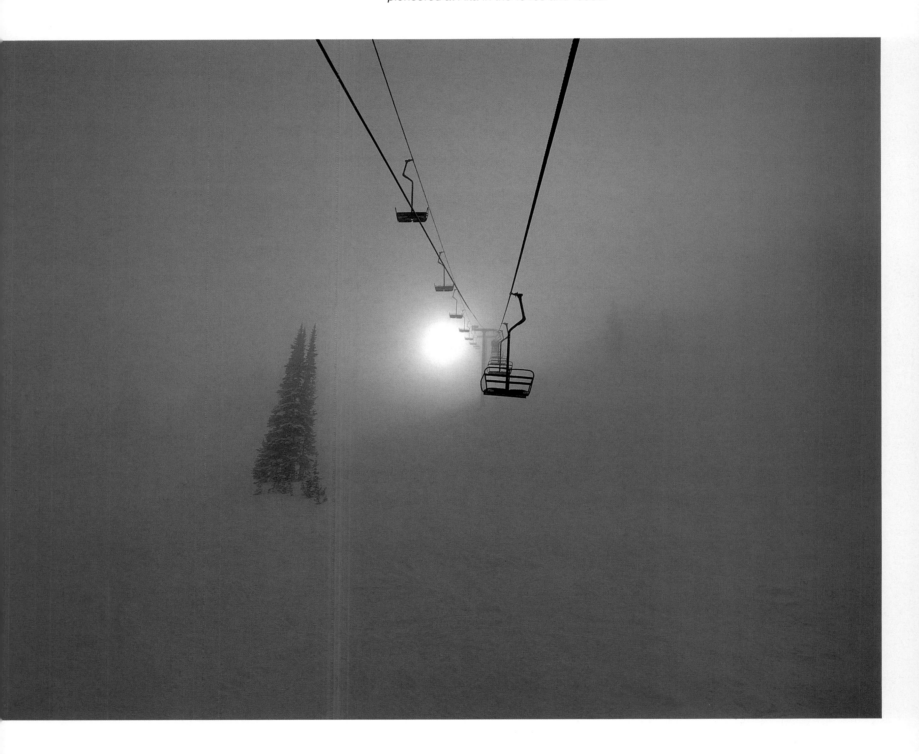

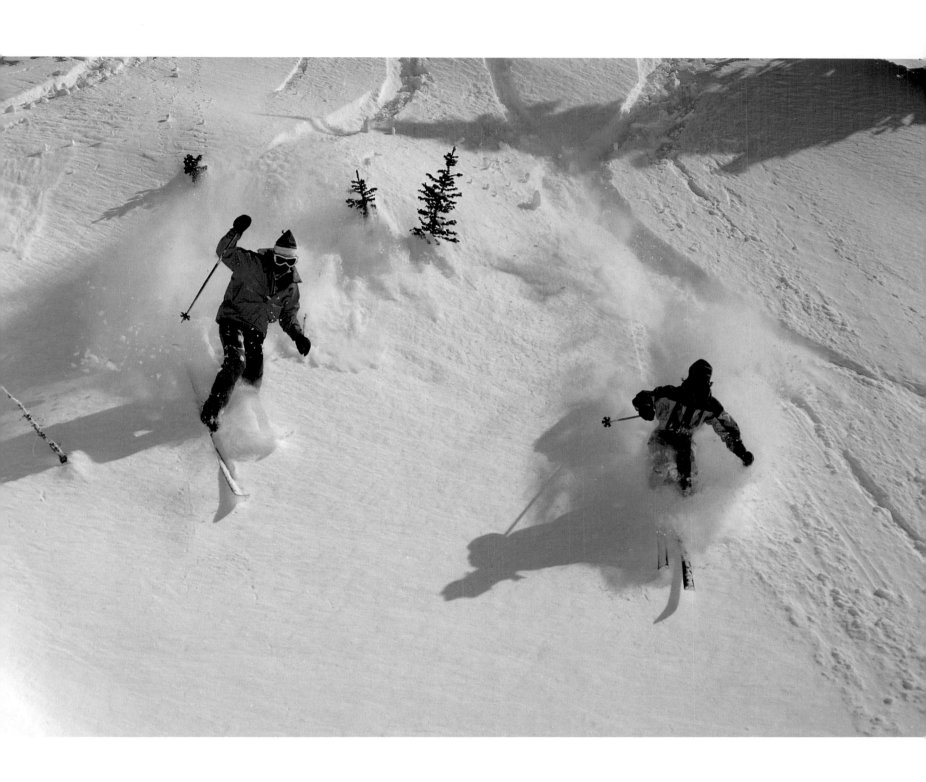

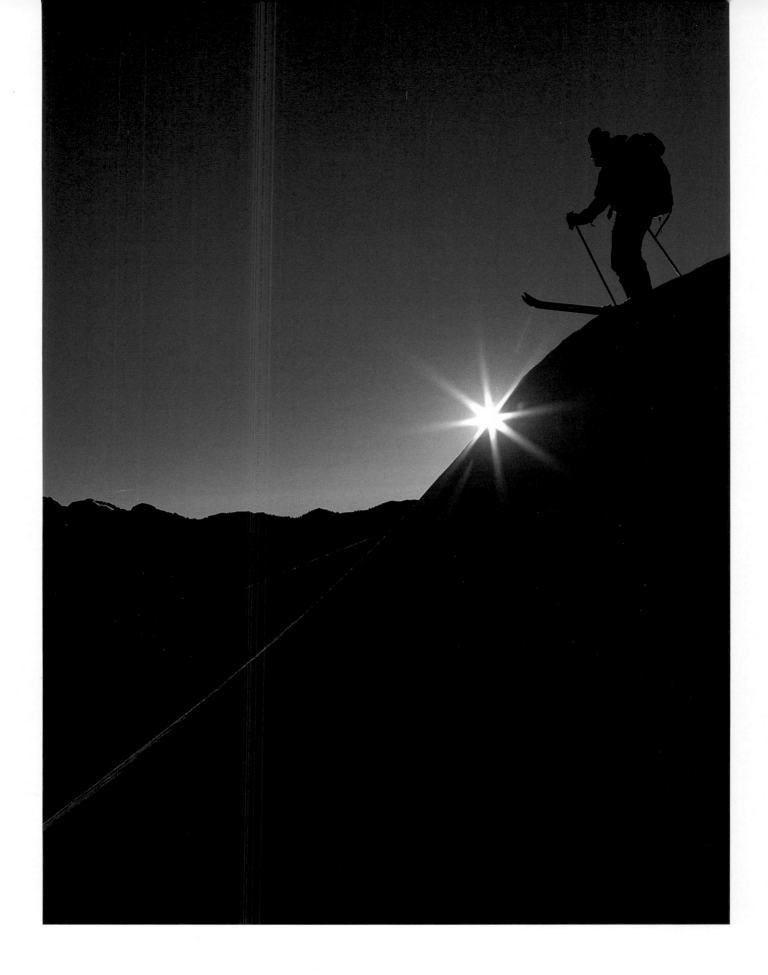

32 \ Backcountry skiers flock to the high perches

in the Wasatch Range from nearby Salt Lake City.

33 \ No matter how they get up the mountains—

on foot or by way of the lifts—the goal is the same:

sleuthing through patches of eiderdown-soft snow.

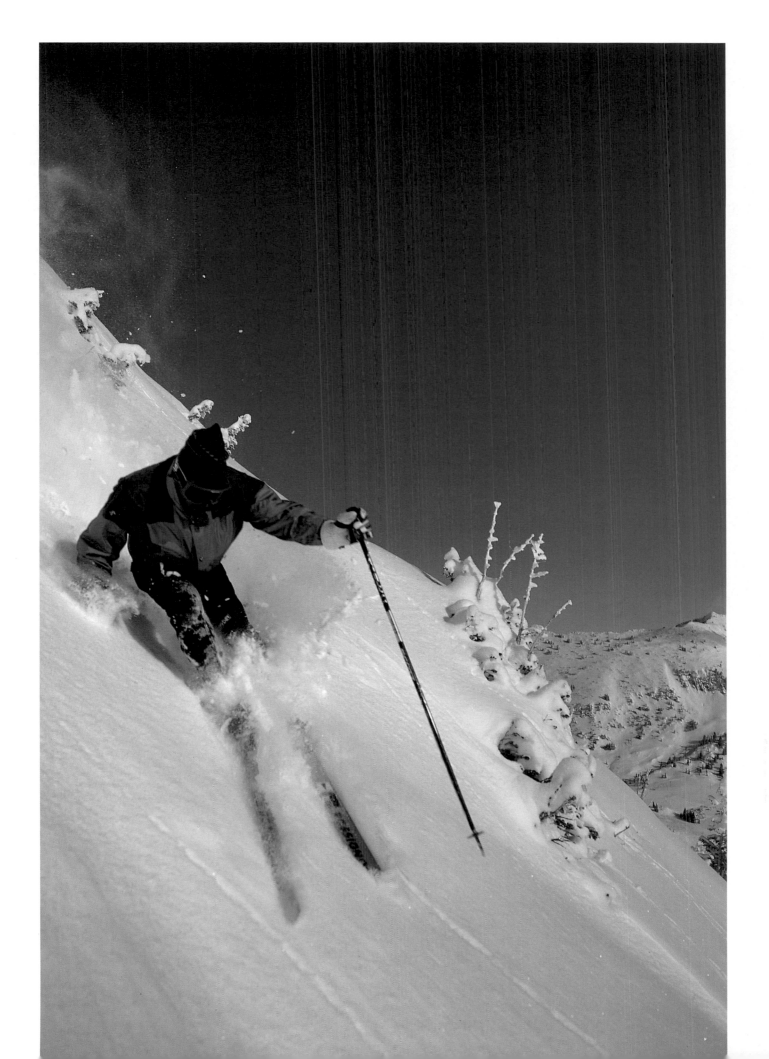

34 \ Just a mile down the Little

Cottonwood Canyon from Alta, Snowbird's

cubist Cliff Lodge settles gently into evening.

35 \ Peruvian Ridge launches skiers from

Hidden Peak at eleven thousand feet into

one of the two timberline bowls at Snowbird.

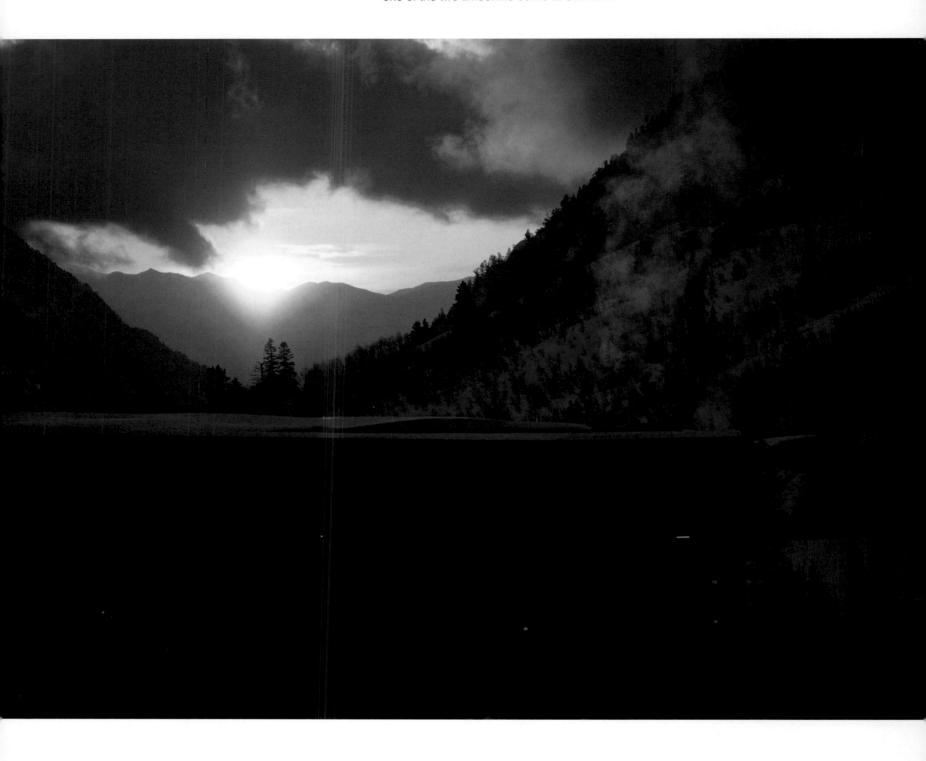

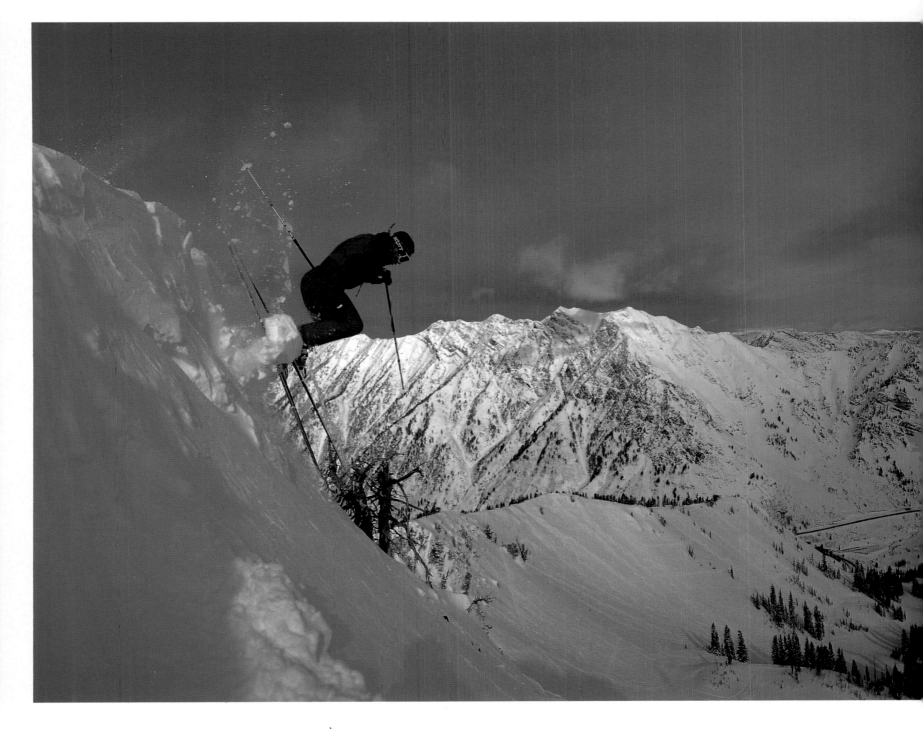

36-37 \ Powder snow slows time. It

washes up your legs and chest and over

your shoulders like white silk scarves. Alta

receives over five hundred inches—that is

forty-one feet—of snow like this every year.

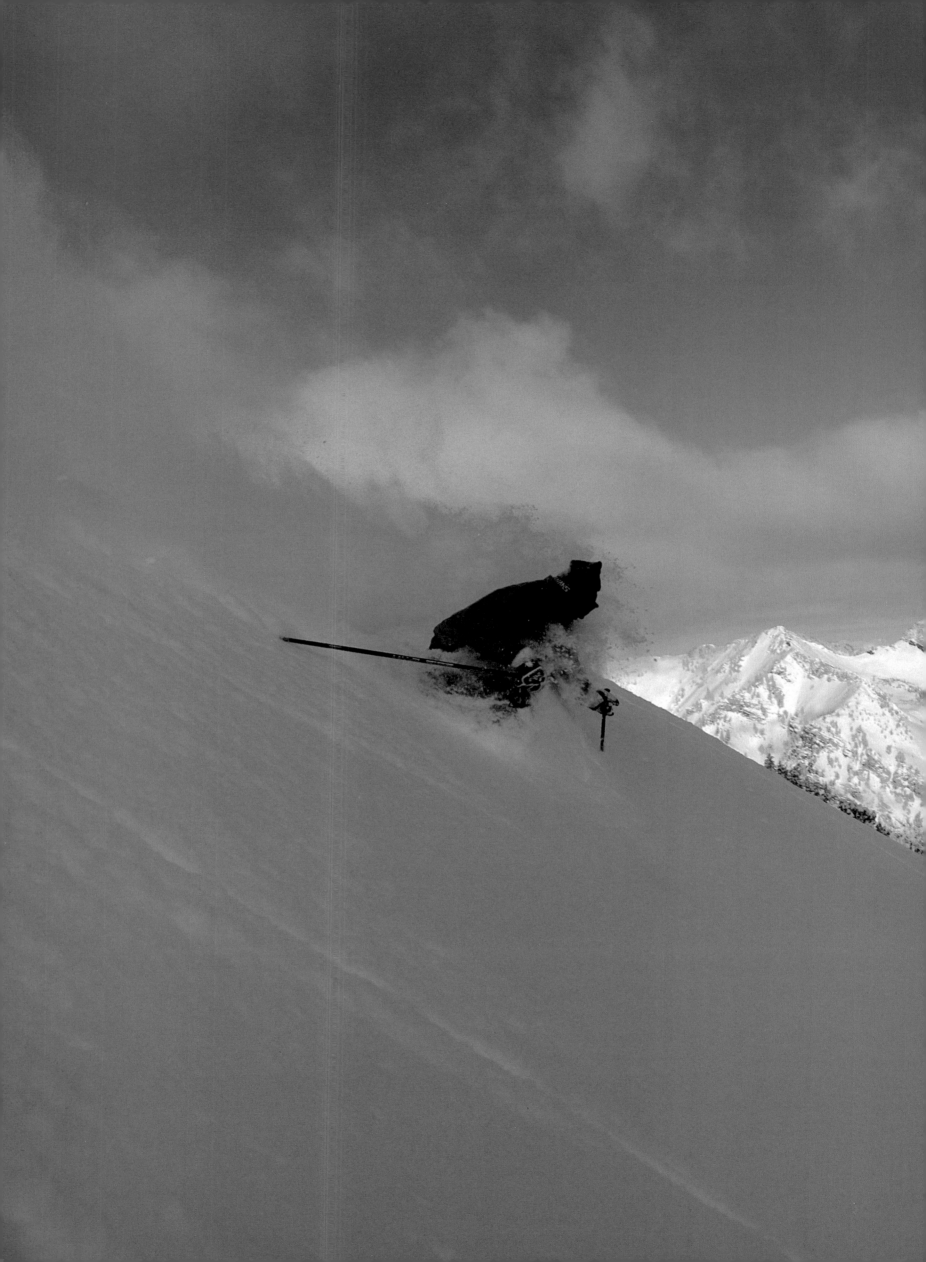

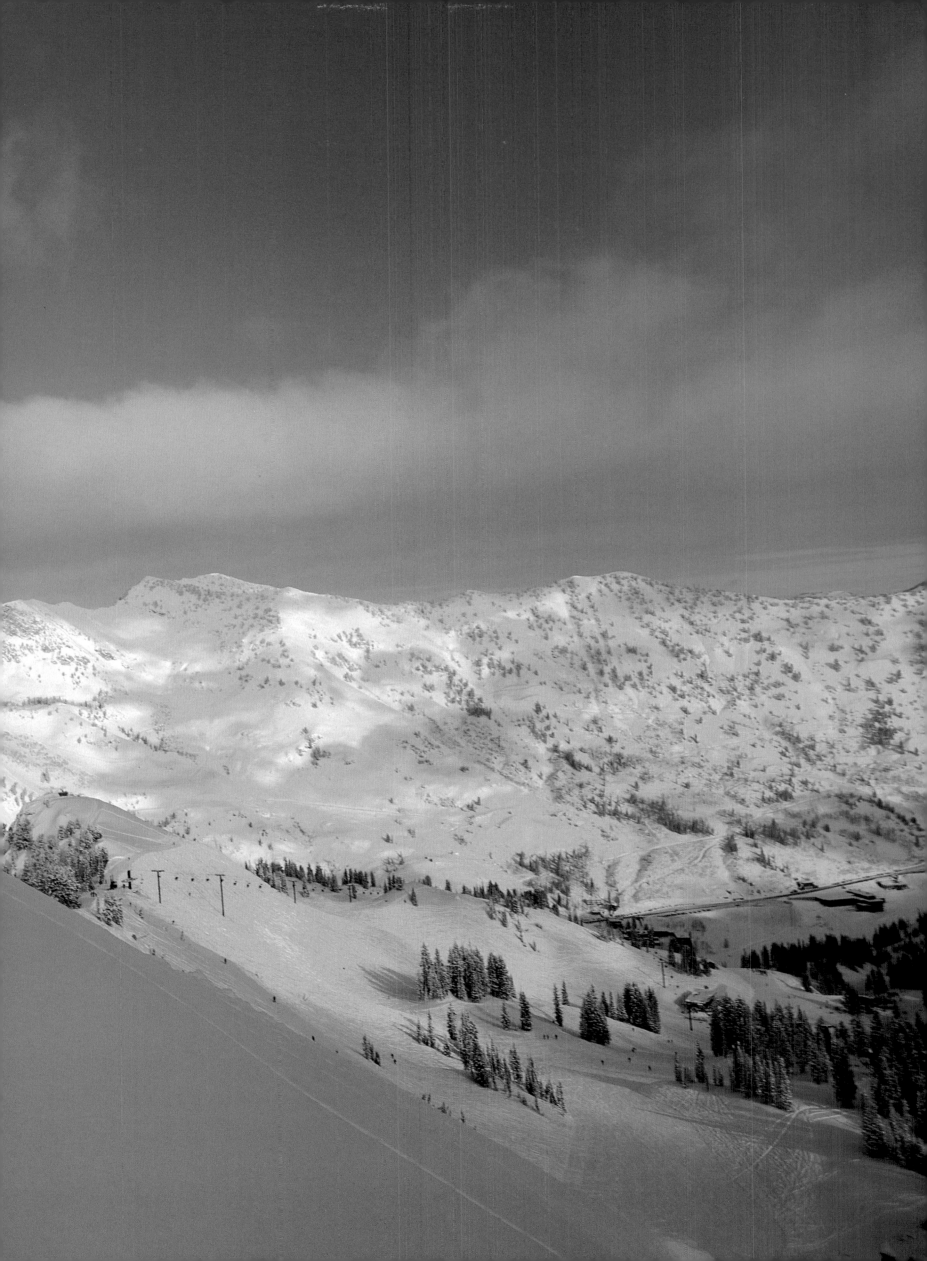

38 \ Across the canyon from Alta, Cardiff

Bowl awaits the stalwart backcountry skier

who must hike before receiving his reward.

39 \ Snowbird's Swiss-made 125-passenger

tram whisks skiers to the top of Hidden Peak

and some decidedly European-like terrain.

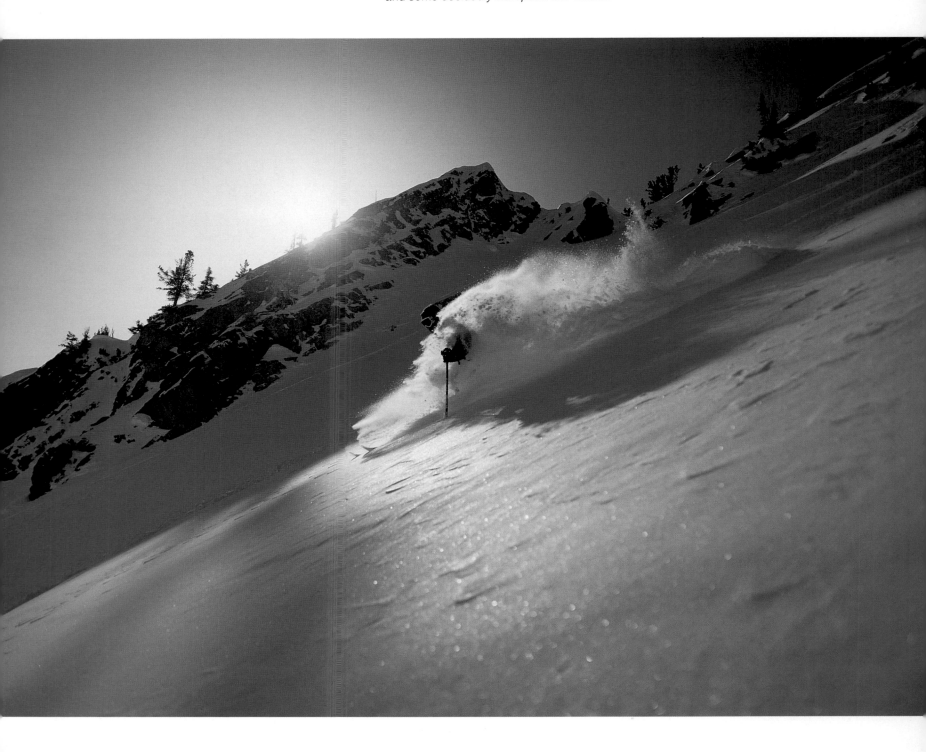

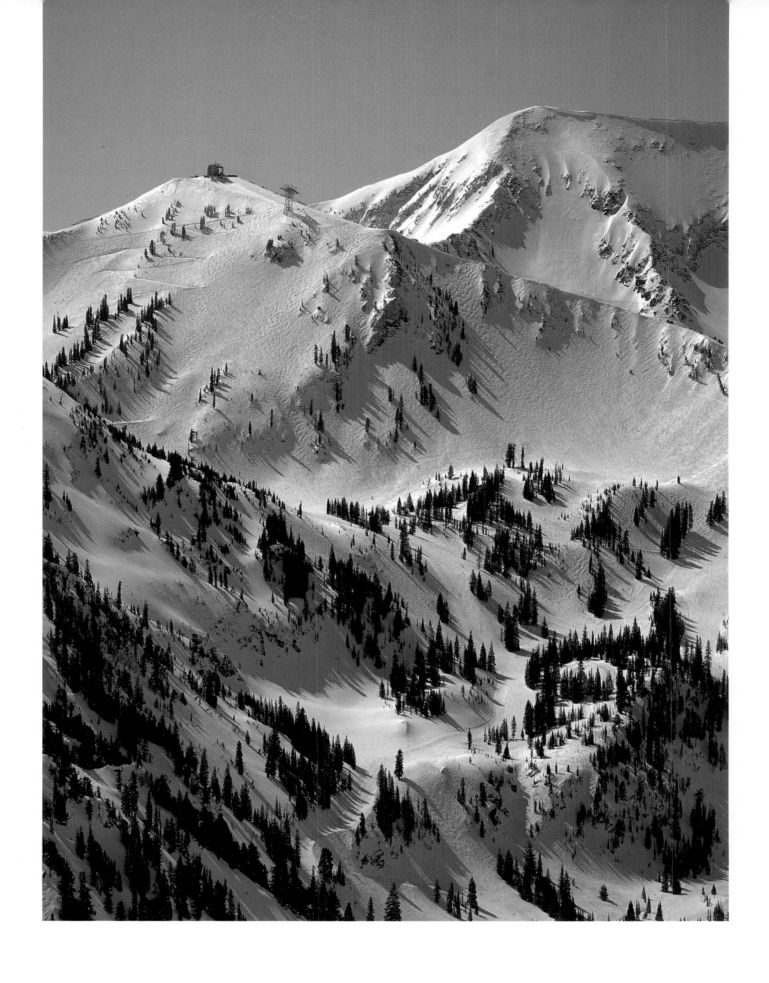

40-41 \ So numerous are the hidden

powder stashes at Alta that the ski patrol

does not even have names for all of them.

This shot might be called "That little gap

skier's left of the two pines in North Rustler."

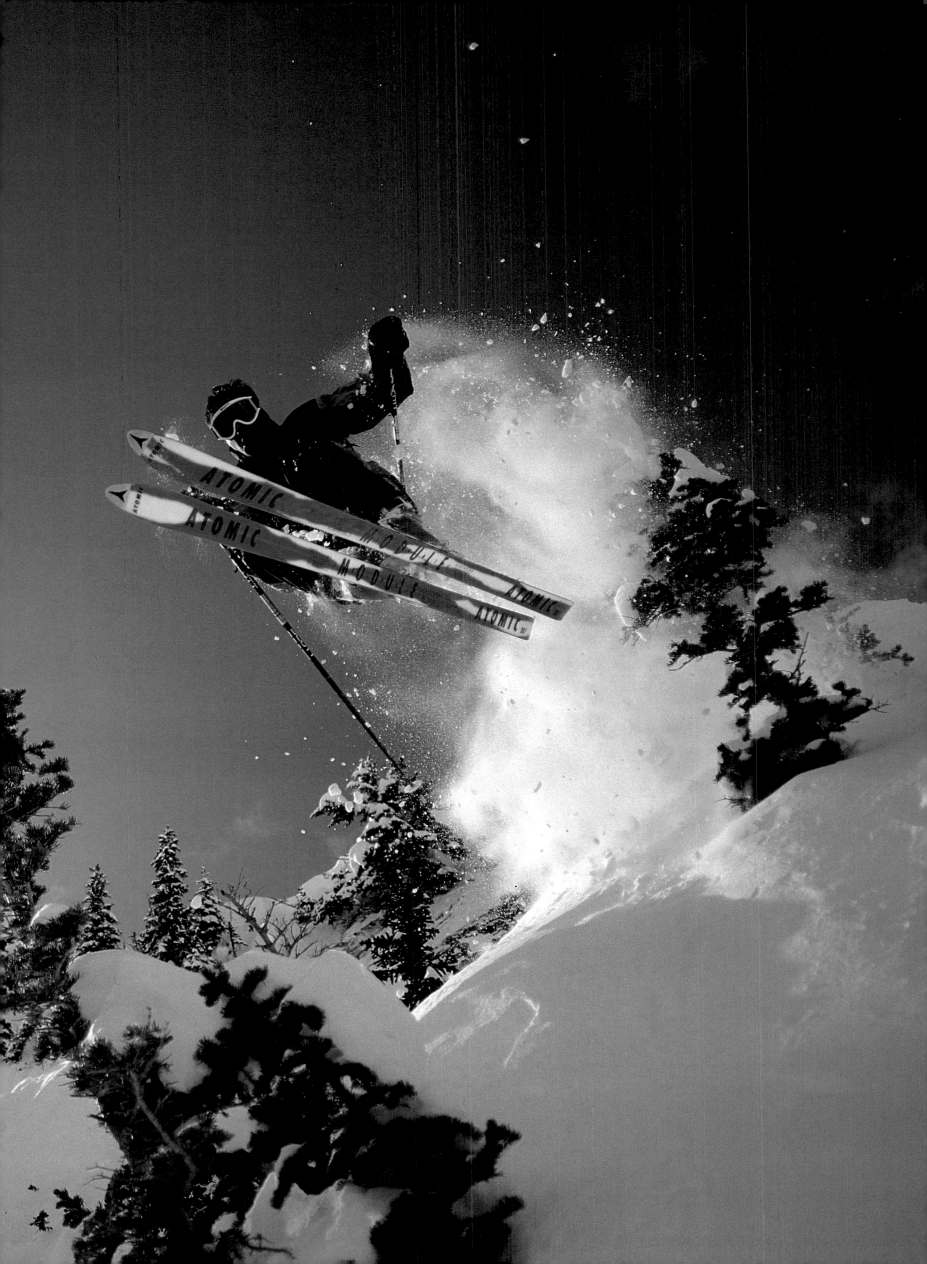

42 \ *Snowbird is not all steep and deep. There is*

some tasty grooming, too, here on Wilbur Ridge.

43 \ *Ten stories high, the Cliff Lodge sports a*

spa and pool on the roof. The view through the

atrium glass takes in most of the ski mountain.

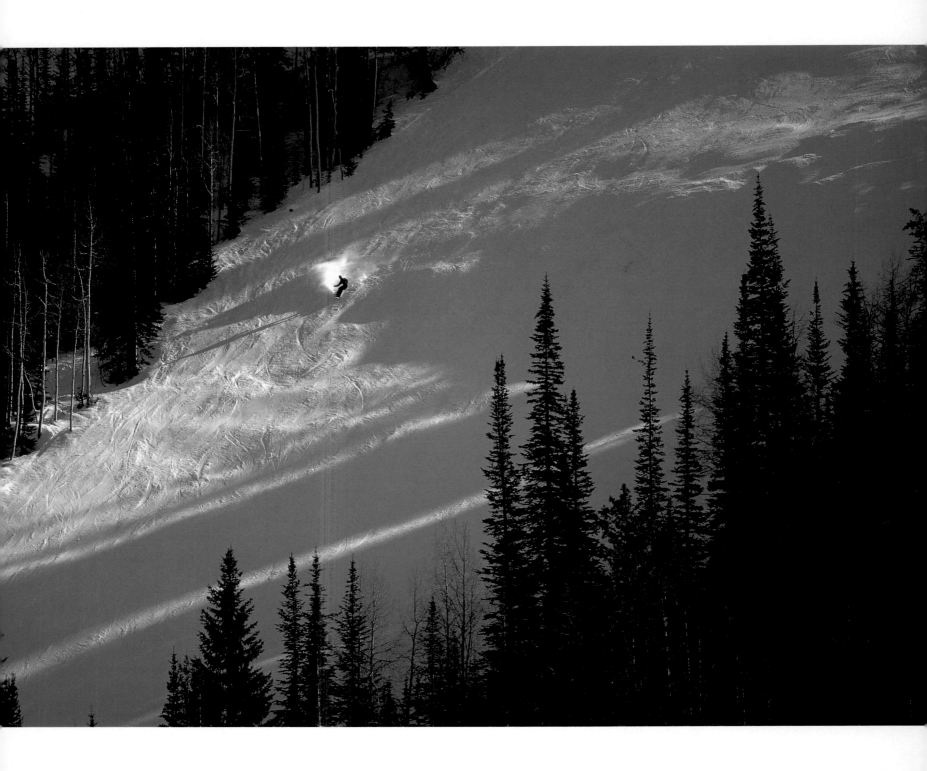

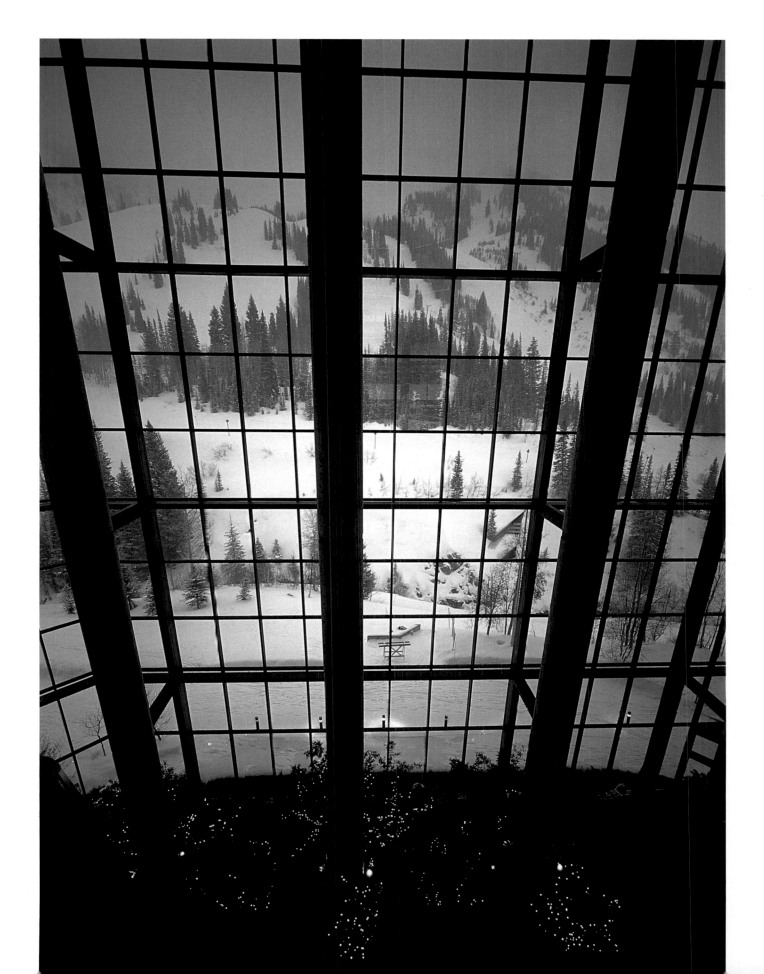

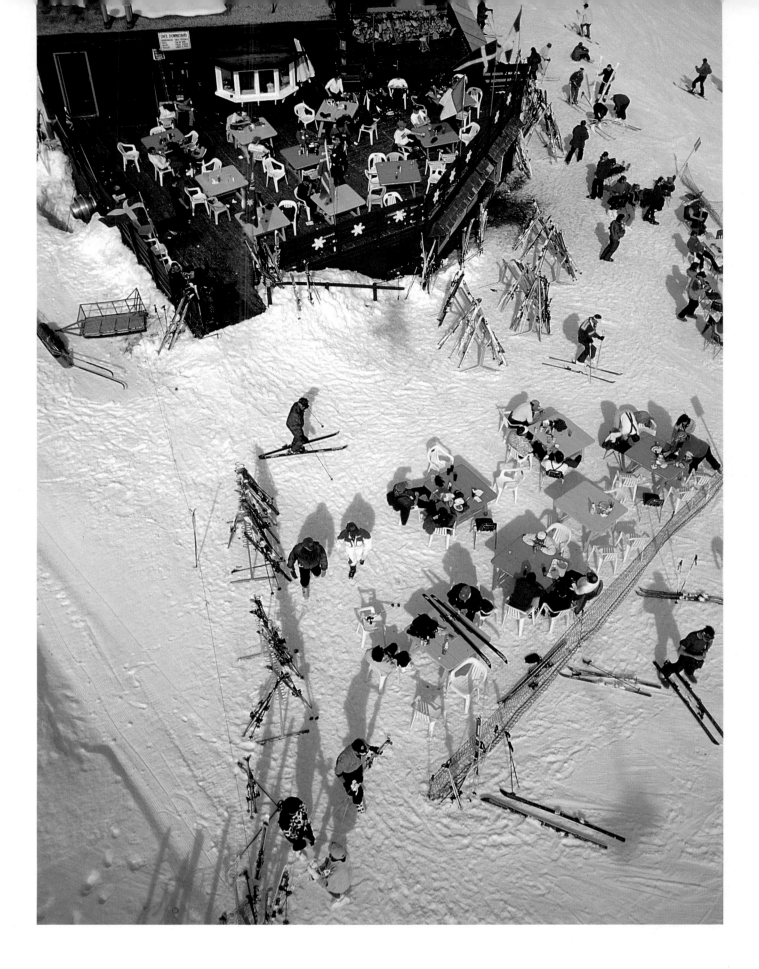

44 \ *Watson Shelter, mid-mountain at*

Alta, was named for the mayor (and sole

resident) of ghost town Alta, circa 1935.

45 \ *Snowboards, the newest tools*

used for surfing snow, have soared in

popularity on the great Wasatch waves.

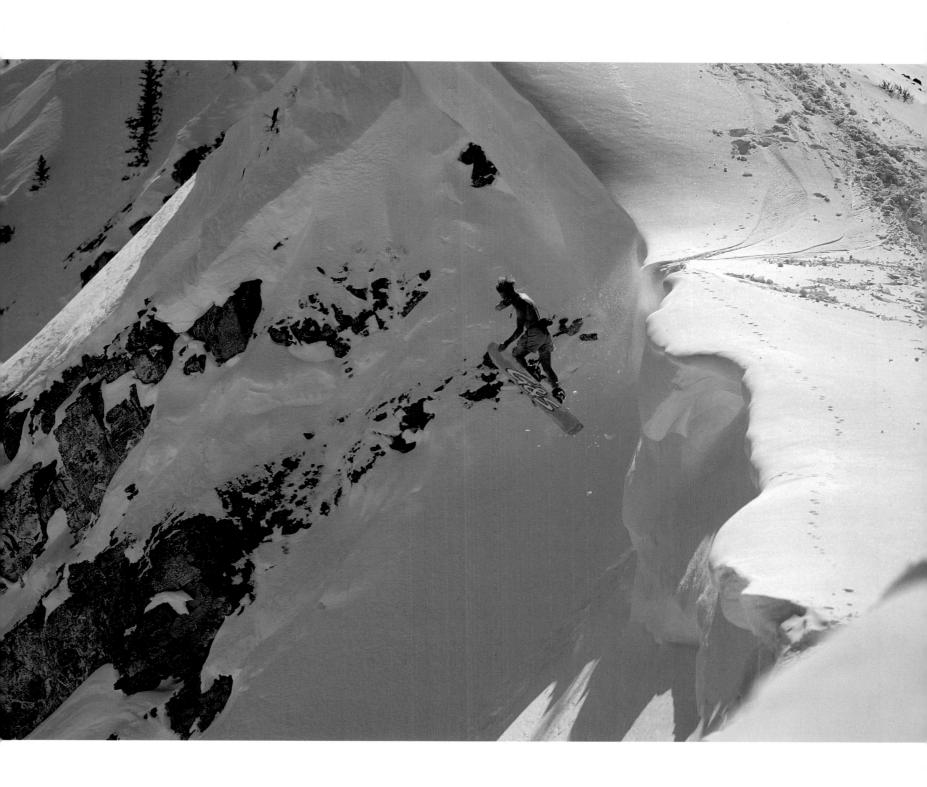

46 This could have been the Alta ski

school director, Alf Engen, forty years ago,

skiing "pretty much like the path of water."

47 When avalanches rumble, guests hunker

down in the Alta Lodge with hot drinks and the

smell of fresh-baked bread until the all-clear.

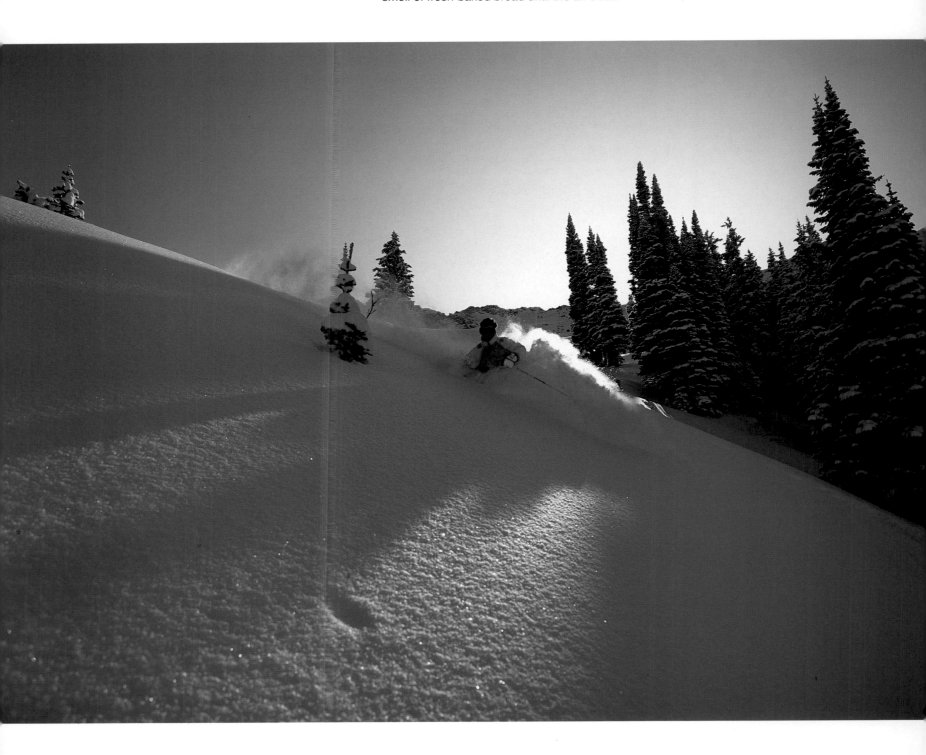

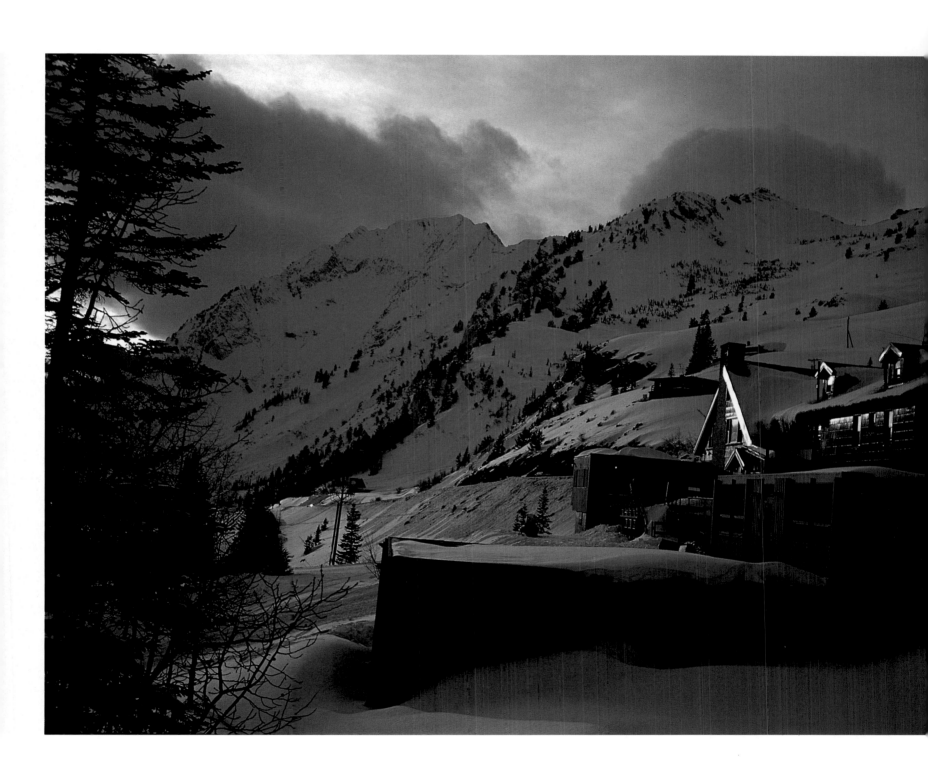

Taos ski instructor Jean Mayer and I came upon her clutching the snow on High Traverse with every fiber of her being, as if she had cat claws sprouting from her gloves, as if by hugging the steep slope ever more tightly she could somehow wish away the predicament she was in.

"Don't touch me!" she said as Jean offered a hand to help. "Don't touch me! Can you see my friend? Is he down there? Is he okay?" We peered into the chute known as Stauffenberg, a pearly sweep of steep moguls between rocky walls, blending finally, four hundred vertical feet below, with gentler shapes in the West Basin bowl. We saw one ski stuck in the snow like a toothpick about a hundred feet down, then a couple of poles and the other ski and finally, down near the bottom, a blue figure beginning the long climb for his disconnected gear.

"Come on," Jean said. "Stand up and we will do it together. Come on."

"But somebody said that there was a big opening farther out here, an easier way down." In fact, she had found it. Stauffenberg is the broadest and easiest of the twenty-odd skiable slots that score this ridge, fine white seams through the trees. Two of the ones she passed on the traverse, Fabian and Oster, are barely wider than a ski length and pitched nearly forty-five degrees. These two, together with Stauffenberg, were named with typical puckish humor by Taos founder Ernie Blake after three German conspirators who tried, unsuccessfully, to blow up Adolph Hitler. Ernie named a lot of the runs here after his heroes, most of whom were also martyrs.

Not all of Taos is so unrelentingly steep, although the first impression, the view up Al's Run from the parking lot in the valley, is scarier than Ernie would have liked. There is a sign down there that reads: "Don't Panic! You're Looking at only 1/30 of Taos Ski Valley. We have many EASY runs too!" But a lot of the terrain here *is* genuinely hair-raising. This is what sets Taos apart, what brings the devoted back again and again. Once you get a taste for the steep and make peace with extreme gravity, it is hard to go back to the big boulevards.

When asked about the stunning steepness and its appropriateness for the general skiing public, Ernie used to say in a wry Swiss/German deadpan, "It was a miscalculation. I assumed, after the boom of the 1950s that people were looking for steeper and steeper slopes to test themselves." Most people were not. And thus the popularity of Vail and Snowmass and other breadloaf-shaped mountains. But Ernie went with his instincts, and the result is like no other skiing in the Rockies.

In the early 1950s, Ernie went looking for a mountain to call his own. After working at ski areas in Colorado and at Santa Fe,

New Mexico, he set out in a small plane to scour the Rockies from the air. A lot of the best and most obvious places already had ski areas: Berthoud and Monarch and Wolf Creek Passes in Colorado; Aspen, Sun Valley, Arapahoe Basin, Winter Park. The Sangre de Cristos (the Blood of Christ Mountains) in northern New Mexico were an extension of Colorado's Front Range, the southern tip of the mother chain. They were nearly empty, undeveloped but for a few defunct gold and copper mines. Ernie homed in on the area around the ghost town of Twining near the range's highest point, 13,161-foot Wheeler Peak. The exposures were perfect, north to northeast, the better to catch the Pacific storms generated off Baja California. And the high elevations (the Taos base is 9,207 feet and the summit is 11,819 feet) held that snow most years into July. The access wound up a tortuous V-shaped canyon, but Ernie liked the difficulty; it would guarantee his would be a destination, not a day-skier's, resort. And the terrain was steep, very steep; the Sangres were too far south to have supported large glaciers during the last Ice Age fifteen thousand years ago, glaciers that might have ground out more moderate slopes. Ernie liked that, too. He had been a racer at school in Switzerland, and he expected others to appreciate the challenge as he did.

Jean Mayer finally convinced the woman on Stauffenberg that she was going to have to give it a try. He told her to relax and stand on her skis, that everything was going to be fine. She had made it only a few inches into the couloir, however, when she went down and began to slide. Her skis released, and it was quickly apparent that she was in for the full ride. Jean took off after her like an ambulance-chasing dog. I could not watch, so I eased in and began collecting stray gear.

Who knows what was running through the woman's mind as she accelerated toward the center of the earth. If it was spiritual, certainly we would understand. There is a religious quality to Taos Ski Valley that goes beyond the fact that the mountains are sacred to the Taos Pueblo Indians. Playboy's *Guide to Ultimate Skiing* describes Taos as one of "America's mountain monasteries," a place where *après-ski* is French for "go to sleep." The mountain's challenge is so exciting, so exhausting, so important, that standard ski resort amenities like discos and shopping malls would be out of place.

Also, they would not fit. There is very little flat ground (or private land of any kind) at the base of the mountain. The village is tiny, consisting of half a dozen European-style, full-board lodges and a few condos. Jean and his brother Dadou Mayer operate two of the best, the Hotel Saint Bernard and the Hotel Edelweiss, respectively. Both teach in the ski school all day then hurry back to prepare exquisite meals for their guests, to refuel the body, yes, but with a spiritual flair. Dadou is famous

for his croissants, omelets, and waffles. Jean is apt to serve up lamb provencale with ratatouille nicoise and gratin dauphinois. Saint Bernard is, of course, the patron saint of skiers.

Ernie believed everyone who skied at Taos was in this thing together. He encouraged ski weeks, in which guests slept and ate and skied together for one price all week. For years, they shut the lifts down at noon so everybody could ski back to the lodges for lunch. It all fostered a kind of camaraderie, a loyalty that exists few other places. You were bound to feel like family sharing food with people who witnessed that wipe-out on Blitz *and* the epiphany in the powder of Kachina Basin. This is what Ernie wanted, a place for serious skiers, a family of aficionados.

All the spirituality, the otherworldliness comes clear to me when I get a chance to ski The Peak, Kachina Peak at the south end of the ski area. It's not always open. Wind scours the unprotected, above-timberline terrain. Avalanches regularly rake the steepest slots through the rocks. But when it is open, when the ski patrol sign at the last lift reads: "Ridge Menu for Today—Peak Open—Bon Appetit," then it is always worth adjusting plans to make the hike.

It *is* a walk, forty-five minutes, more or less, depending on your level of fitness and whether or not you have to kick steps in new snow. The air is thinner up there at 12,481 feet on the peak. But it fills the lungs with sweetness, like the taste of cold spring water. From here, it feels as if you could look across the Colorado Plateau and the Arizona deserts all the way to the Pacific. You can't, but you can see the curve in the earth's horizon. Down below, hidden by a forested fold, is the five-hundred-year-old Taos Pueblo, whose Tiwa-speaking residents tenaciously hold to sacred places and sacred ceremonies in these mountains. Just west of the pueblo is the town of Taos, where Spanish culture and architecture and cuisine have predominated for almost as many centuries. The little European alpine ski village up in the mountains is definitely the latecomer. The three have struck a more or less benevolent balance, and the blend is far more interesting than the all-Indian experience down at Ski Apache, for example, or the all-Texan ambience at Red River Ski Area, or the urban milieu that dominates the Sante Fe and Sandia (Albuquerque) ski areas.

The skiing off the top of The Peak is expansive and easy then rolls over more and more steeply until cliffs hover above the pistes. I am headed over to Hunziker Chute (named for a Swiss

chair lift engineer), one of the very steepest of the safe routes through the rocks. I stop at the top, knowing the next turns are going to feel like jumping off the roof.

I have a plan, though, gleaned from Jean and other local masters of the steep. I have prepared: I repeat a mantra in my head over and over until I am ready. "Edge set, pole plant, reach down the hill, relax. Edge set, pole plant, reach, relax." My commitment has to be total, my focus unshakable. Relaxing is the hardest part. I recall Ernie's story about a woman he had in ski school, a good skier, but she "collapsed completely when the sun went behind a cloud." She was literally frozen with fear. So Ernie sent his son Mickey for a martini in a glass pouron and administered it to his charge. "One sip and she skied like a goddess," Ernie recalled. This was in 1959, and ever since, Ernie has stashed pourons at a secret tree somewhere on the mountain, in case one is needed for medicinal purposes.

I survive my descent of Hunziker without the gin. Once I have all the pieces in place, I drop in to a magic hollow where rhythm replaces fear, and the feel of the snow underfoot completely displaces any thought of style or technique. I have fallen down the rabbit hole. I want the steepness itself, the lightness of being, the free falling between turns never to end.

And what of our poor sliding woman on Stauffenberg? By the time I reached the little human cluster at the bottom

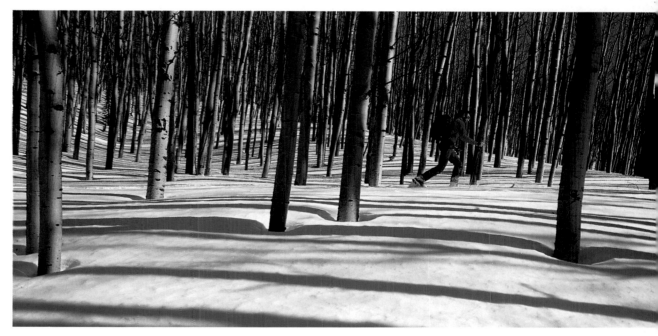

In the Sangre de Cristos, New Mexico's Blood of Christ Mountains.

of the hill (it took a while; the intensity of the pitch and my added appendages had reduced my technique to a cautious survival stem), our lady was sitting up, the color back in her cheeks and then some. Incredibly, she was unhurt. Jean was admonishing her to stick to the easier trails, read the signs, assess her ability, and so on. She was not listening. She was suffused with a deep radiance: one part shock, one part gratitude, and two parts sheer, freaking exhilaration.

50 \ *Wheeler Peak, the highest in*

New Mexico at 13,161 feet, looms

over Highline Ridge at Taos Ski Valley.

51 \ *Ski Valley founder Ernie Blake named*

most runs off the Ridge for heroes like the

Mexican patriot-priest and martyr, Hildalgo.

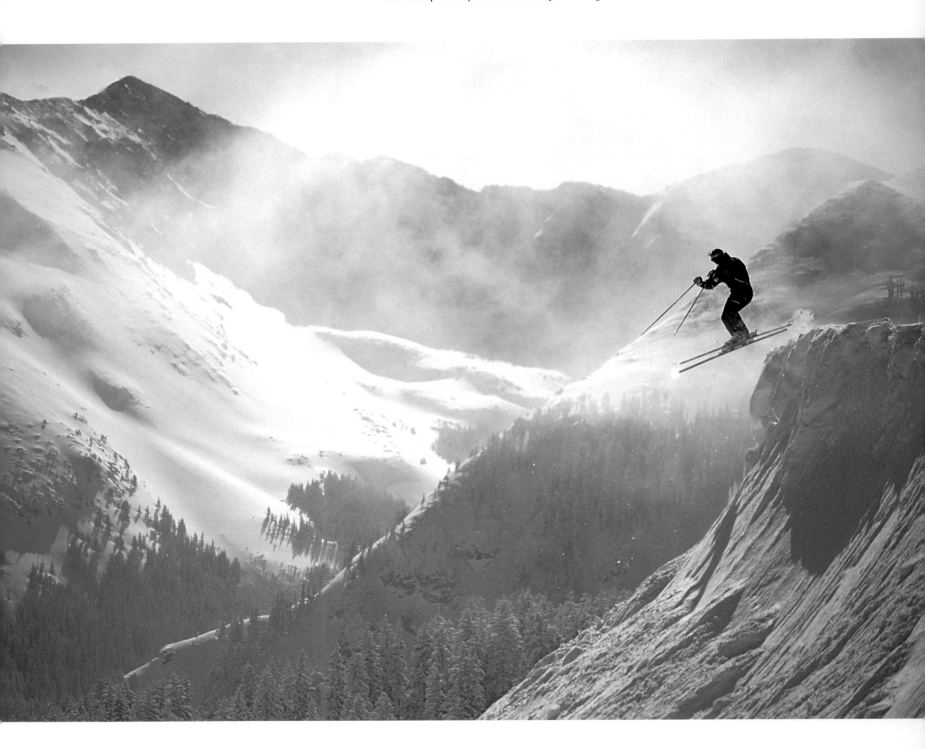

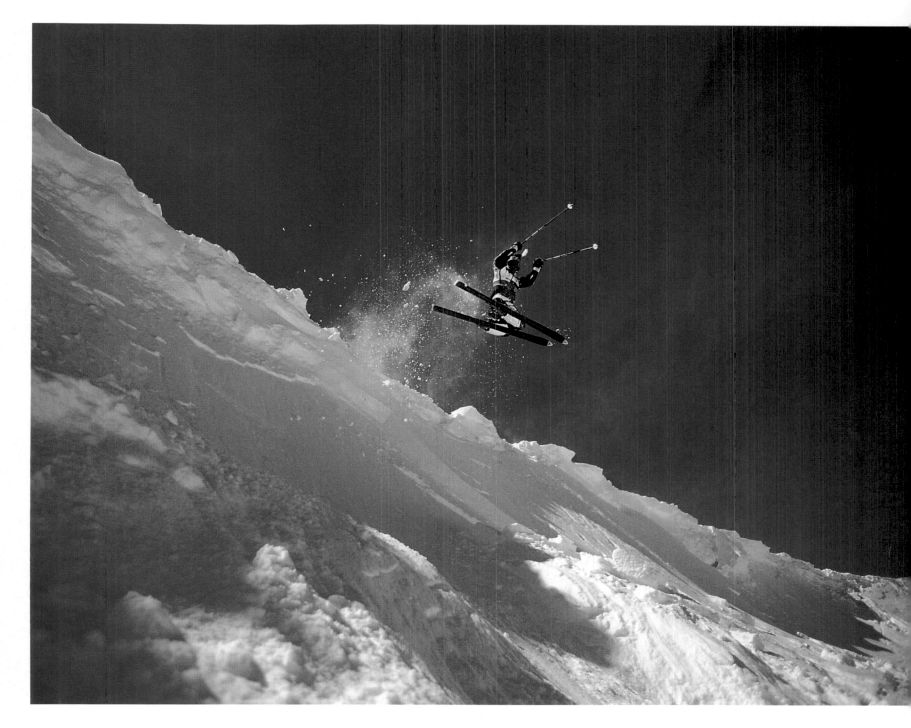

52-53 \ *On the site of a mining ghost town*

known as Twining, just a few miles from the

five-hundred-year-old Taos Pueblo, Ernie

Blake built a Swiss alpine village at the foot

of one of the steepest mountains in the Rockies.

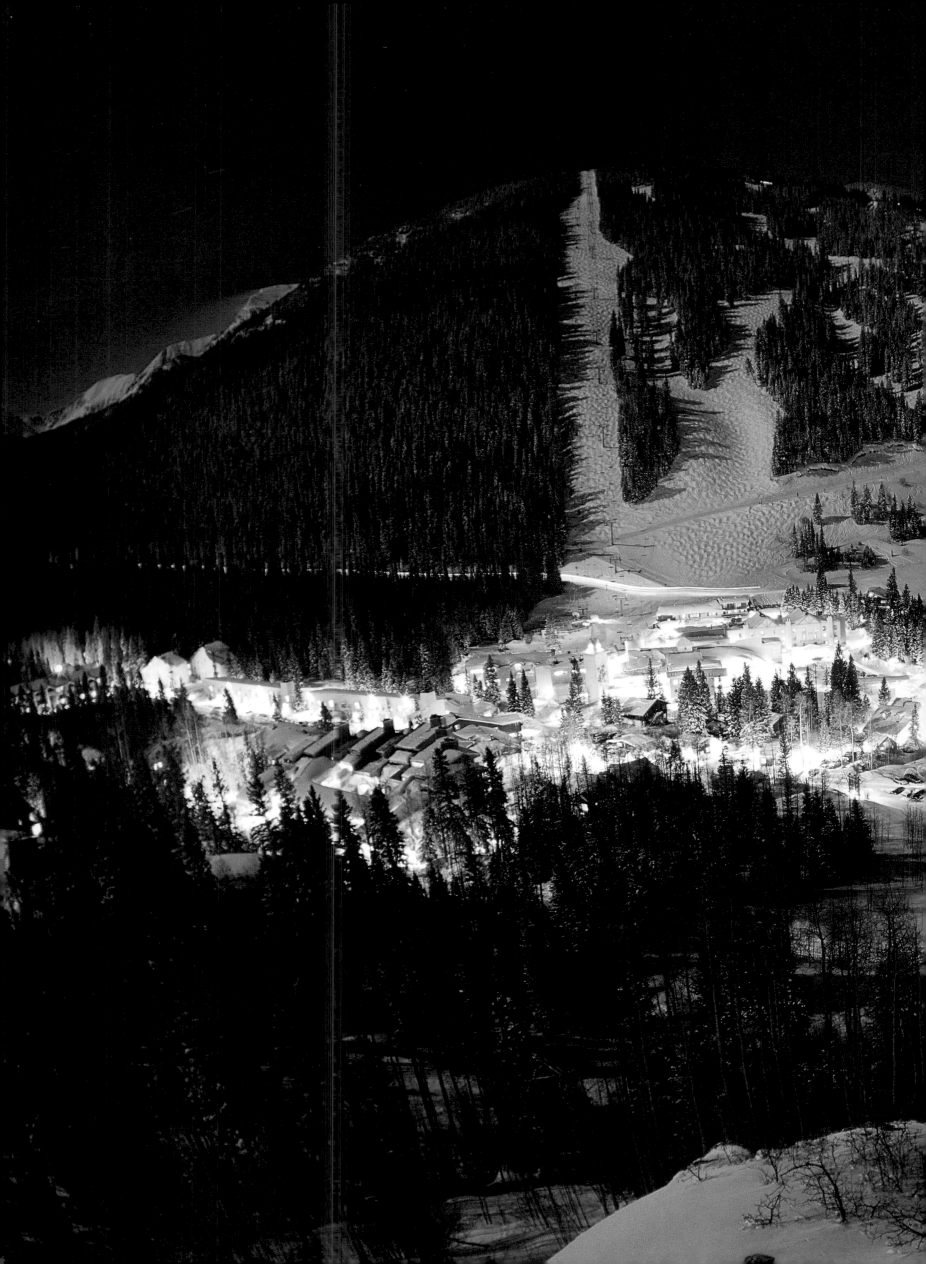

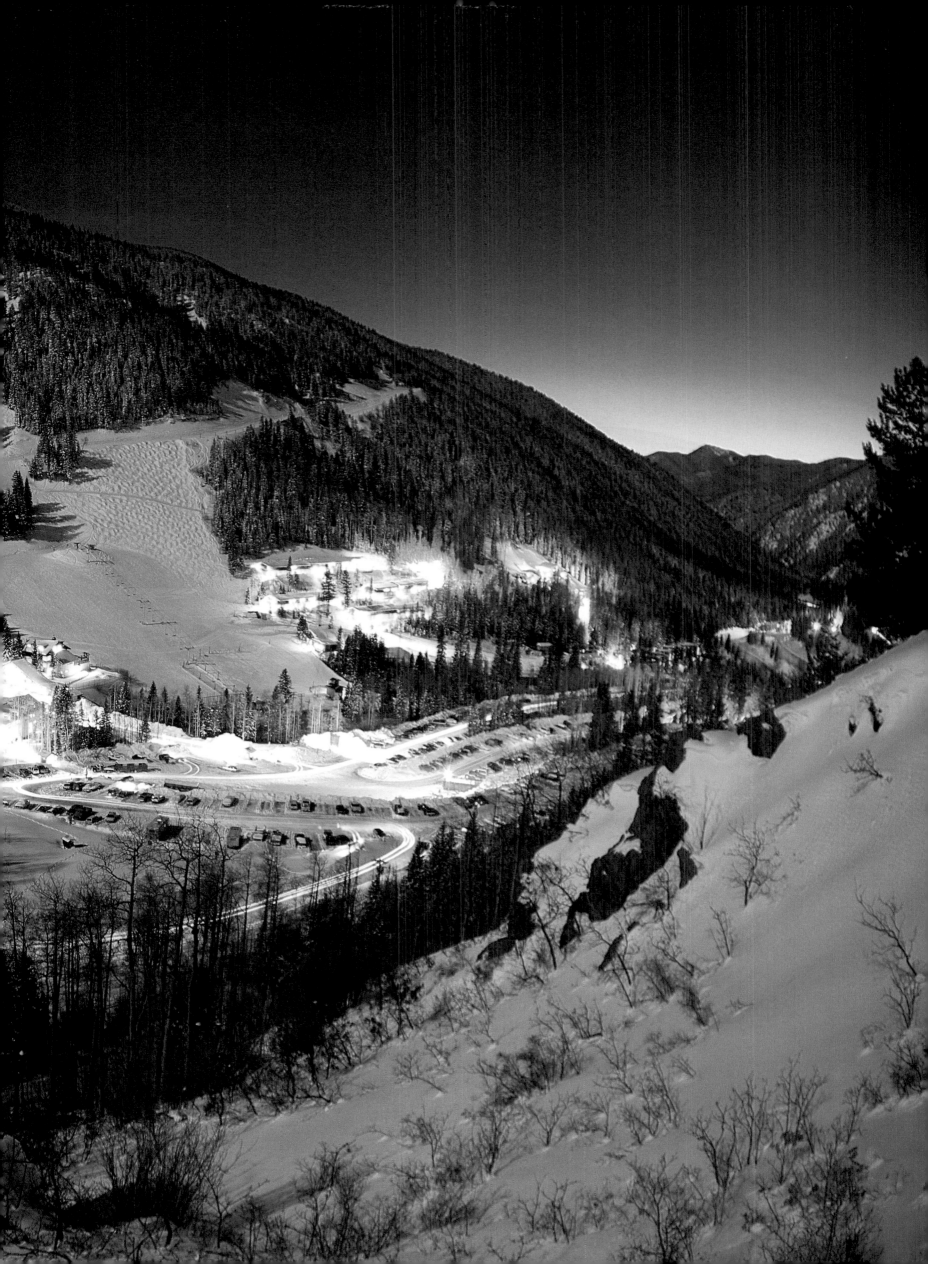

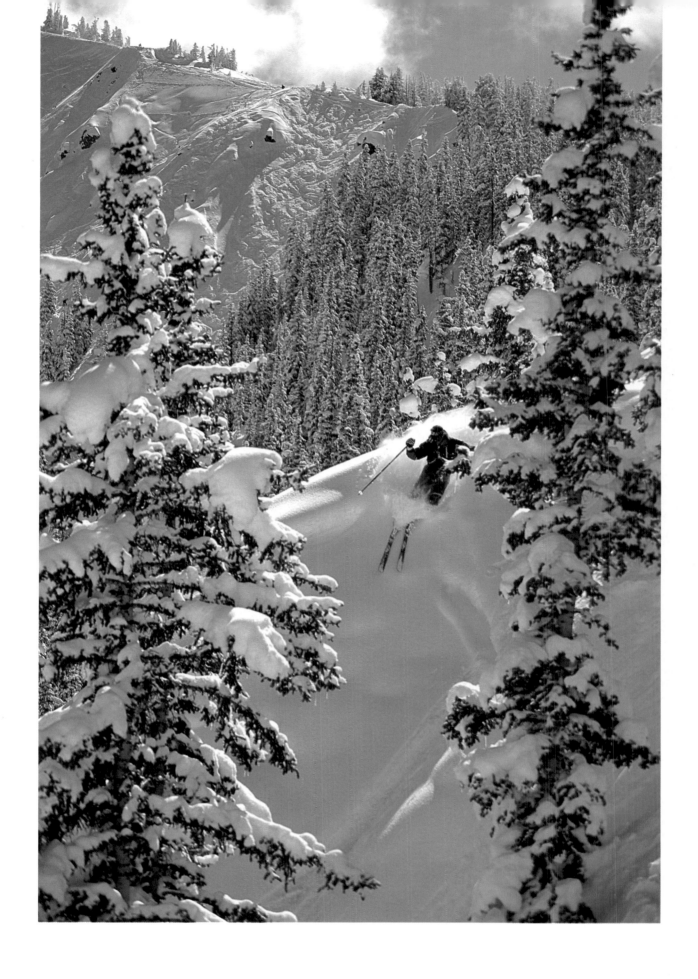

54 \ Winter storms blowing in from Baja

California blanket the Southwest, here on

New Mexico's Sangre de Cristo Mountains.

55 \ The West Basin Ridge of Taos offers

ultra-steep powder for the connoisseur; each

turn seems analogous to leaping off the roof.

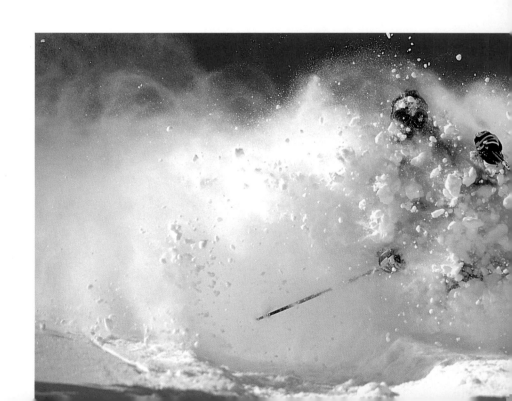

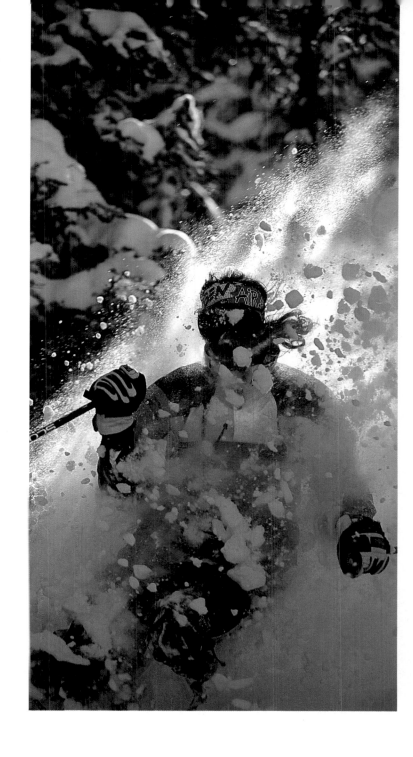

56-57 \ Skiing deep powder at Taos

is kind of like having a falling dream.

You fall into cloudlike snow; snow

covers your goggles and fills your

astonished mouth. When it is all

working right, your skis dive and

then bound to the surface like

porpoises playing a tilted bay.

Rhythm replaces fear; a sen-

sation of floating creates an

instant addiction; you want the

falling and floating to go on forever.

58 \ *The ski patrol hurls explosives off the*

Ridge into known start zones, encouraging

avalanches to run before the ski day begins.

59 \ *Kachina Peak hovers tantalizingly above*

the rest of the area. When the patrol says

"Go," ski tracks bloom like coils of DNA.

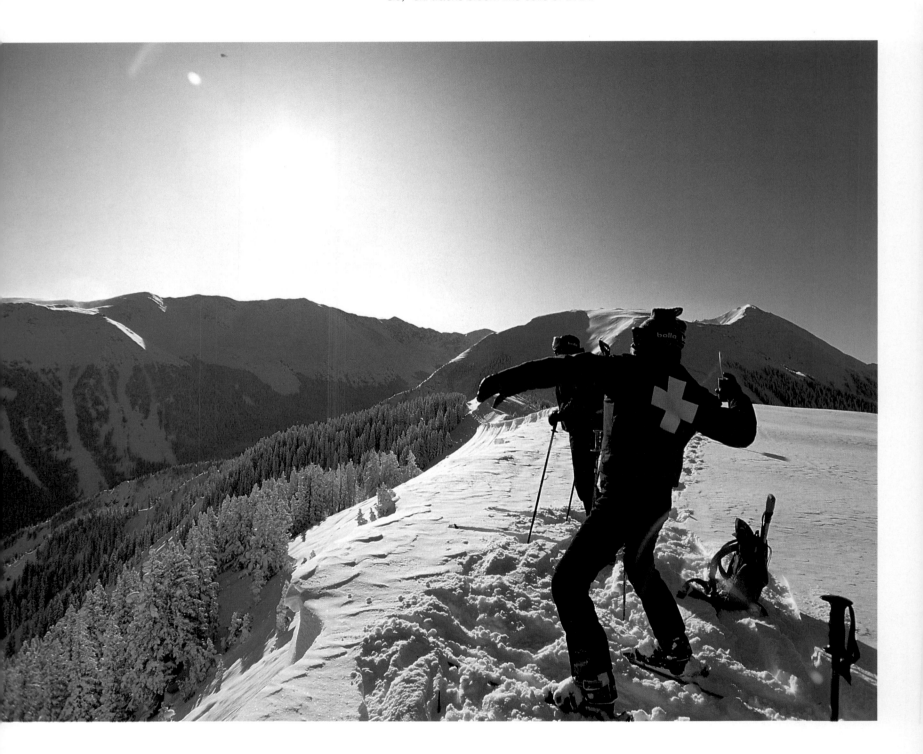

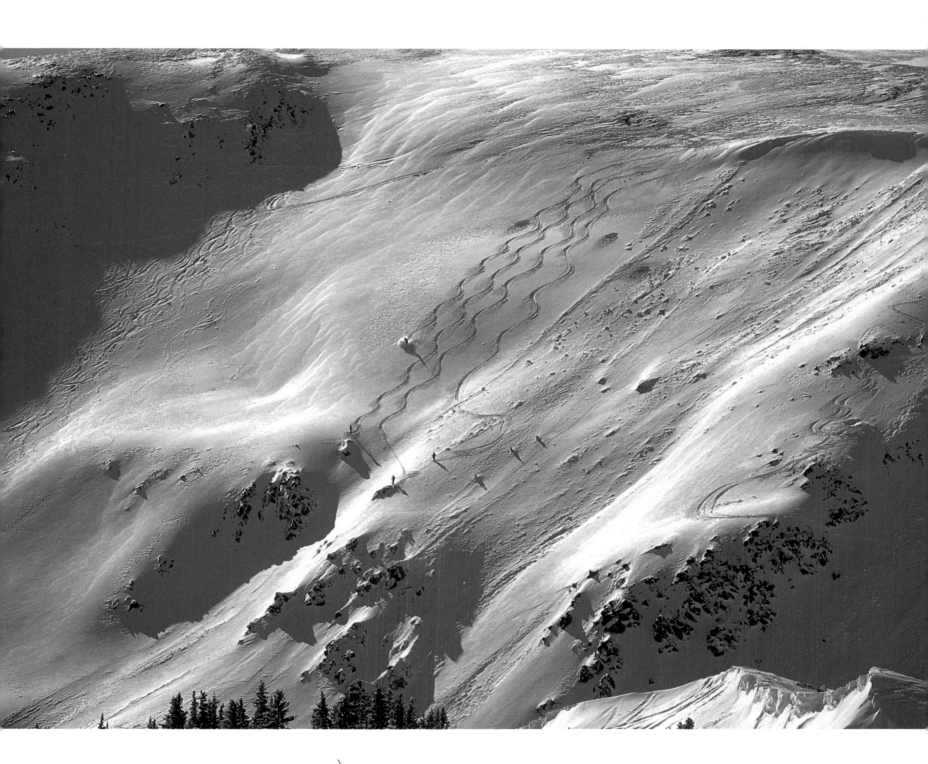

60-61 Hondo Chute off West Basin Ridge.

The runs in the background—Oster, Fabian,

and Stauffenberg (center)—are named for

three German military officers who tried,

unsuccessfully, to blow up Adolf Hitler.

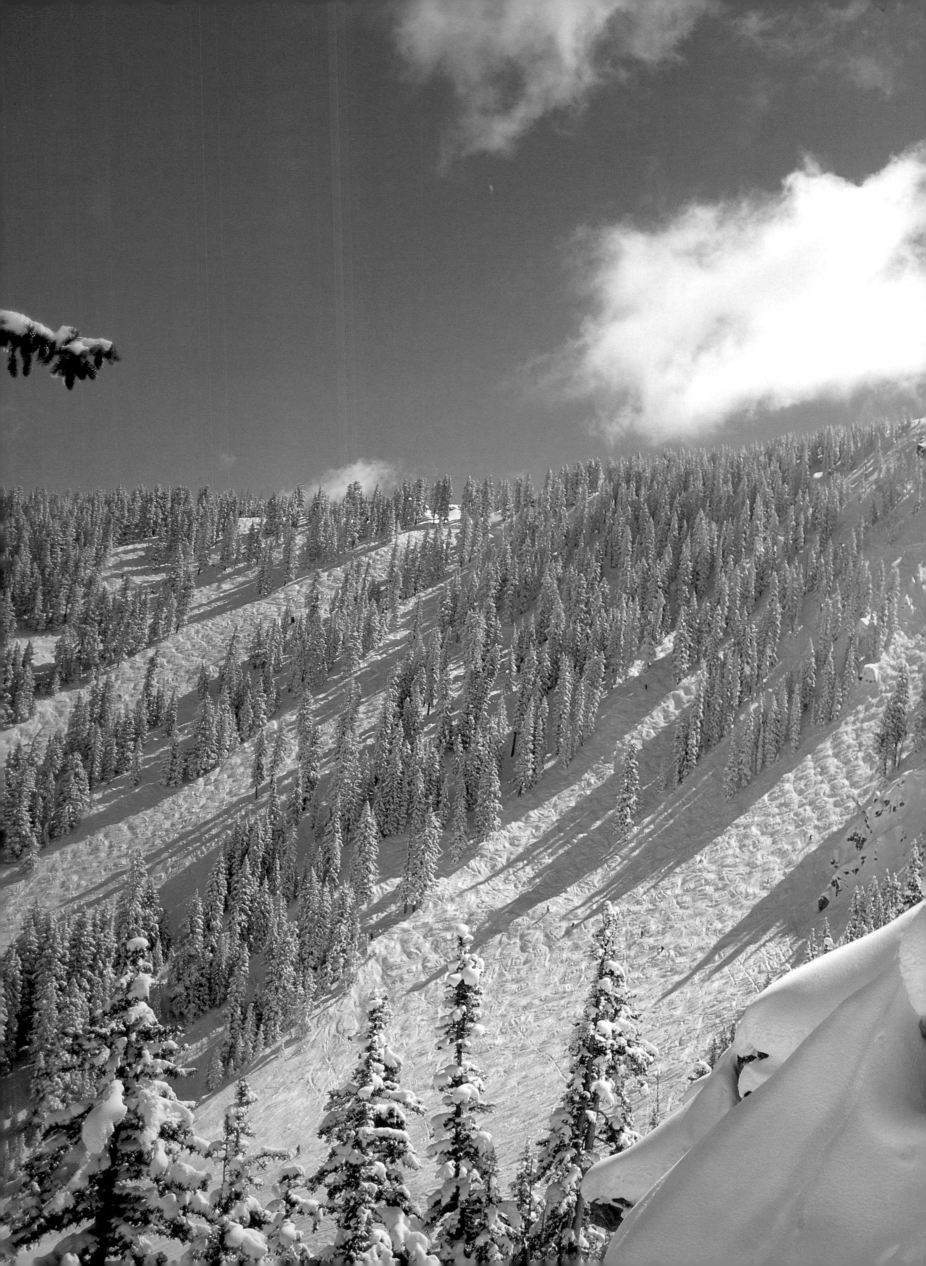

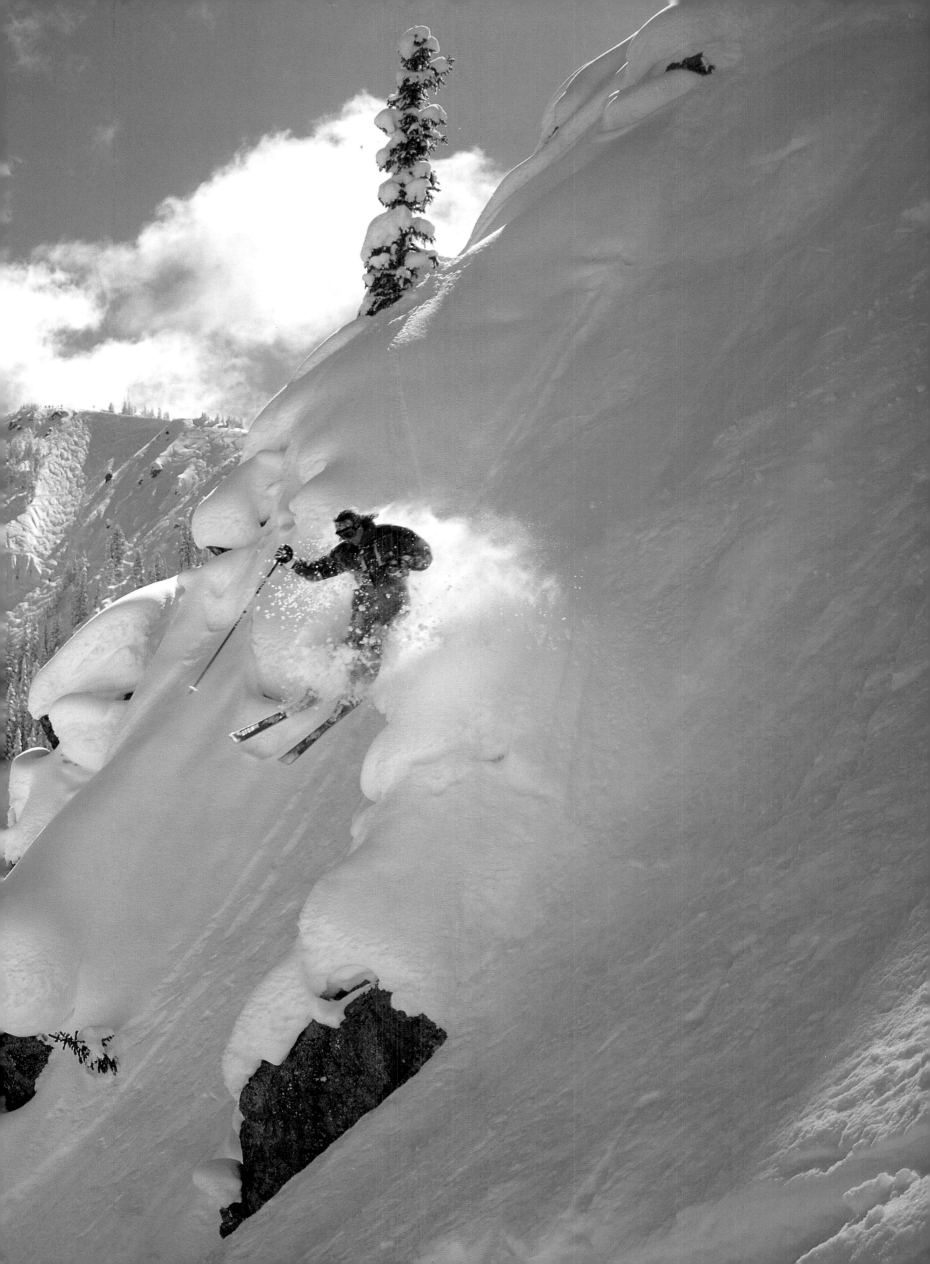

CRYSTAL CITY OF THE ROCKIES

On New Year's Eve 1986, former Secretary of Defense Robert McNamara and a few friends skied cross-country to the Margy Hut north of Aspen along the Tenth Mountain Division Trail. That night, McNamara scribbled a note in the hut log book: "Jupiter and Mars at Night . . . Biscuits and bourbon . . . Plans for the future: 1) Hyper Thermic Wellness Test Facility (sauna); 2) Solutions to economic and physical woes of Aspen/Snowmass and the rest of the world; 3) Next trip." McNamara may be a mere planet compared to the supernovae who call Aspen home, but he is a better skier and a quicker wit than most former World Bank presidents. And no one more thoroughly appreciates an escape to the hills.

Aspen draws the famous and the wannabe famous like a magnet. The reasons are as simple as the sublime beauty of the Elk Mountains and as complex as the perfect cup of cappuccino proffered around every corner of this sophisticated minicity. More than anything else, perhaps, it is the long-standing local attitude that prohibits gawking and says, in effect, we are all equal here in the cupped hand of the Roaring Fork Valley.

With only a hint of voyeurism, you might, for example, see tennis great Chris Everet bump into "Wonder Woman" Lynda Carter at the top of the lift. And then Martina Navratilova might ski by with her personal trainer and clink Chrissy's pole with her own. And together they might hail Indy-car driver Danny Sullivan, who whooshes past with Chris's husband, Aspen native and one-time U.S. Ski Team star, Andy Mill. Later, they might all run into Jack Nicholson nursing a cool one on the Ruthie's Restaurant deck. No big deal: just another day on the slopes. They have to solve the same riddles of gravity and momentum as we do. The sun at eleven thousand feet burns their cheeks as surely as anyone else's. Bigger than fame, the mountains render them human.

Aspen's current boom is actually a reprise of an earlier star-studded heyday when rich veins of silver were the draw. Sara Bernhardt sang at the Opera House, and Aspen was known as the "Crystal City of the Rockies." By 1890, eleven years after the first claims were staked, the town boasted six newspapers, three schools, ten churches, a hospital, three banks, seventy bars, and its own brewery. The population—twelve thousand—swelled to twice what it is now.

Then in 1893, Congress repealed the Sherman Silver Act demonetizing silver and forcing the price to plummet. Miners bolted for new gold strikes at CrippleCreek on Colorado's Front Range, and almost overnight Aspen slumped to a population of seven hundred, mostly cattle ranchers and potato farmers.

And that is the way it stayed until the twin prods of skiing and culture stirred the ghost town in the 1930s and 1940s. Skiing came first. With Sun Valley's success, entrepreneurs combed the Rockies for potential resorts. Renowned Swiss engineer and skier Andre Roche roamed the peaks of the Sawatch and Elk ranges on both sides of Aspen's valley and wrote in 1937 ". . . it is easy to see that America could find here a resort that would in no way be inferior to anything in the Alps." He started the Aspen Ski Club and cut the first run on Aspen Mountain (Roch Run) and helped build the infamous "boat tow," a heavy wooden sled on a mine cable that hauled skiers up the mountain's first short pitch. But World War II scuttled Roch's efforts.

Ironically, the war also guaranteed Aspen's future. From 1942 to 1945, the Army's Tenth Mountain Division trained for winter warfare just east at Camp Hale, between Aspen and what is now Vail. Some of the country's best skiers, including Sun Valley ski school director Friedl Pfeifer, were recruited to teach skiing. Friedl and a number of other ski troopers spent weekends over the hill at Aspen during their training. Pfeifer fell in love with the place and returned immediately after the war.

Other Tenth Mountain vets returned to spark the biggest ski industry boom: Pete Siebert founded Vail; Sverre Engen pioneered development at Bogus Basin and Brundage Mountain, Idaho; Larry Jump started Arapahoe Basin, Colorado; Bob Nordhaus founded Sandia Peak, New Mexico; Gordon Wren ran the mountains at Loveland and Steamboat, Colorado, and at Jackson Hole, Wyoming.

Pfeifer envisioned a ski area on Aspen Mountain, but he had no money. That came in 1946 from Walter Paepcke, a Chicago industrialist who, with his wife Elizabeth, "discovered" Aspen in 1945 and decided to build a summer cultural center there, a kind of "Athens in the mountains." Pfeifer convinced Paepcke that his ski mountain would complement Paepcke's Institute for Humanistic Studies, and the Aspen Skiing Company was born. The first single chair opened in 1947.

Aspen's star rose again. Paepcke organized a Goethe Bicentennial Convocation in 1949, which brought Dr. Albert Schweitzer to the U.S. for his only visit. In 1950, Aspen convinced the FIS, the international ruling body of skiing, to hold its World Alpine Championships there, putting Aspen on the racing map. The annual Aspen Design Conference flourished, and the Music Festival floated its huge tent in a hay meadow.

Aspen Mountain's reputation soared to superstar status. But this was no mountain for beginners, so, in 1958, Pfeifer started Buttermilk on a gentler mound down river. That same year, Aspen Highlands opened on a sharp, tall ridge to the south. Finally, in 1967, Snowmass cranked up its lifts for the first time, completing the foursquare development of Roaring Fork Valley.

Each mountain is different. The precipitous slopes of Aspen Mountain, the flagship, run right onto the Victorian streets of town. From the summit restaurant, called the Sundeck, the view stretches across some of Colorado's highest, most dramatic terrain, including "fourteeners" Pyramid Peak and the red cliffs of the Maroon Bells. The north slopes hold cold, powder snow from November to May. And the aspen trees, for which the town was named, open a fine lacy canopy to the sky. Shadows, like Venetian blinds, stripe the snow. When you ski fast through the aspens, the flickering of light and shadow is like an old black-and-white movie with you as the star.

Buttermilk, now called Tiehack in reference to cutting cross-ties for railroad beds, has aspens, too—and humor to go with its reputation as the easiest Aspen mountain. Halfway down the slopes is a sign that says *The Wall of Death, the World's Shortest Black Diamond Run.* It is true. Three moguls' worth.

Highlands drapes a steep, knife-edge ridge with giant moguls over the biggest vertical drop—3,800 feet—in the central Rockies (second only in the continental U.S. to Jackson Hole's 4,139 feet). Not so many one-piece suits or furs or celebrities here; this is the locals' mountain, the maverick.

Snowmass dwarfs the others in terms of scale. The ski terrain spreads over three mammoth drainages—the Big Burn, the Cirque, and the Hanging Valley Wall—twenty-five hundred acres' worth. A lot of it is pitched just right for going fast, standing tall, and letting the skis ride the humps and rolls of the land. It is the kind of stuff (quoting from Andre Roche again in 1937) "where your face freezes in the wind and clouds of powdersnow rise behind you, making the skier seem like a rocket shooting along the ground."

Or a shooting star. Most stars these days build out of town, in a development called Starwood, or up secluded side creeks feeding the Roaring Fork. Saudi Prince Bandar spends a couple weeks a year in his fifty-five-thousand-square-foot home with twenty-six bathrooms for himself and his wives. Private jets have to line up for take-off and landing at Sardy Field.

It is all somewhat dizzying for Aspen architect and Tenth Mountain Division veteran Fritz Benedict. He was one of those who came over on weekends from Camp Hale to ski. They would hitch a ride with a mine truck up the back side of Aspen Mountain to the Midnight Mine. Then they walked the final thousand feet for a single run back to town. After the war, Fritz lived in a chicken brooder house with a pot of venison stew bubbling on the wood stove. He drove a horse-drawn sleigh when he and his wife, Fabi, went to town in the winter.

"Initially," Fritz says, "rich people were drawn to this place and to the mix that was already here. They loved it so much they stayed. They didn't flaunt their wealth; it was a classless society. But in recent years, the wealthy seem to have rolled over this, brought their own values." Nowadays, four-wheel-drive stretch limos with tinted windows ply the snowy roads.

Benedict will leave a legacy beyond anything Hollywood has brought to Aspen. He created the Tenth Mountain Trail and Hut system, a series of ski trails in a two-hundred-mile circle around the Holy Cross Wilderness. The trail connects Aspen with Vail to the north, with the deserted Camp Hale site on Tennessee Pass, and with Leadville to the east; it crosses the continental divide twice, before coming back around to Aspen. A dozen huts dot the trail now, each about a day's cross-country ski from the one before it. Fritz designed the first two in 1981; his friend Robert McNamara paid for them and named the second after his wife Margy. Tenth Mountain veterans from all over the country have contributed to build the others.

When you ski the huts, bring a sense of adventure. Bring your own food, perhaps some bourbon, and a sleeping bag. Bring your best friends. The firewood is all split and waiting.

Snowmass is the youngest of the four Aspen mountains.

Compliment Fritz, an Aspen star for fifty years, on the huts, and he will blush, his blue-gray eyes crinkling up beneath berry-thicket eyebrows. They represent a kind of victory for simpler times and tastes: snow, sun, devoted skiers plying the crisp air. "You know," he says, eyes roaming the sky behind bone-white aspens, "a lot of people get fed up and leave. But a lot of them come back, too." Somehow, the problems of paradise are not so bad compared to those of the outside world.

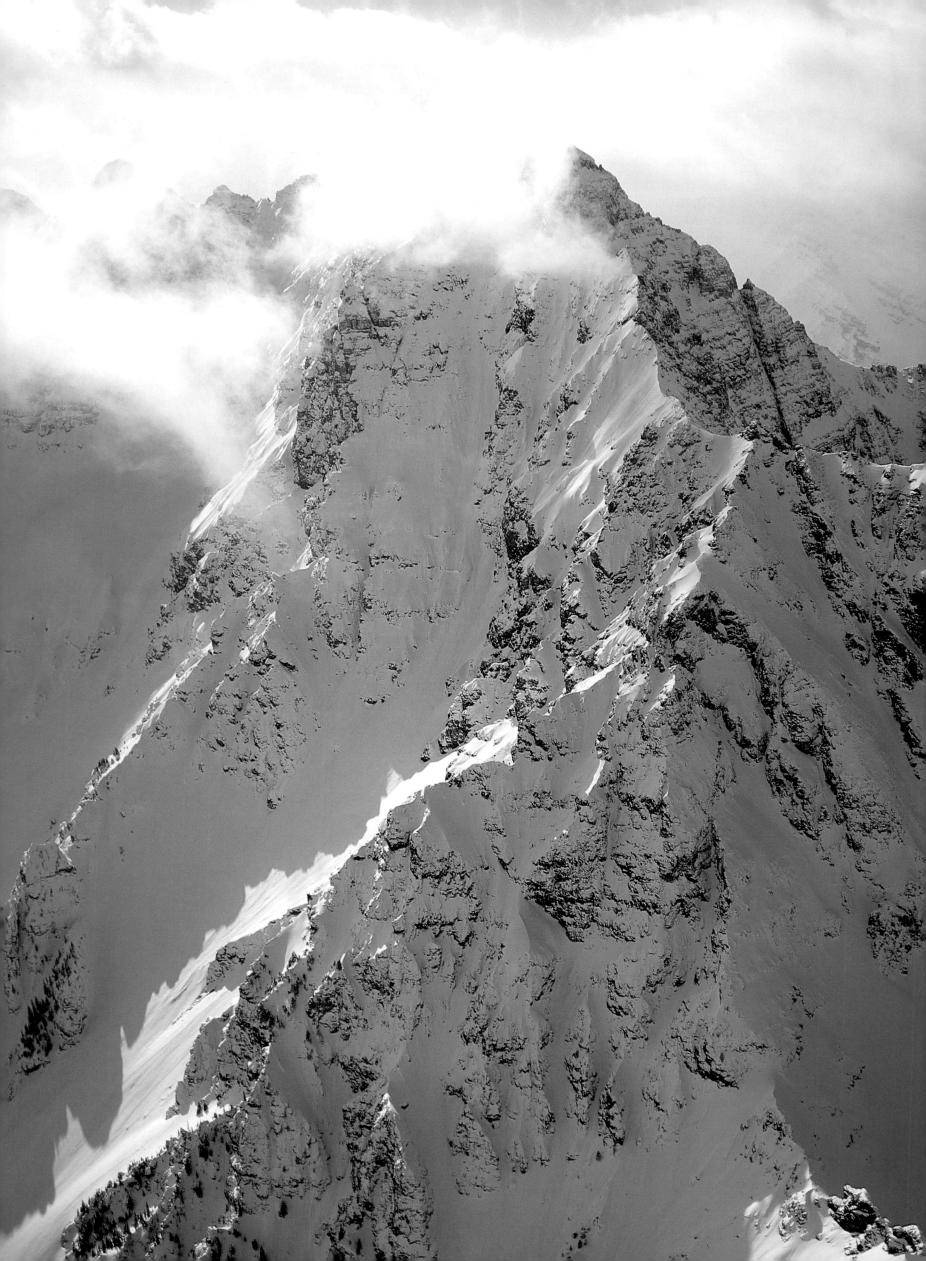

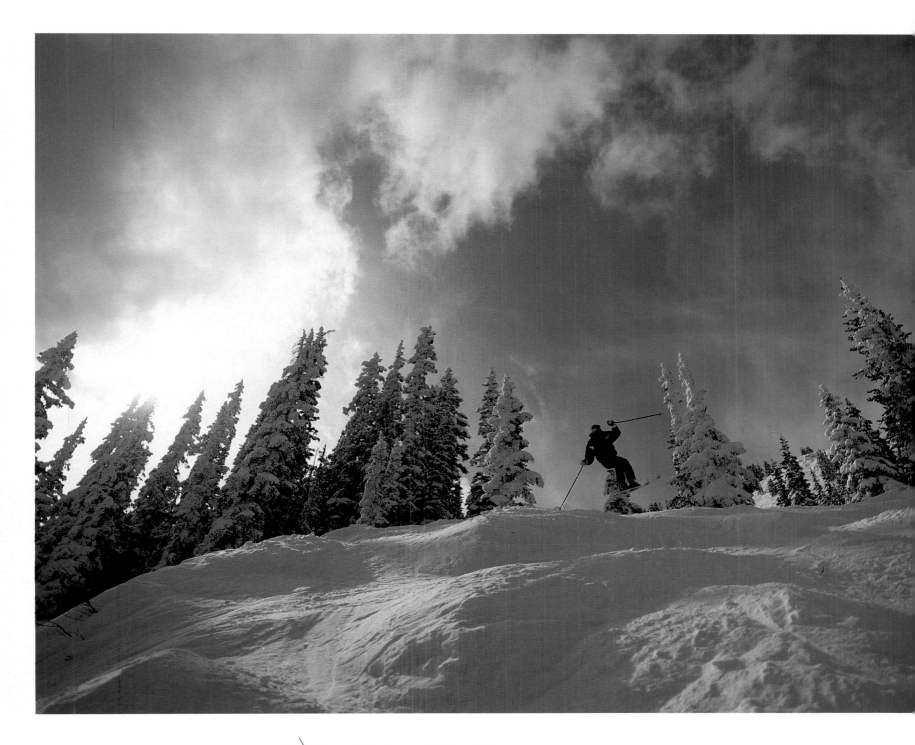

64 \ Pyramid Peak, one of Colorado's

fifty-three "fourteeners" towers above

the skiing in Aspen's Roaring Fork Valley.

65 \ Moguls to match the mountain spill

down the steep faces at Aspen Highlands.

66 \ Pro racers take one of three

"pro bumps" en route down the

dual slalom course called Little Nell.

67 \ In 1950, Aspen hosted the Alpine

World Championships, helping to pull the

silver mining town into its current Renaissance.

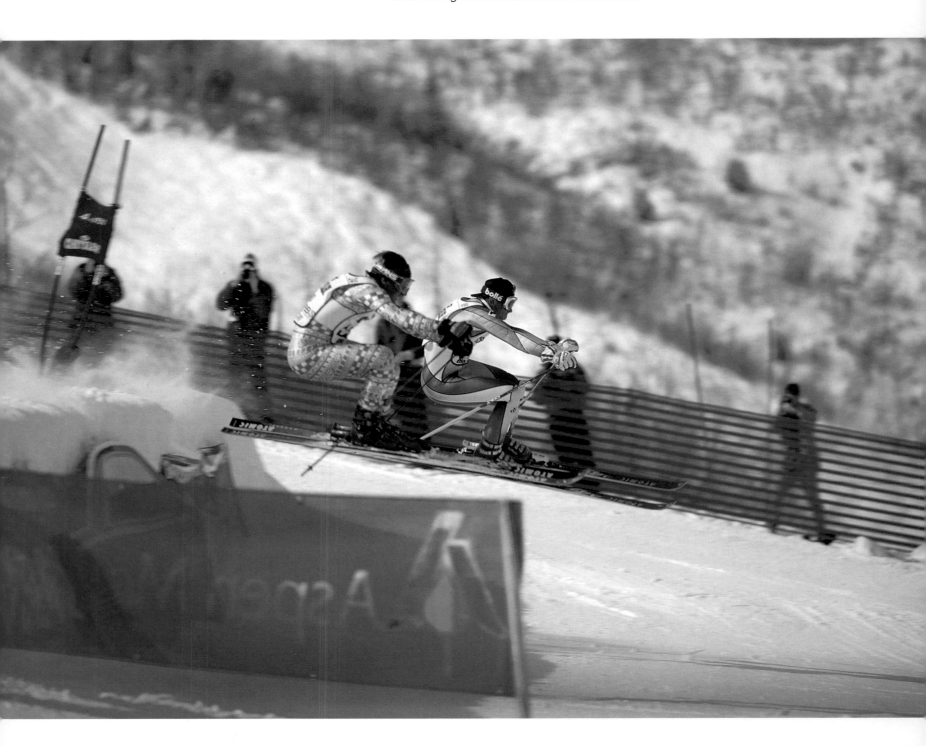

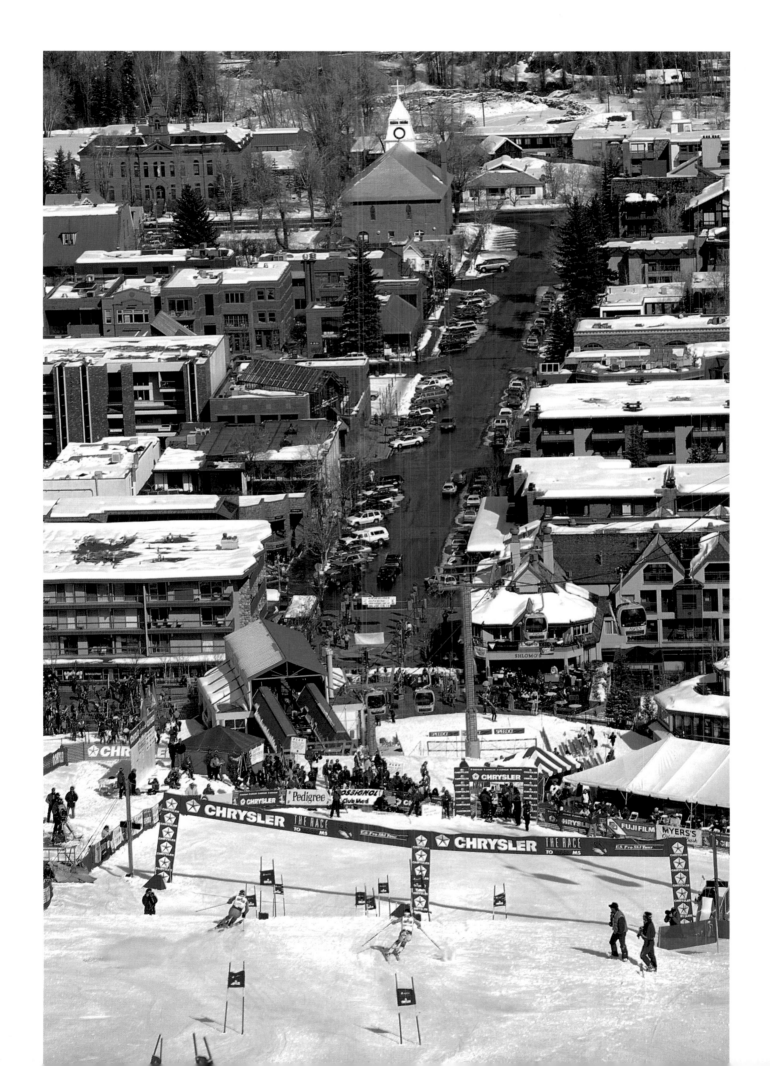

68-69 \ *The Face of Bell on Aspen*

Mountain is duly famous for well-

formed moguls and sublime esthetics.

70 \ *Unlike "purpose-built" ski resorts,*

Aspen was a town first, a place for families

and fences and frolicking in the streets.

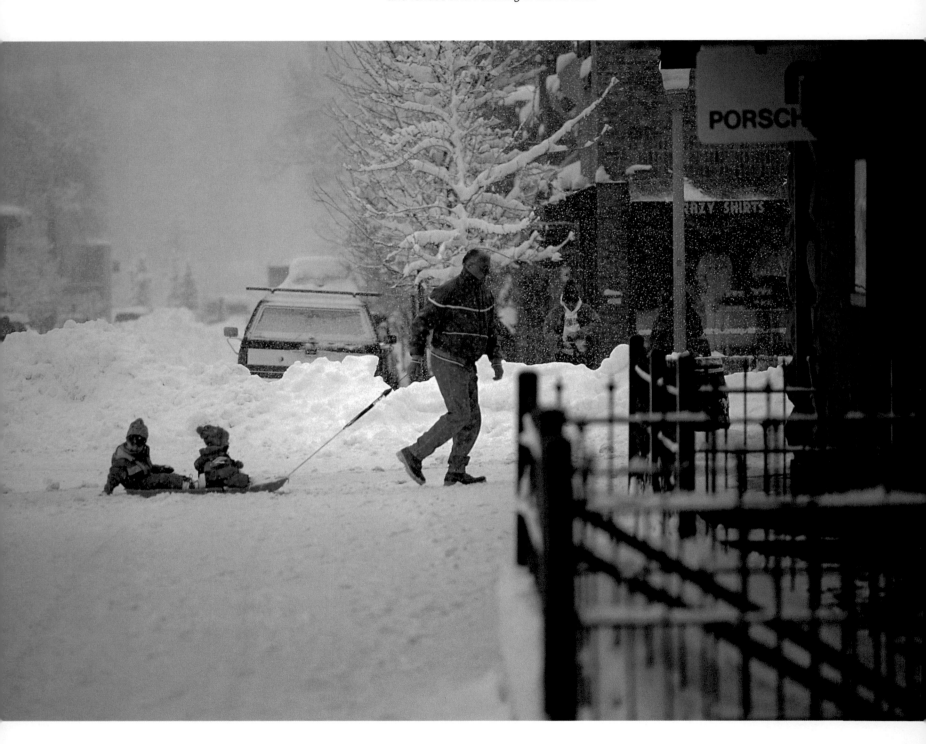

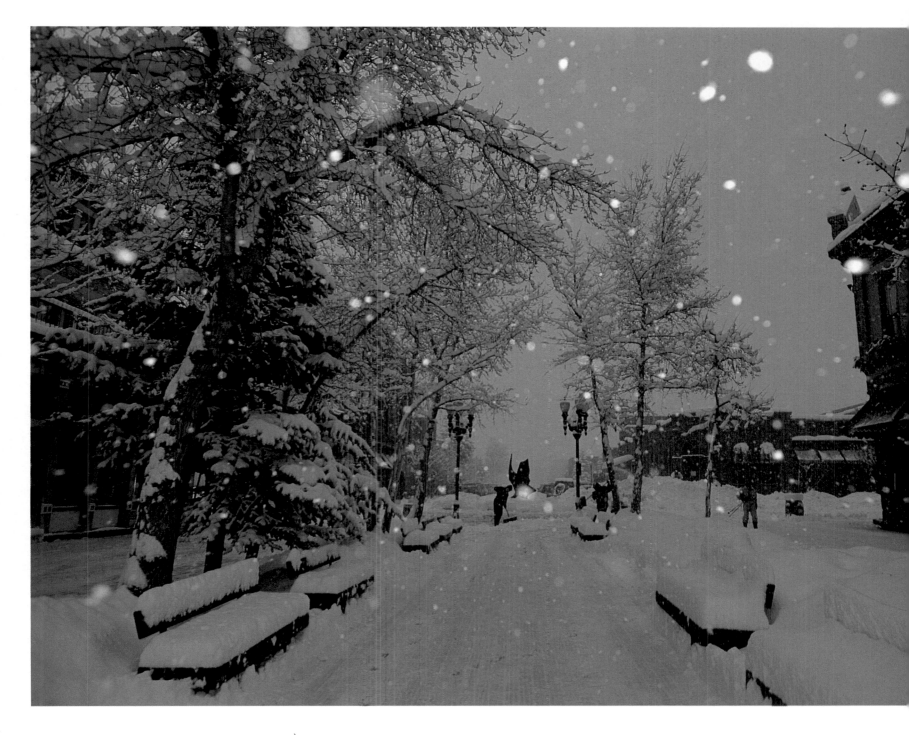

71 \ *Streets in Aspen were designed for the*

Victorian horse and buggy. City fathers have

since closed some of them to cars altogether.

Parking's a bear. But the resulting pedestrian

malls provide a magic serenity when it snows.

72-73 \ Colorado has the driest snow

in the Rockies, even dryer than Utah's,

due to the extreme elevations and the

distance storms must travel to reach

the mountains of the continental divide.

Thus the term, "champagne powder."

Really dry snow sparkles like fool's

gold in the sun and hisses like a

glass of bubbly when a skier passes

through. This particular baptism took

place in Rock Island at Snowmass.

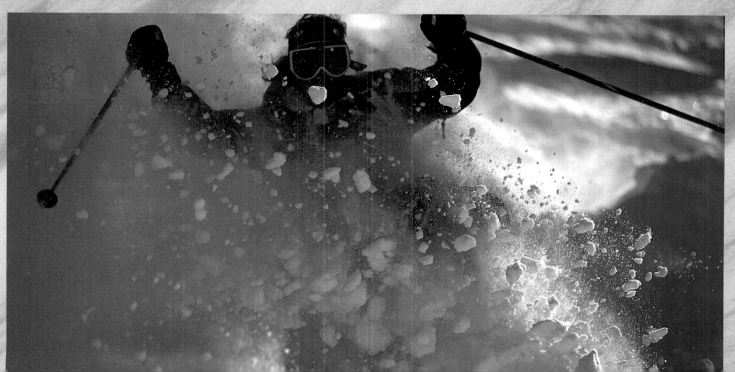

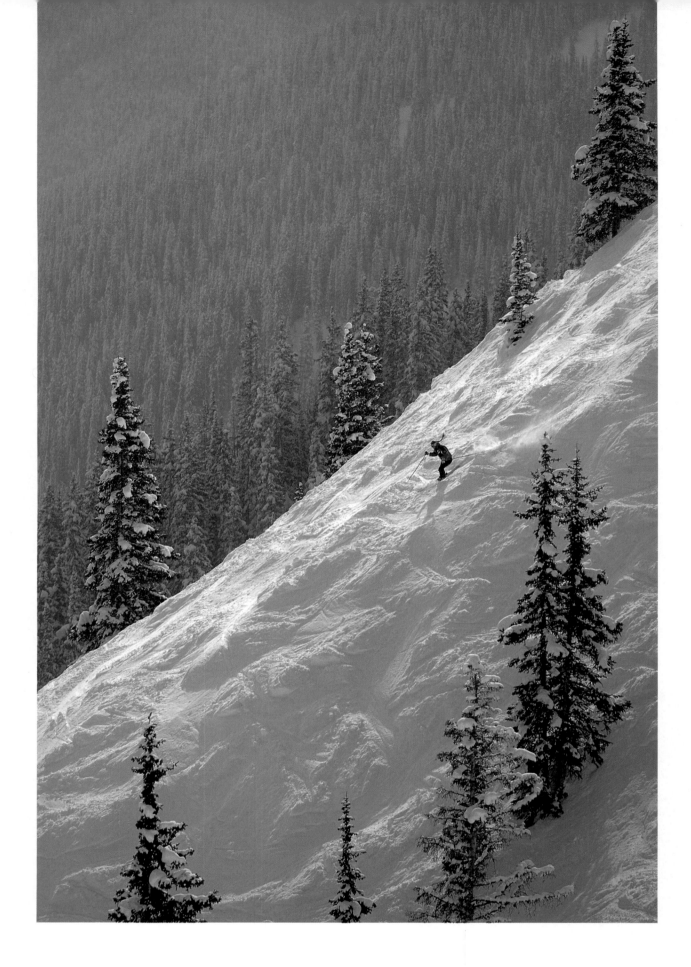

74 \ *Aspen may be home to the stars,*

but all skiers are equal on the moguls

of Snyder's Ridge at Aspen Highlands.

75 \ *Spruce and fir trees, encased with*

thick rime ice, wrap the sinuous shapes

near the summit of Aspen Mountain.

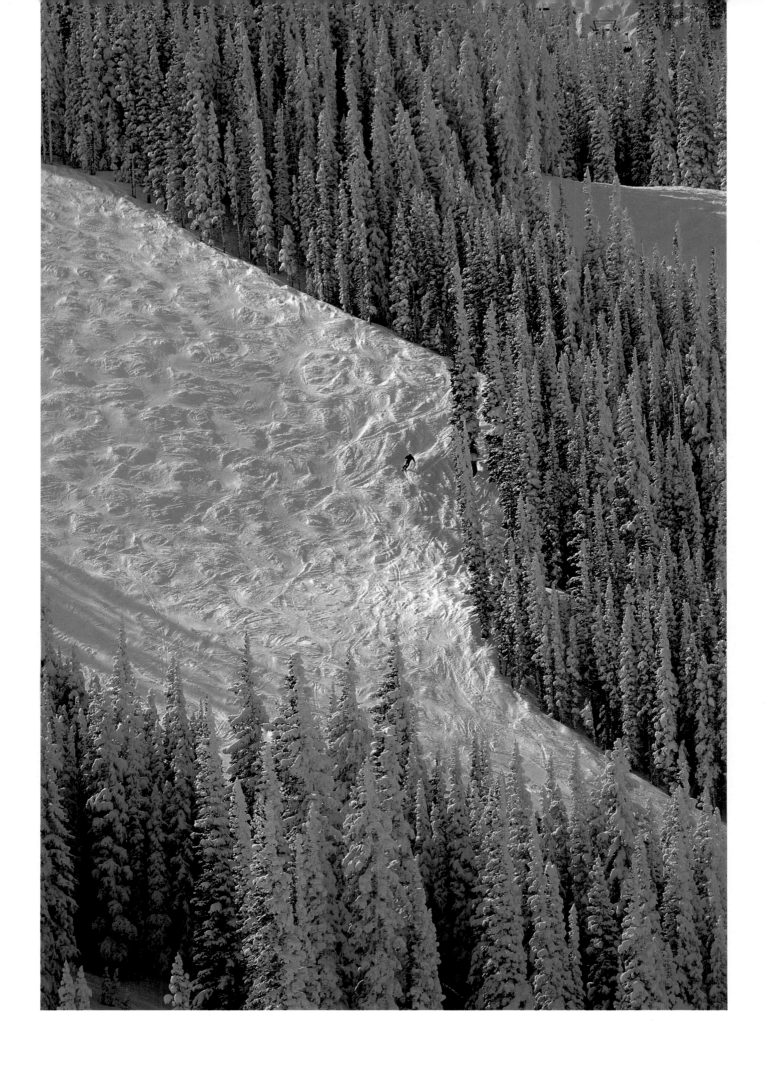

76 \ Krabloonik, within howling distance

of Snowmass, offers dogsled rides and

a unique menu of fresh game and fish.

77 \ The Wolf Creek Ski Area sits right

atop the continental divide in southern

the San Juan Mountains of Colorado.

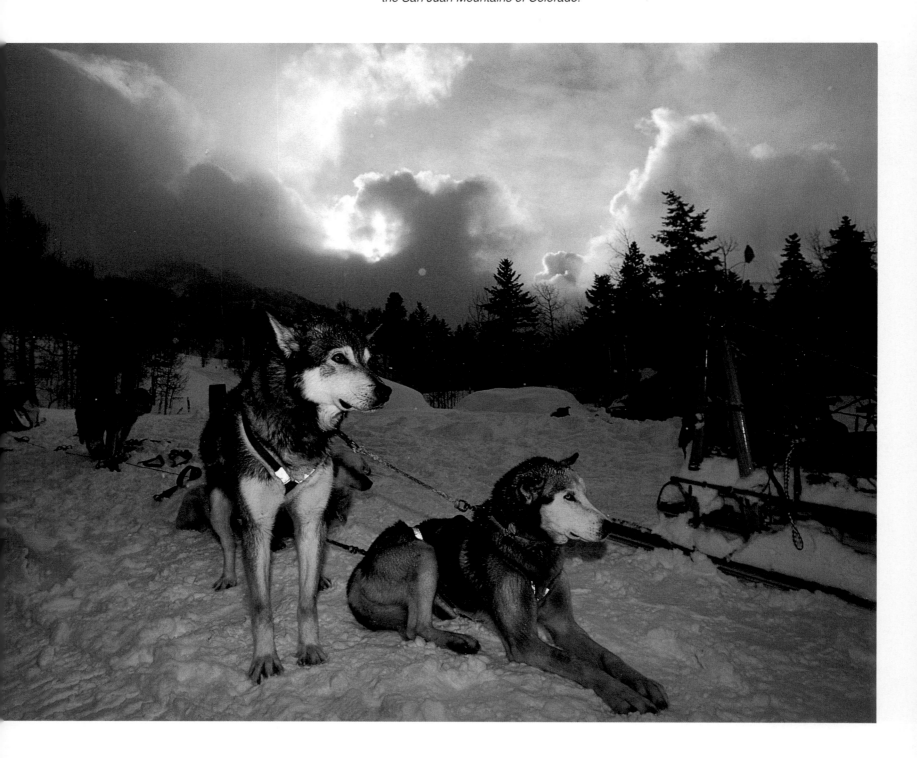

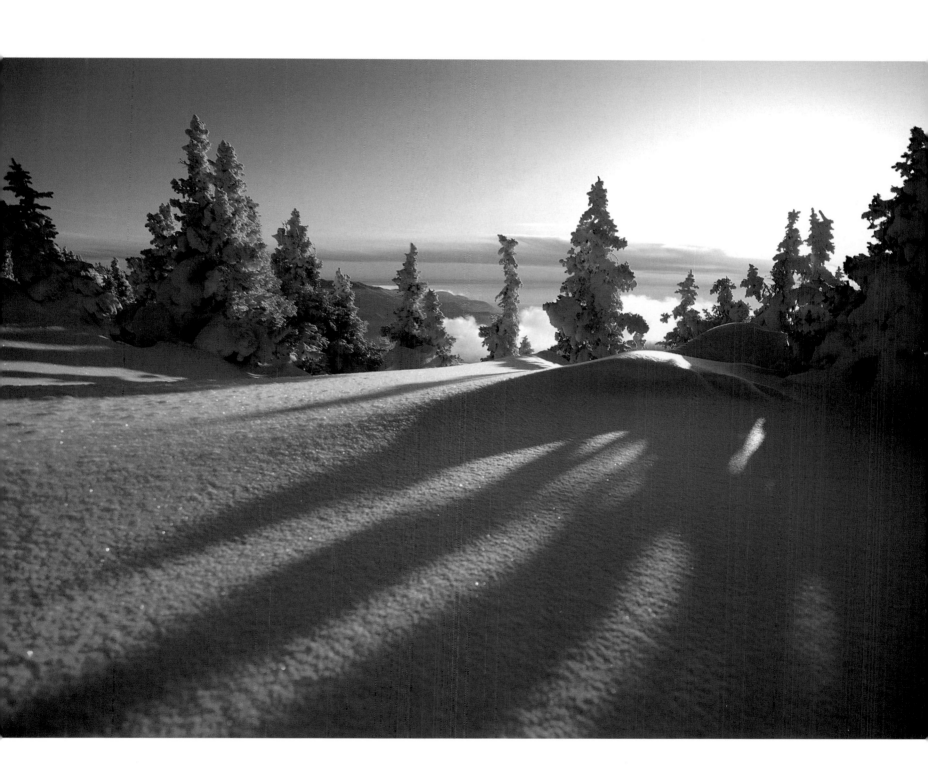

78 Farm communities on both sides of

Wolf Creek Pass got together during the

1930s to build themselves a ski hill. Today,

Wolf Creek is one of the biggest little ski

areas in the state: miles of sublime slid-

ing at an altitude of twelve thousand feet.

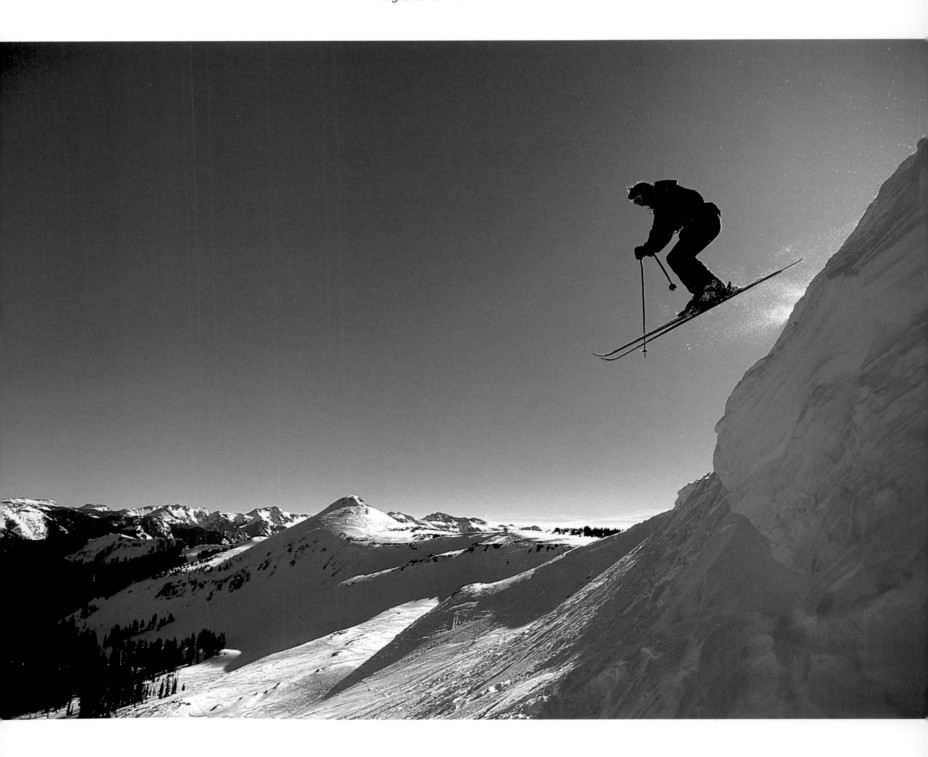

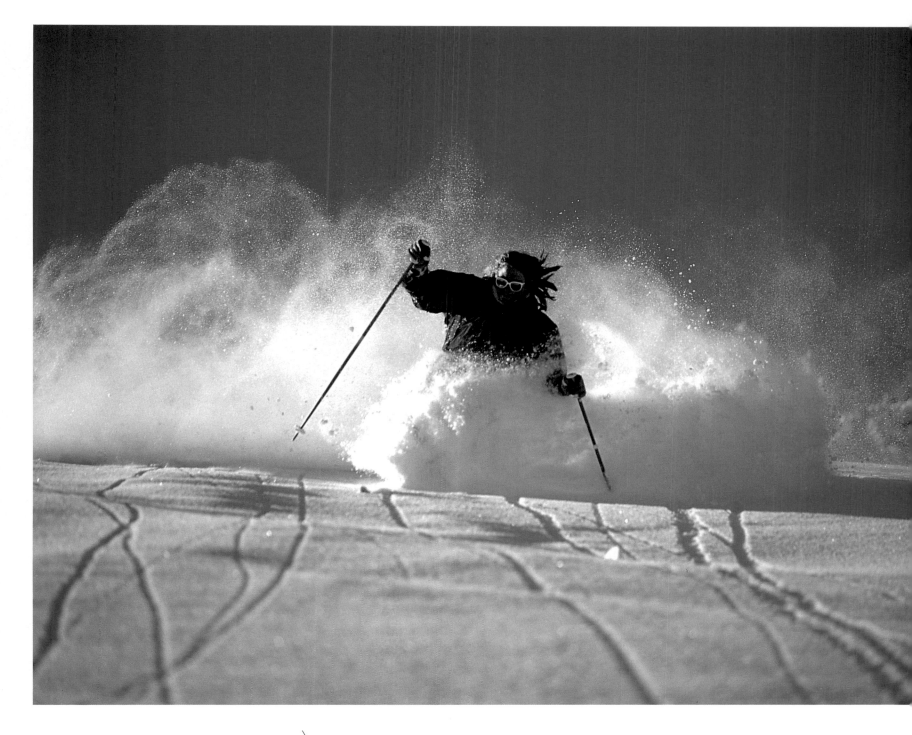

79 \ *Wolf Creek regulars float through an*

average five hundred inches of snow per

season, by far the most in Colorado. No

one knows exactly why; it is just a sweet

spot, a powder magnet, the place to be.

80 \ Out West, the glittering ex-gold

mining town of Telluride reinvented

itself when ski lifts started up in 1972.

81 \ Crested Butte, in the high, cold

West Elk Range, turned from coal mining

to skiing, here on the precipitous North Face.

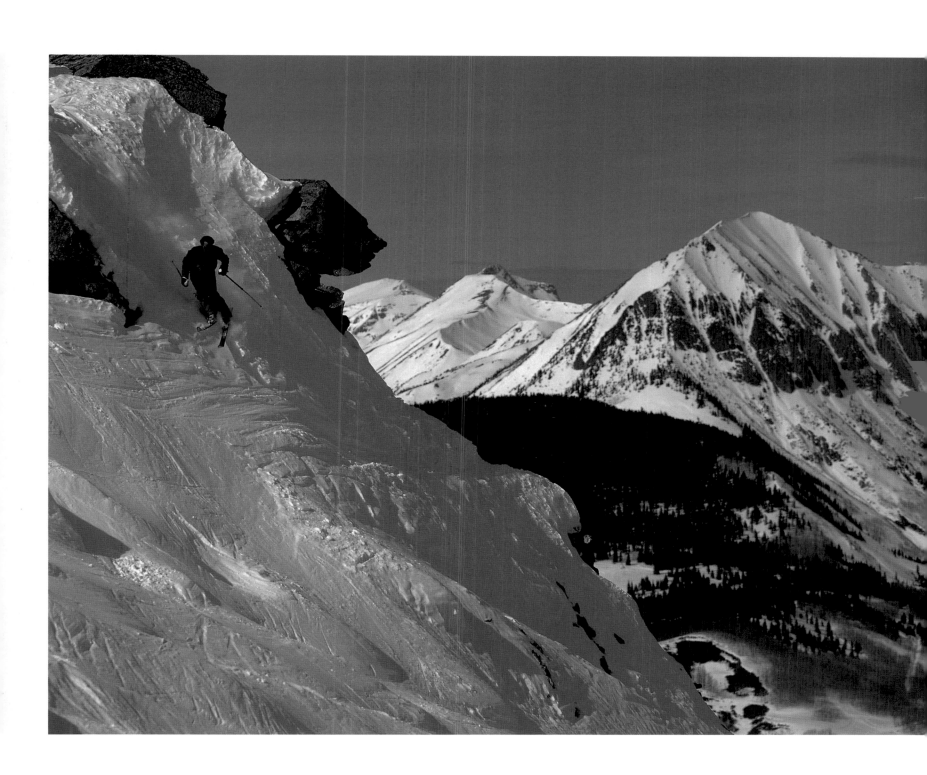

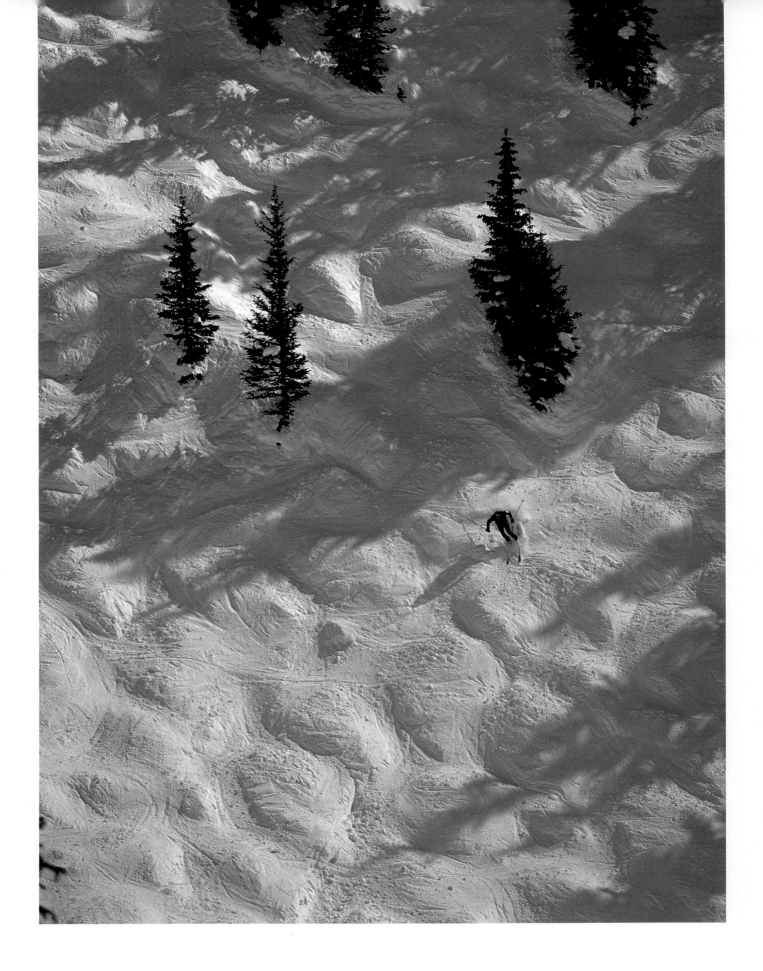

82 \ *Steep slopes grow big moguls, as a*

skier finds on Telluride's Silver Glade run.

83 \ *Treeline on the ski mountain at Telluride*

reaches all to the way to twelve thousand feet,

creating dark, secret powder bowers like this one.

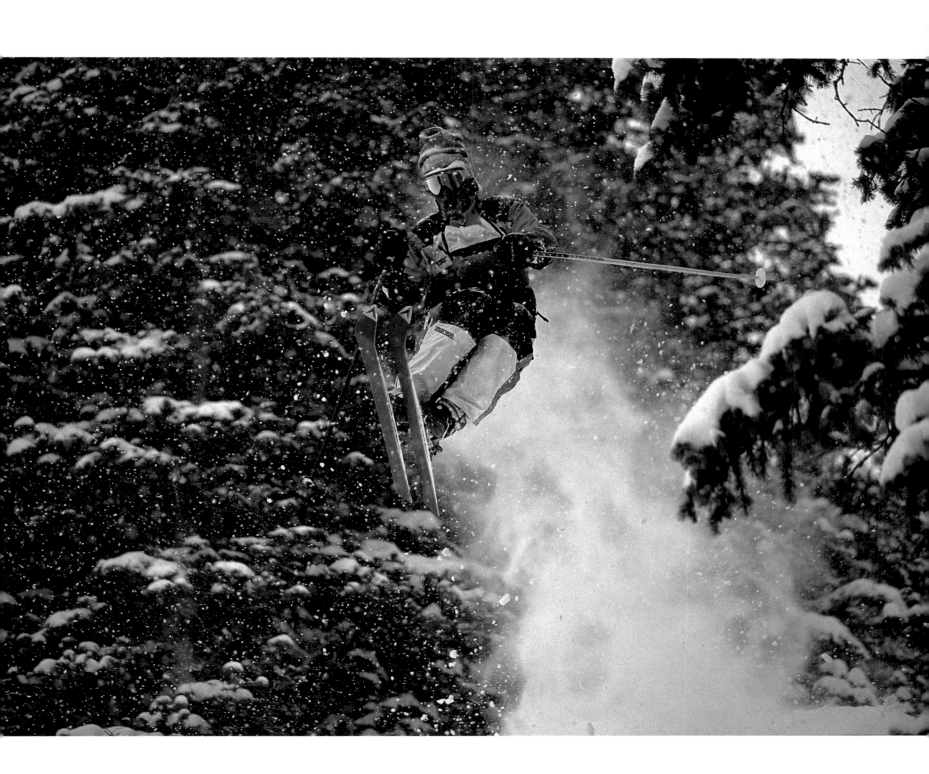

84 \ The highest heliskiing in North

America occur outside Telluride where

landing zones top thirteen thousand feet.

85 \ In the San Juans, winter softens an aban-

doned barn near the Mount Wilson Wilderness.

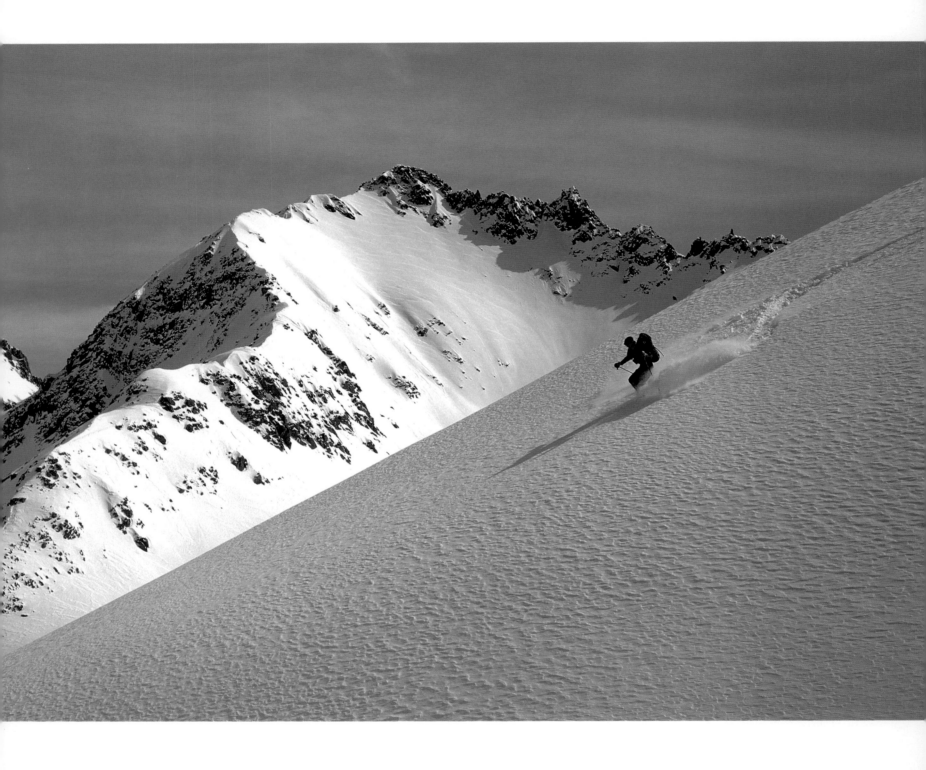

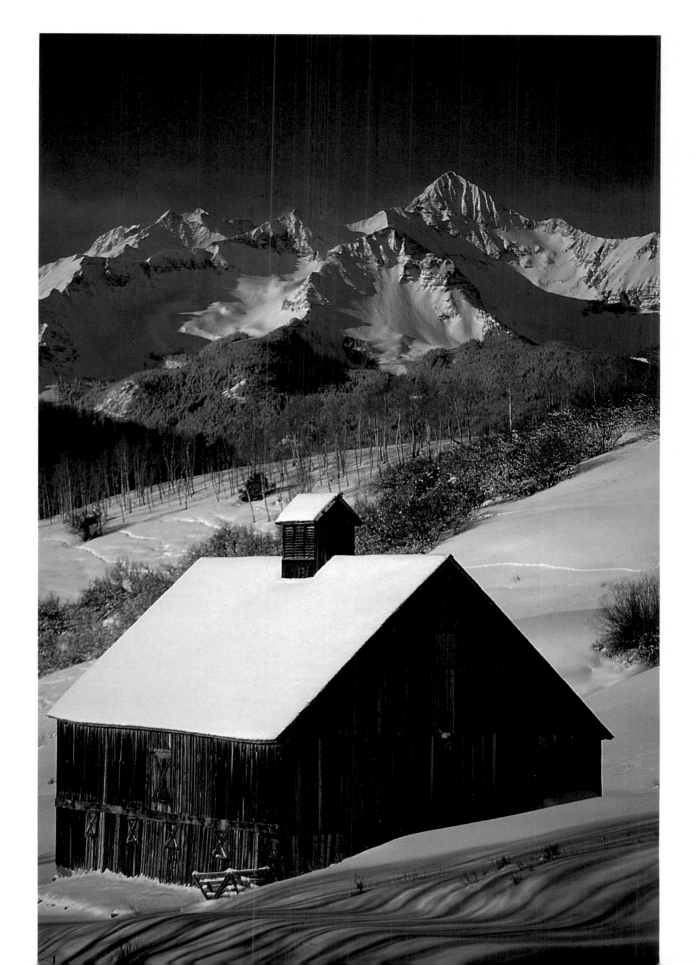

86 \ *Colorado Heliski drops skiers off*

in the Ten Mile Range near Breckenridge.

87 \ *Colorado's biggest ski area, Vail has*

something for everybody: from shady

glades, here on Northwoods, to the Back

Bowls to baby-bottom-smooth beginner hills.

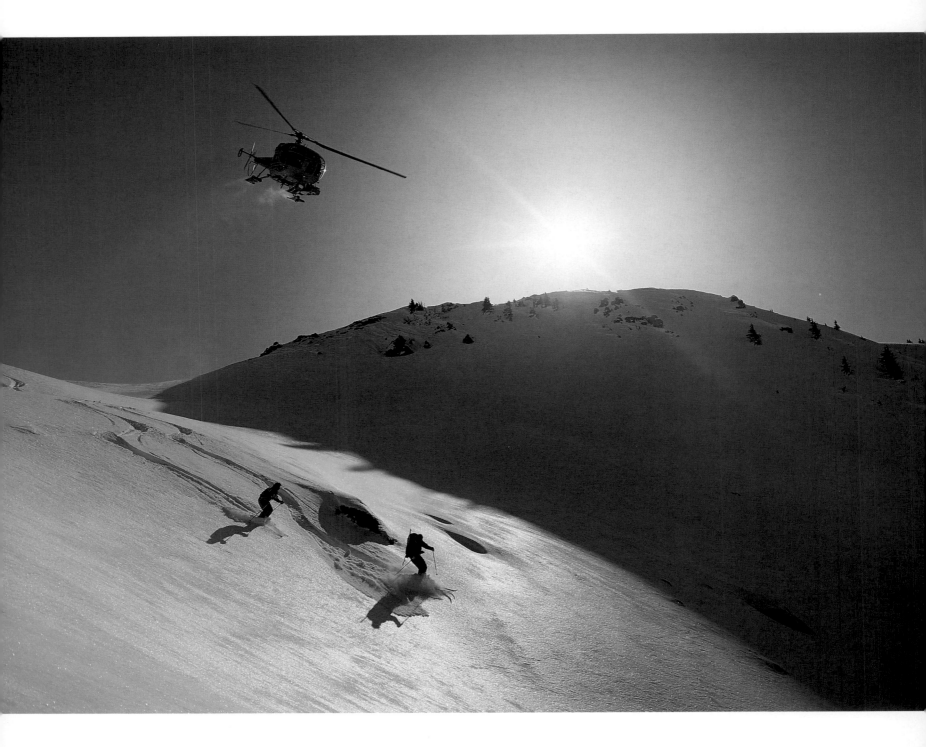

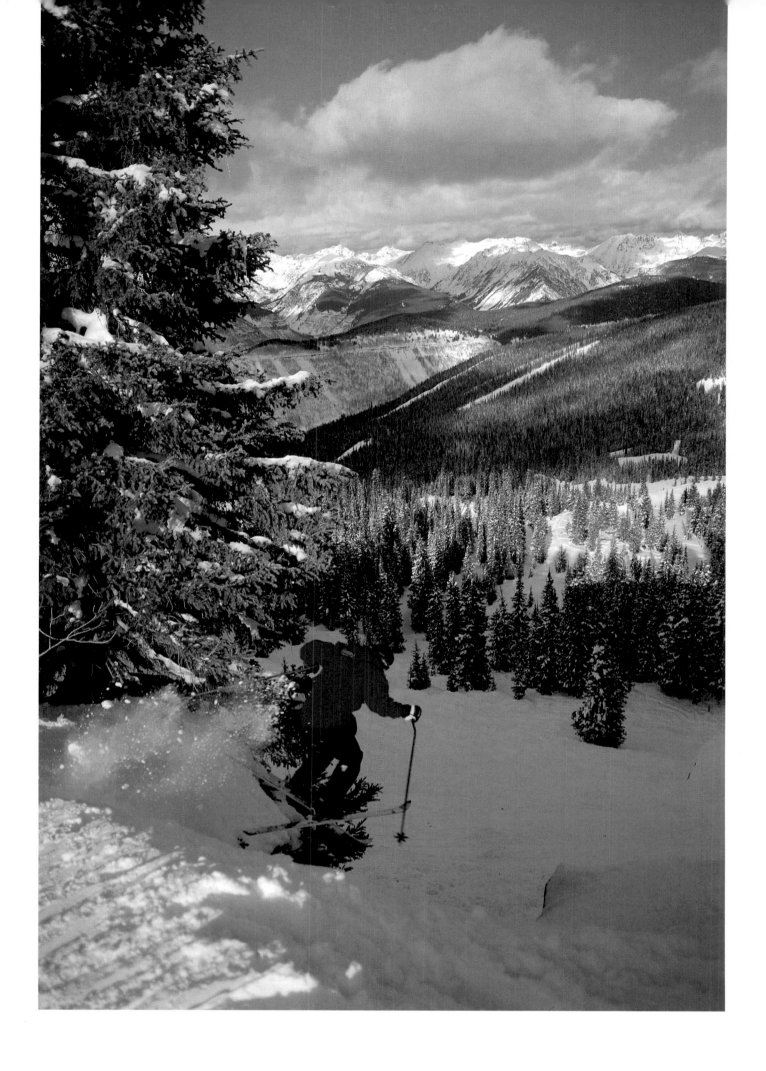

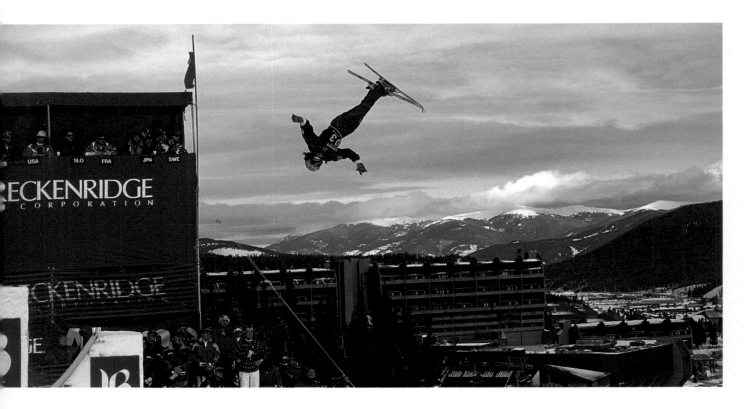

88-89 \ *Yet another Colorado mining town*

retooled by white gold, Breckenridge has

joined the mega-resorts—Vail, Steamboat,

Keystone—with over one million skier visits

per season. The Breck's niche revolves

around freestyle skiing—here a competi-

tor in aerials flips for the judges—and

the restored Victorian charm of Main

Street. Strong children's programs

reflect a push throughout the Rockies

to bring whole families to the sport.

90 \ Après ski happy hour at a Breckenridge bed-

and-breakfast means kicking back before the fire.

91 \ Nighttime need not mean the end of the

action at Keystone, where the skate pond lights up,

and top-to-bottom night skiing continues 'til ten P.M.

92A \ *Aerials are the most dramatic of the*

freestyle arts, combining speed, big air and

gymnastic gyrations before the skis touch down.

92B \ *Breckenridge hosts World Cups in all three*

freestyle disciplines: aerials, moguls, ballet skiing.

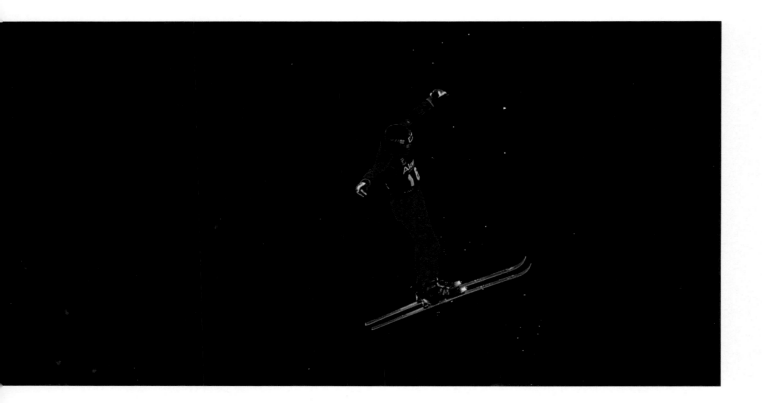

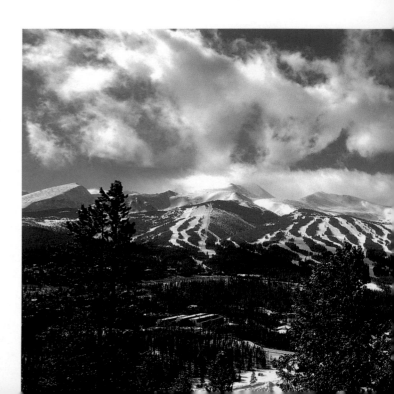

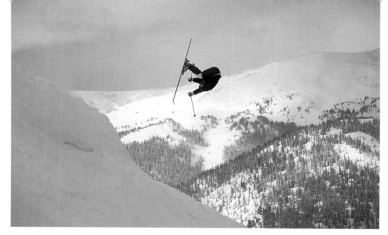

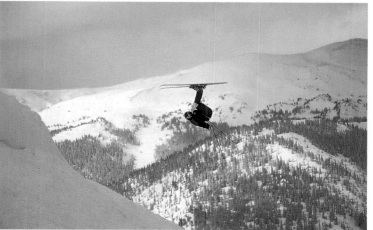

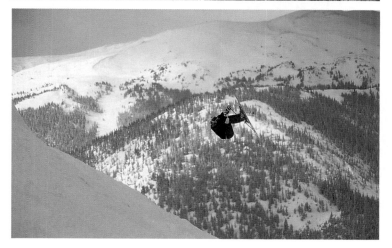

93A, B, C *This skier at Arapahoe*

Basin was not competing. He simply

went airborne off the cornice. Just

expressing his joy at being higher—

12,450 feet above sea level—than any

other lift-served spot in the Rockies.

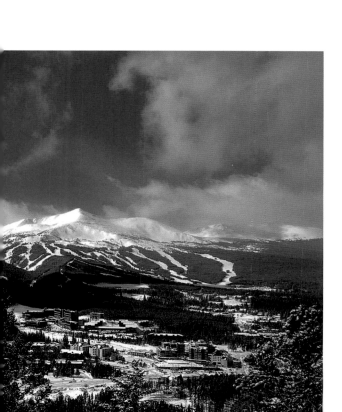

94 \ Hike out past the last gate on Mount

Werner at Steamboat, and you come

to a run called the Toutes, all alone.

95 \ Inbounds Steamboat, with its lacy

trees and boulevards of soft moguls, is

big enough to transform skiers into ants.

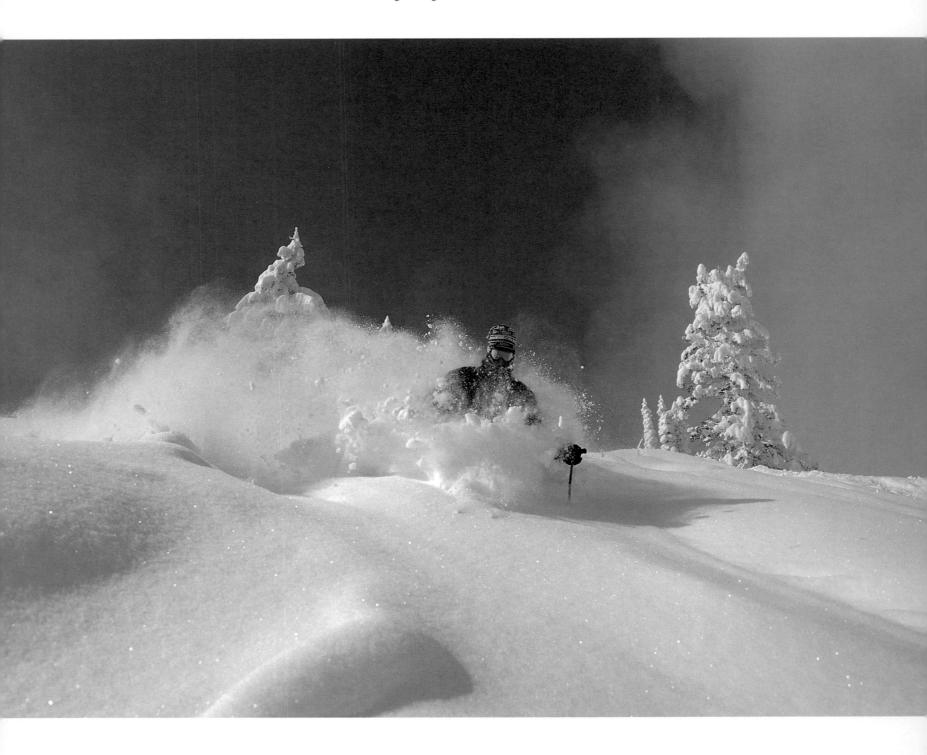

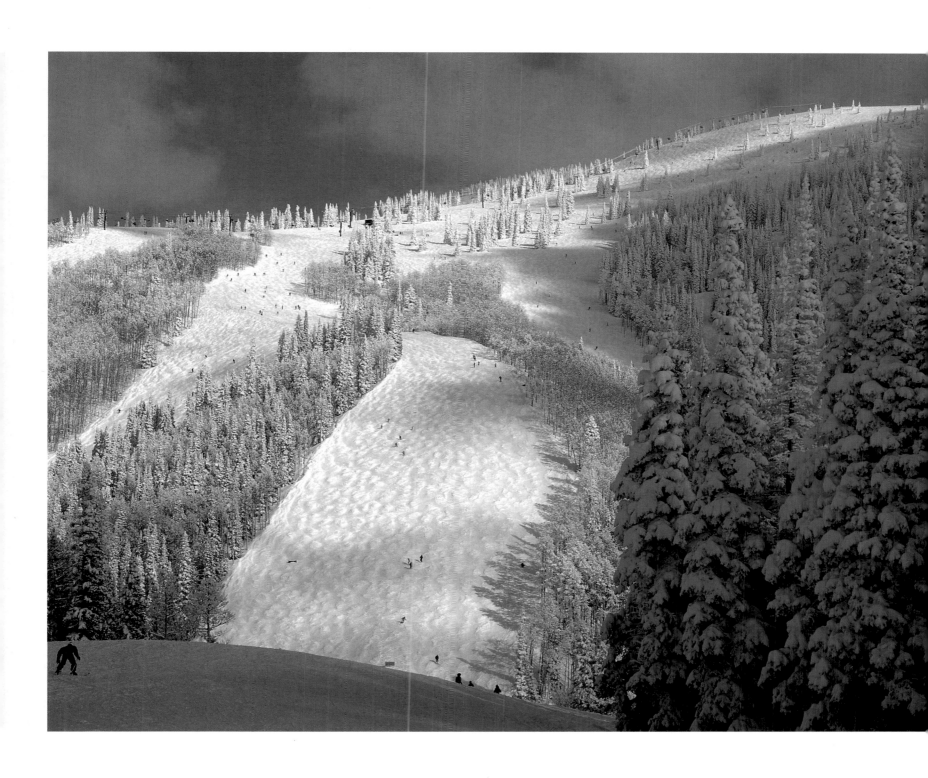

96 \ Tree skiing has become a religion

at Steamboat. Here on the Shadows

Run, aspens form a powder cathedral.

97 \ An old cowboy town, Steamboat Springs

strings out below Mount Werner, named for

1950s hometown racer-hero, Buddy Werner.

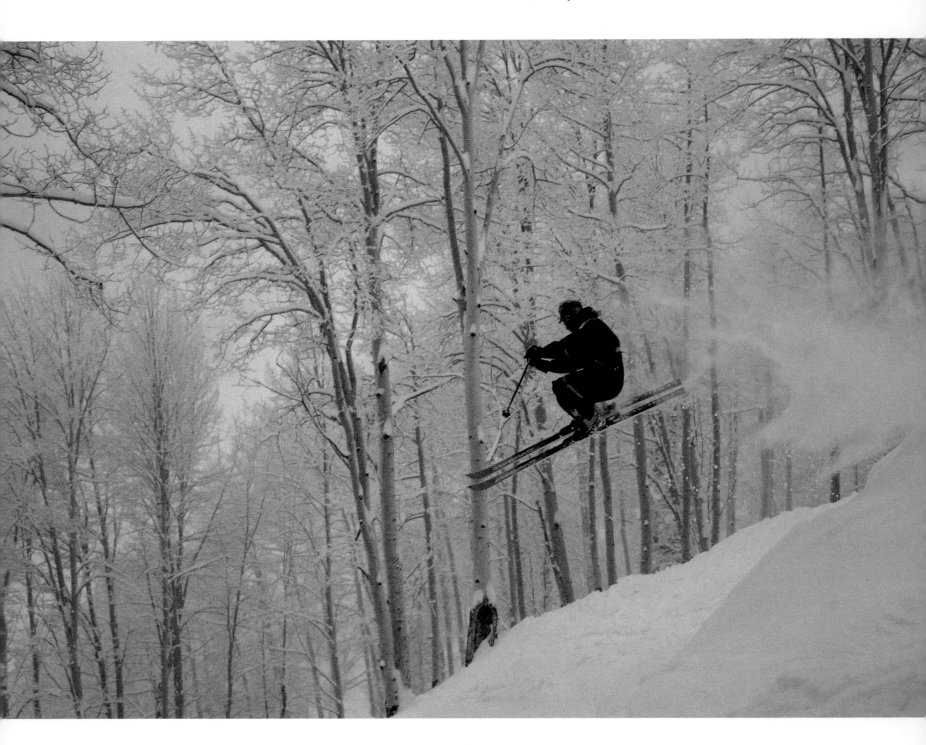

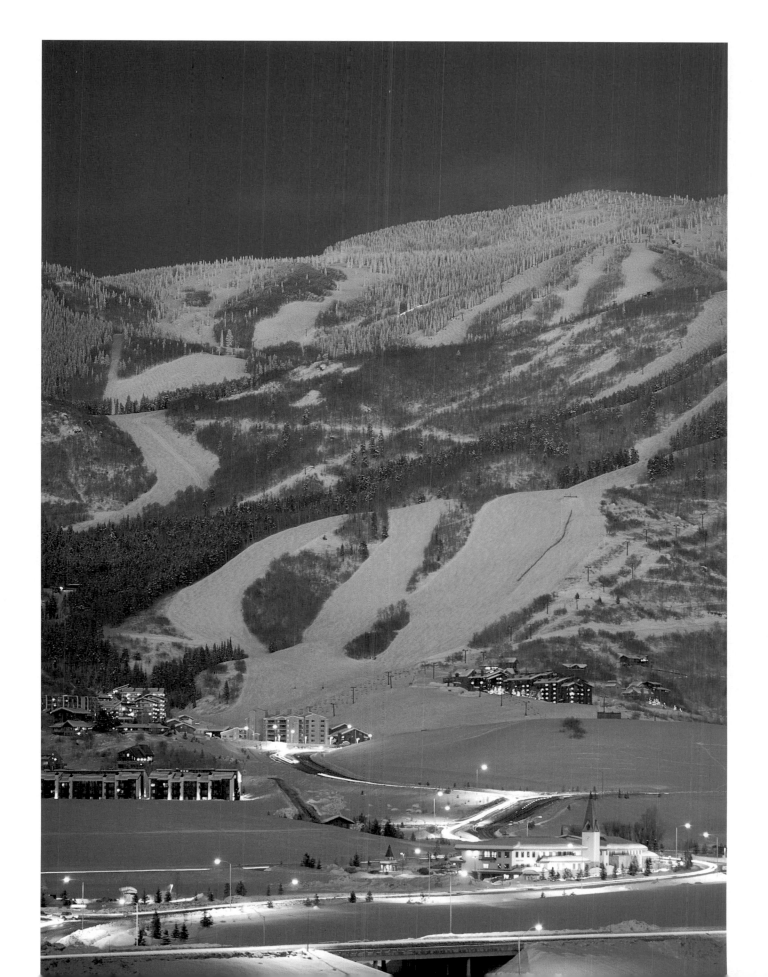

98 *Winter in the Rockies is mostly blue-*

and-white, unless, of course, you float a

fine balloon one morning above Steamboat.

99 *Then again, floating takes many forms.*

This lucky fellow is trying out the buoyancy

of the snow in Chute One at Steamboat.

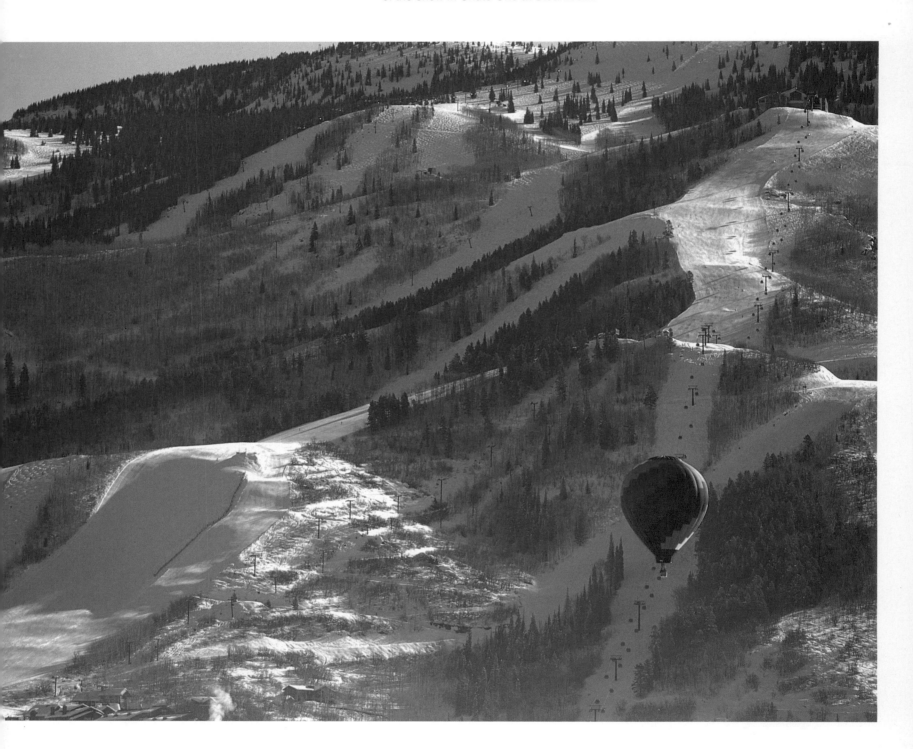

slightly forward of center, like a figure on the bowsprit of an old sailing ship; let go. Find terminal velocity. It comes surprisingly quickly on these mammoth seas. It is also surprisingly comfortable. Small imperfections underfoot disappear as you focus on the coming distance. A major dip at ten miles per hour becomes a tick in the road to someone cruising at thirty-five or forty. The mountain shrinks in relation to your speed.

Looming above Gros Ventre, the thousand-foot scoop of the Cirque requires a very different technique. Here the steeply pitched snow absorbs solar radiation all morning; the texture is heavy, like thick paint. Your skis, instead of brushes, are now palette knives. Leap up out of the muck, turn, and land as gently as you can. Hop from edge to edge in a sure, slow, stair-step descent. Not pretty, but satisfying, the way a Van Gogh sky shimmers in muscular repetition

Moving again. Now to the tram, Jackson's *pièce de résistance,* the magic carpet ride to the top. There is a certain society of anticipation on each tram ride, sixty-three of you stuffed into the red steel cabin. Nylon shoulders swish against nylon shoulders. Steamy breath fogs the windows. Boots scuffle. Skis clack together. Conversations usually run from where you skied last to where are you headed this time? At the top, you scramble out and onto the snow. It is strangely quiet. There is no other way up here, no chair lifts. It is just you and sixty-two comrades until the next car comes up twelve minutes from now. The mountain is yours.

You might choose the bumps of Rendezvous Bowl swooping down off the summit to the south. The bowl is so big that the skiers half way down already look like ants. If you really like bumps, you can keep going into the Cheyenne or Laramie bowls below Rendezvous. The moguls go on and on, turning your line into a purely reactive, fast-twitch squiggle. Great bump skiers are kind of like *The Who's* blind pinball wizard, reacting and reacting again, never letting the ball drop.

Or maybe you would prefer the performance art taking place over on Corbet's Couloir. It is a fifteen-foot air walk from the cornice to the snow below. Down there between yellow rock walls, blue craters mark the snow where unsuccessful birdmen have landed crazily, punched through, and scattered their equipment up and down the piste. Called a yard sale.

The crowd along the sides ebbs and flows like courage itself. Every minute or two someone commits into the void.

Contrary to first impressions (and survival instincts), this is not always pointless Dada. About one in five survives the drop, touches down smartly to notch high-speed turns down the chute and out into the sunlight at the base of the cliff. Done with skill, the air time assumes an ethereal, riveting quality: risk mastered and transformed.

You want trees? There are shady bowers on Bivouac. You want chutes? Alta Chutes plummet like a third-floor laundry drop. You want adventure? Take a trip out to the out-of-bounds zones of Rock Springs, Green River, and Pinedale.

But first we stop at the patrol shack on top, sign out, chat with a patrolman about where the best snow is, throw a snowball for Coop, the avalanche dog. Not long ago, she became the first dog in America to dig a buried skier out alive. Where we are going the slide danger is minimal, but it is beyond the area boundary, ungroomed and wild, Jackson's avant-garde.

First you notice braids of powder tracks up on the shoulder of Cody Peak where they held a figure-eight, synchronized skiing contest. Two thousand turns like ropes of DNA. Surreal.

Down where we are going, into Rock Springs, the snow might take any of a hundred textures: anything from blue-shadow, talcum-soft powder to sun-warmed mashed potatoes at the base of the cliffs to a magic wind crust, powder blown smooth and hard over the bones of the land. It is different

Rendezvous Mountain awaits the Wyoming dawn.

each day. You see something new every time you look. We have just skimmed the surface, like studying Picasso's *Guernica* without knowing anything about the Spanish Civil War.

I hope someday I will be able to do justice on the ground to Uncle Hal's painting of Jackson Hole. We are both of us looking for some kind of grace. I have yet to fashion the perfect run. He paints on and says to himself, "I keep thinking I can make it silkier and softer and colder . . ."

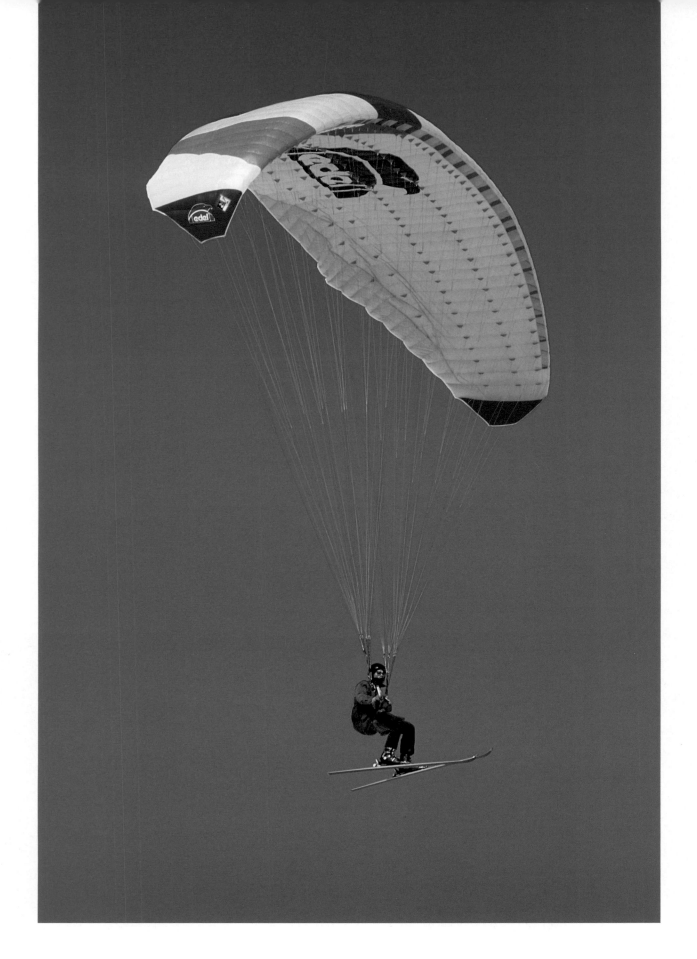

102 \ *Soaring off the summit, a paraglider*

on skis takes a different kind of descent.

103 \ *When you ski Jackson Hole, your*

path follows the rocky bones of the land.

There are few trails per se; it is as if Titans

had flung a monstrous white rug over the land.

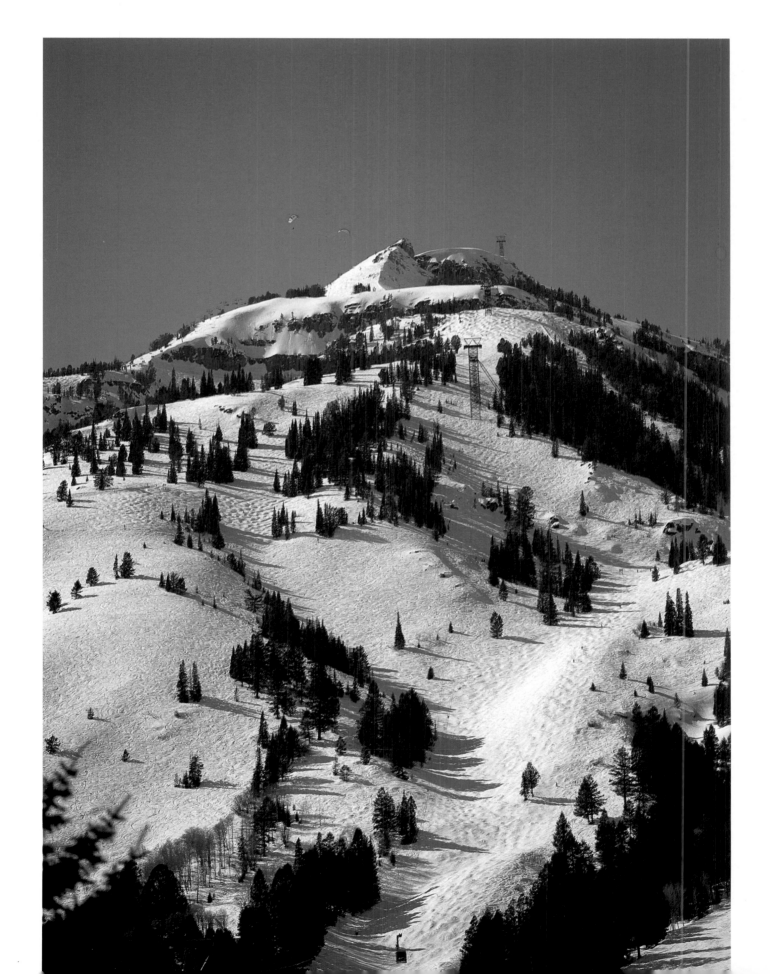

104 \ High Mountain Heliski out of Jackson

flies off to secret Teton powder stashes.

105 \ Backcountry snow, by definition wild

snow, takes many forms: from breakable

crusts to sun-warmed slush to the really

dreamy stuff, like this feather-soft fluff.

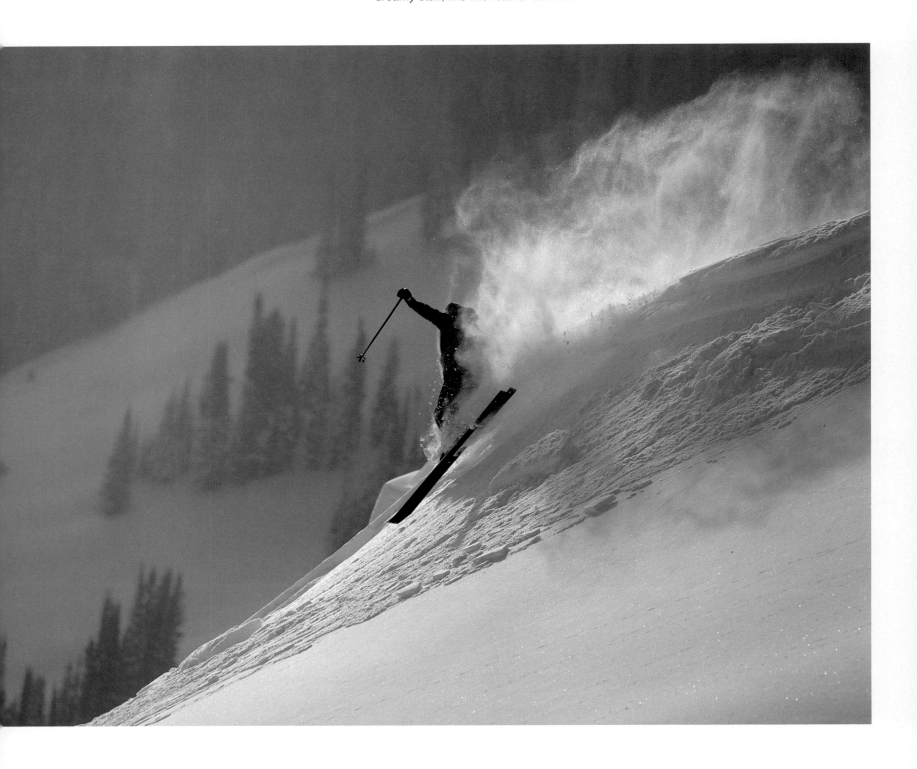

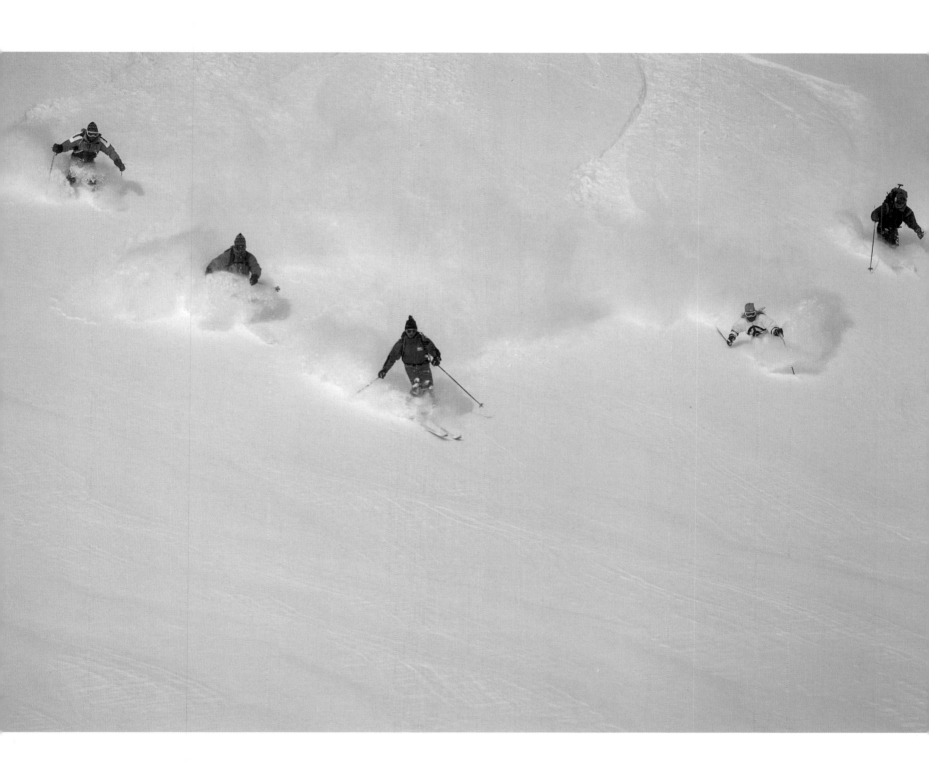

106 \ *Bolting up out of the plane known*

as Jackson Hole, named for beaver trapper

Davey Jackson, Rendezvous Mountain and its

trademark tram climb 4,139 feet, the most lift-

served vertical in the United States. Snow King,

the local town hill, appears in the background.

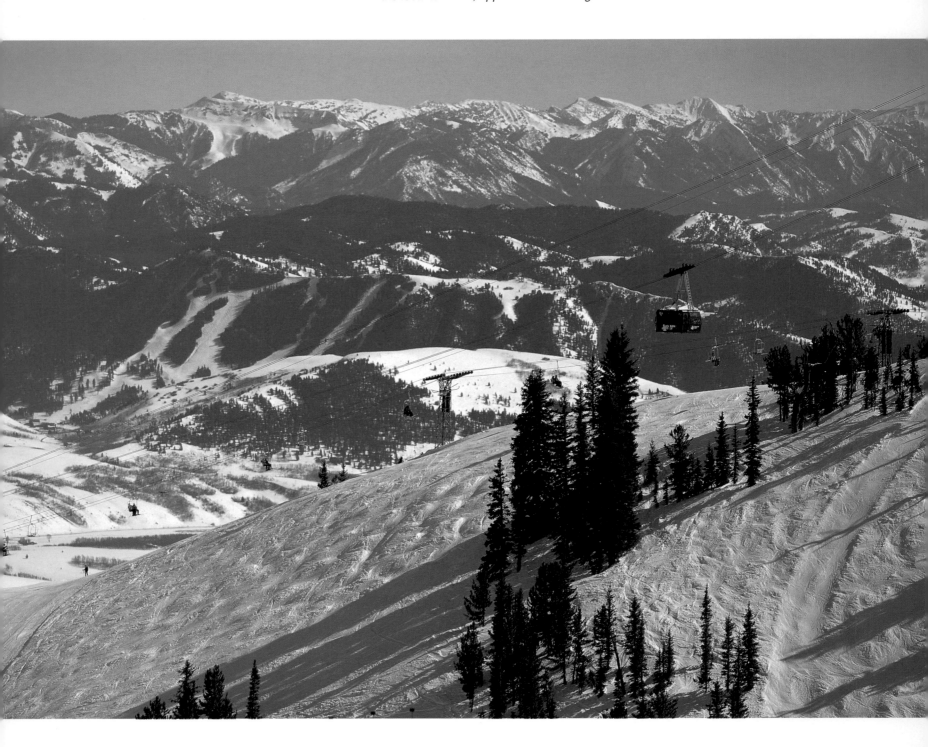

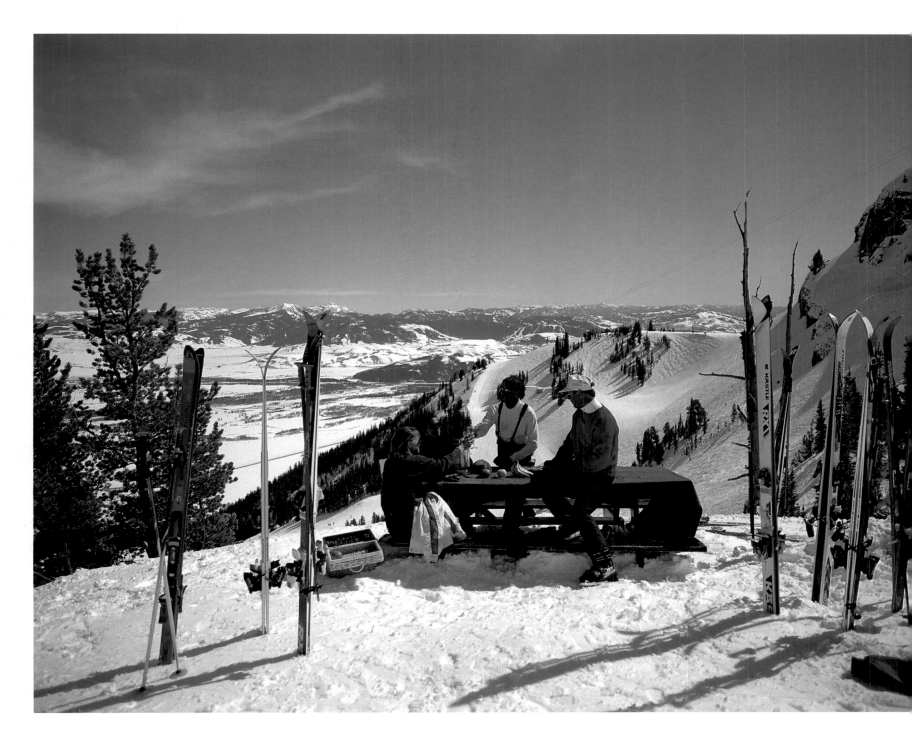

107 \ A fine northern day, a picnic lunch

in the Cirque, and afterward these skiers

can look forward to at least a three-mile

descent to the base at Teton Village, where

they can hop the tram and do it all again.

108 \ *At the top of the mountain,*

between trams, your only company may

be the silence and the wind-dwarfed pines.

109 \ *Across the Teton Range to the northwest,*

Grand Targhee resort faces Idaho and a setting sun.

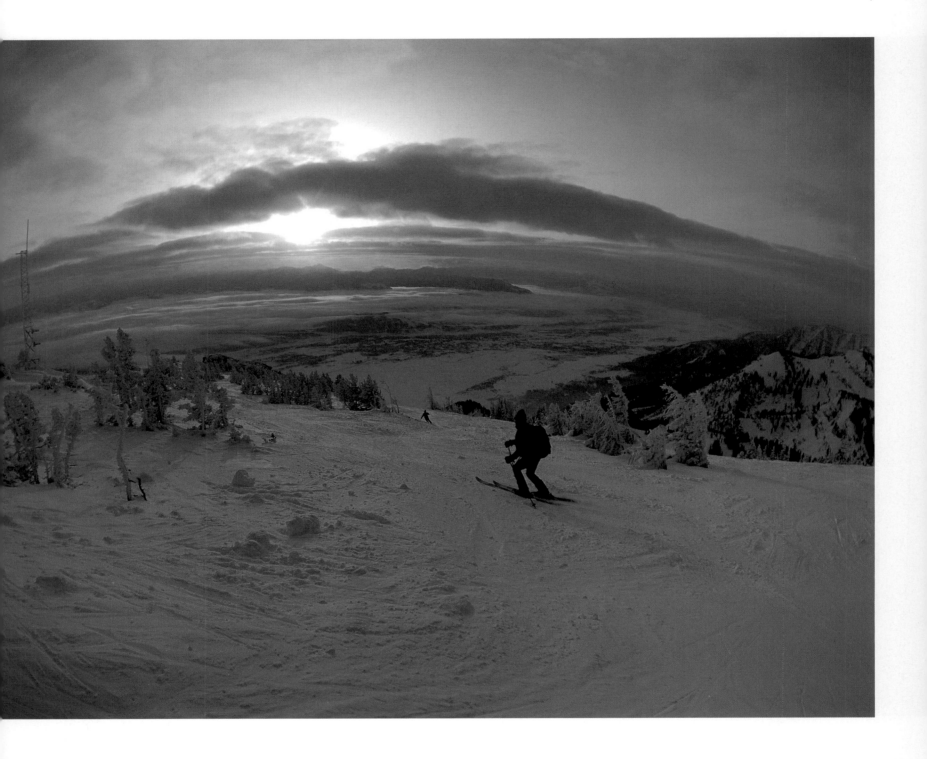

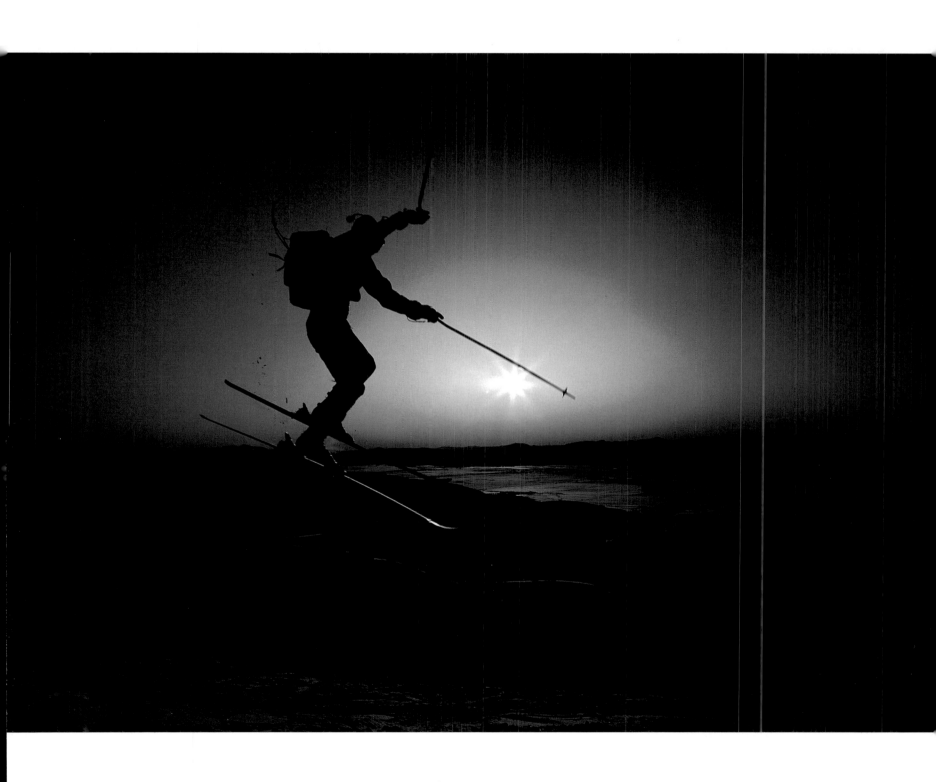

110 \ *Corbet's Couloir is a litmus*

test for the best skiers at Jackson

and for aspiring bird-men everywhere.

111 \ *The gentler side of Jackson Hole,*

Après Vous Mountain, soaks up morning sun,

still giving opportunity for lightness of being.

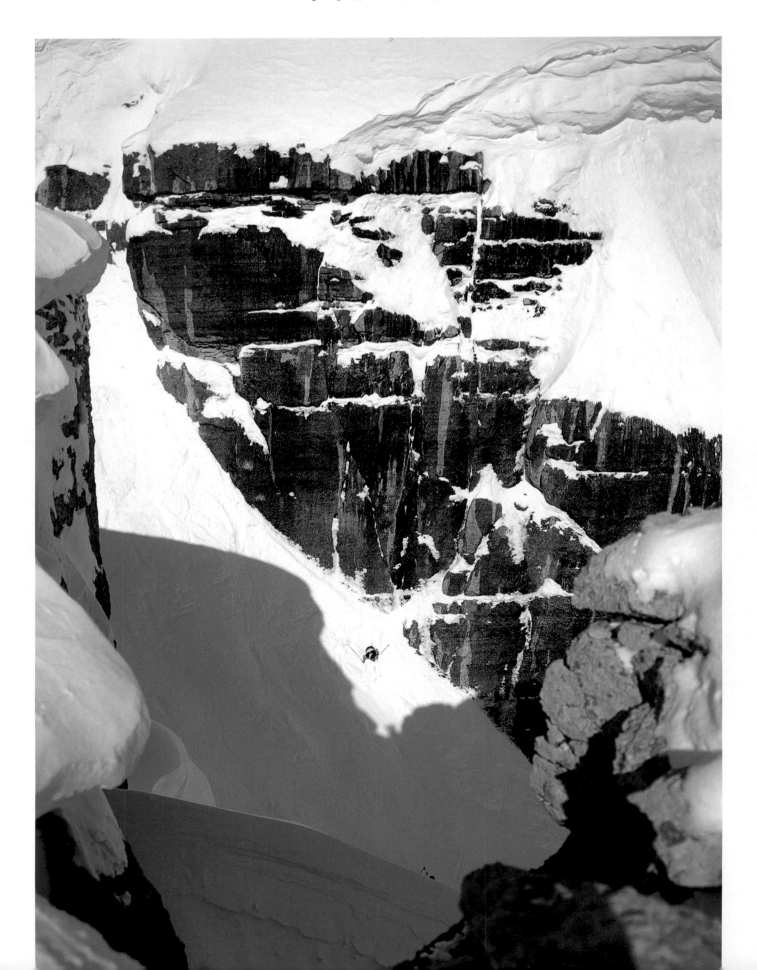

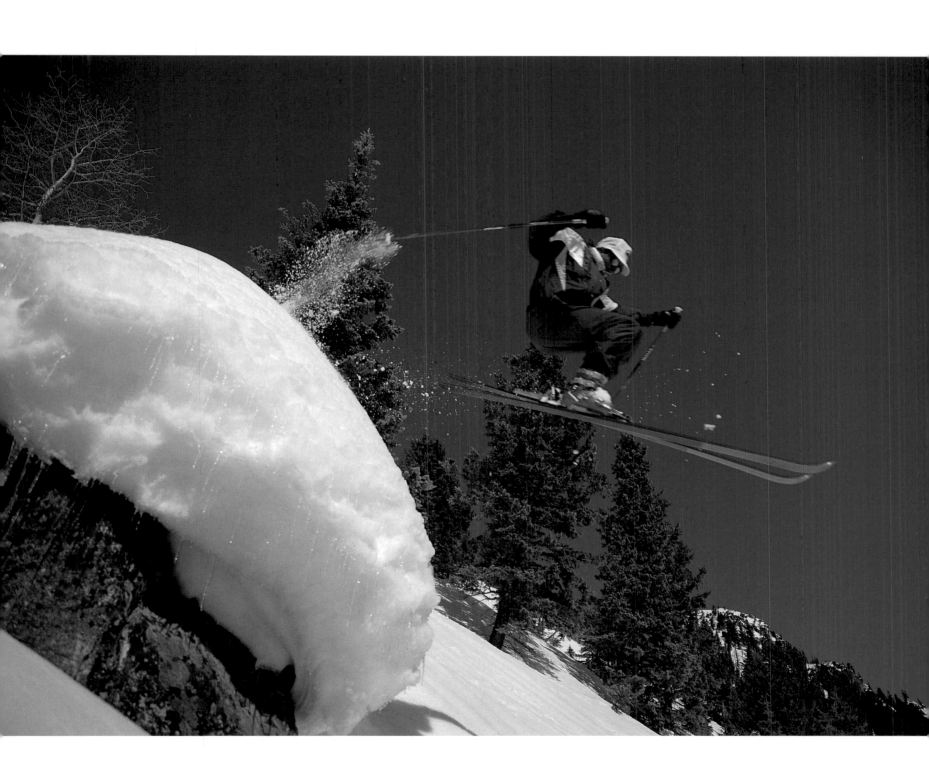

112 \ *The slopes of Grand Targhee*

rush down a tilted slab toward what

used to be called, in the days of the

French trappers, Pierre's Hole. The

dominant granite peaks they named

"Les Trois Tetons," the three breasts.

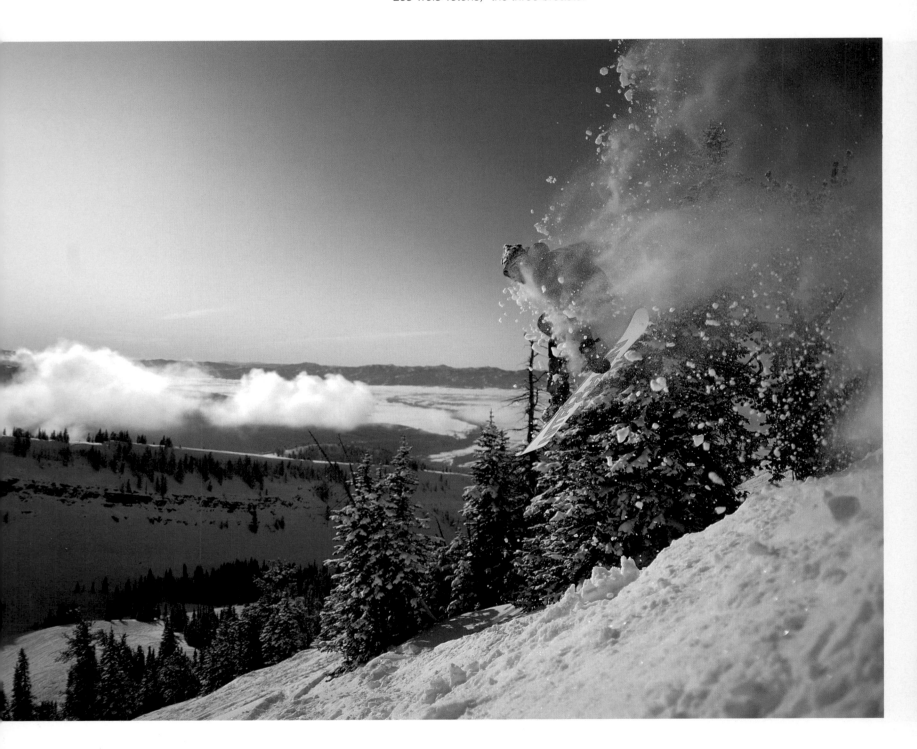

113 \ *The Snake River Valley winds up*

to Yellowstone National Park on the north

and down to the Gros Ventre, the "big belly"

range, in the south. In between is some of

the best natural ski terrain in the Rockies.

114 \ Up north of Yellowstone at Big Sky,

Montana, TV anchorman Chet Huntley

envisioned a ski area on 11,166-foot Lone

Mountain. Most days the name is apt.

115 \ This lone ranger rolls across Big Sky

terrain known to the ski patrol as Cue Ball.

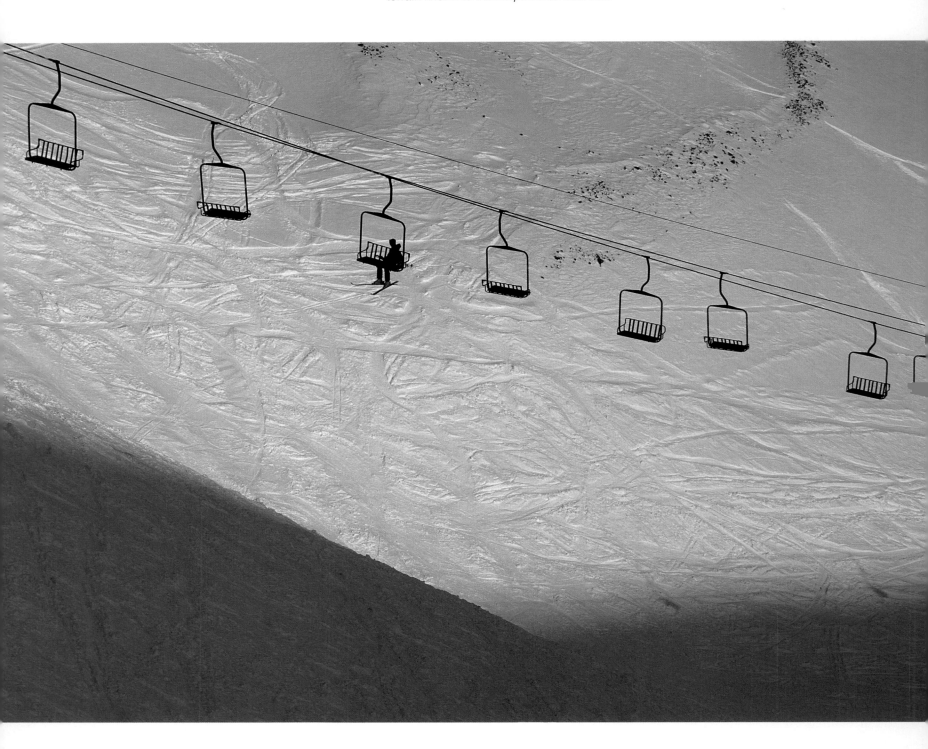

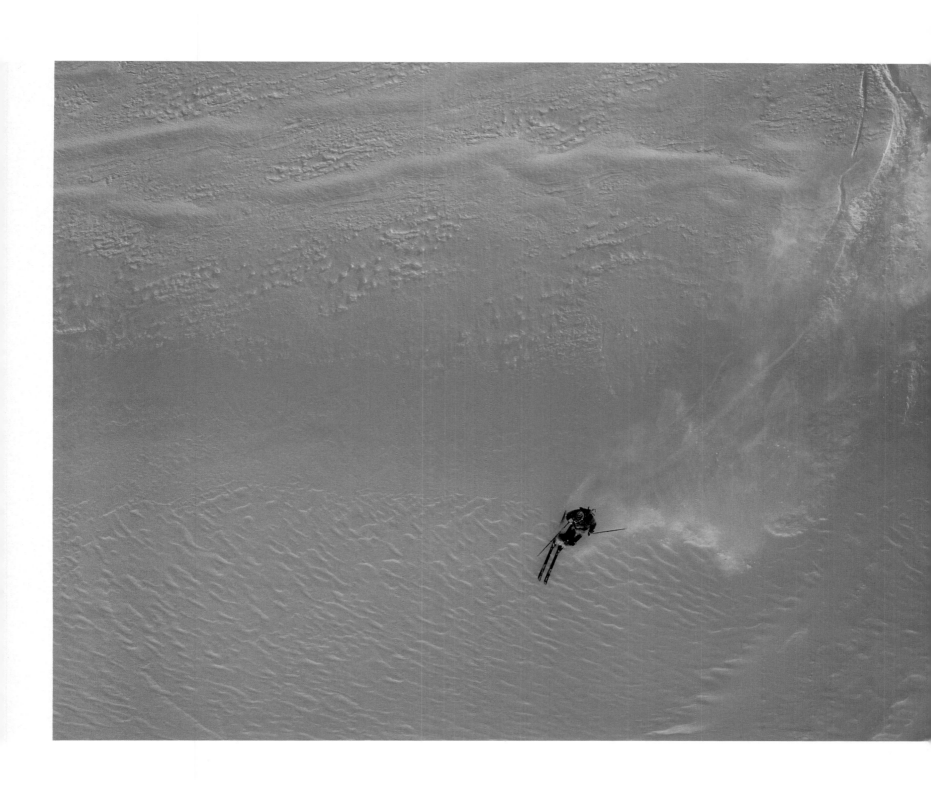

116 \ Skiers ply the powder on Andesite

Mountain with Lone Mountain and its

connecting trails in the background.

117 \ With the Spanish Peaks behind,

a skier drops into a piece of Big Sky's

extreme terrain, known as the A-to-Z Chutes.

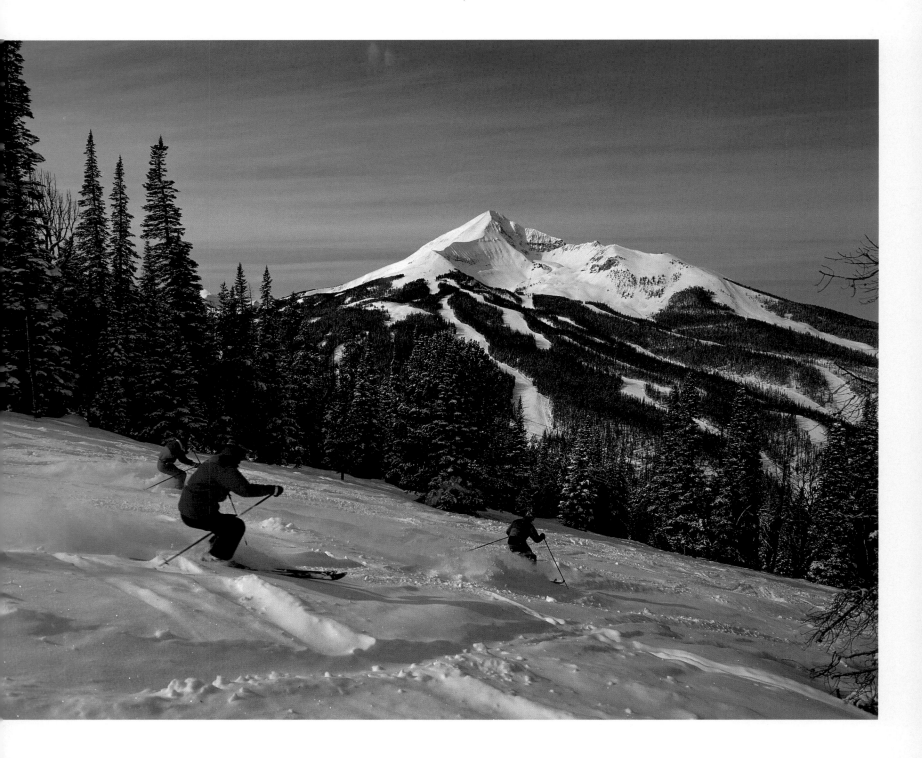

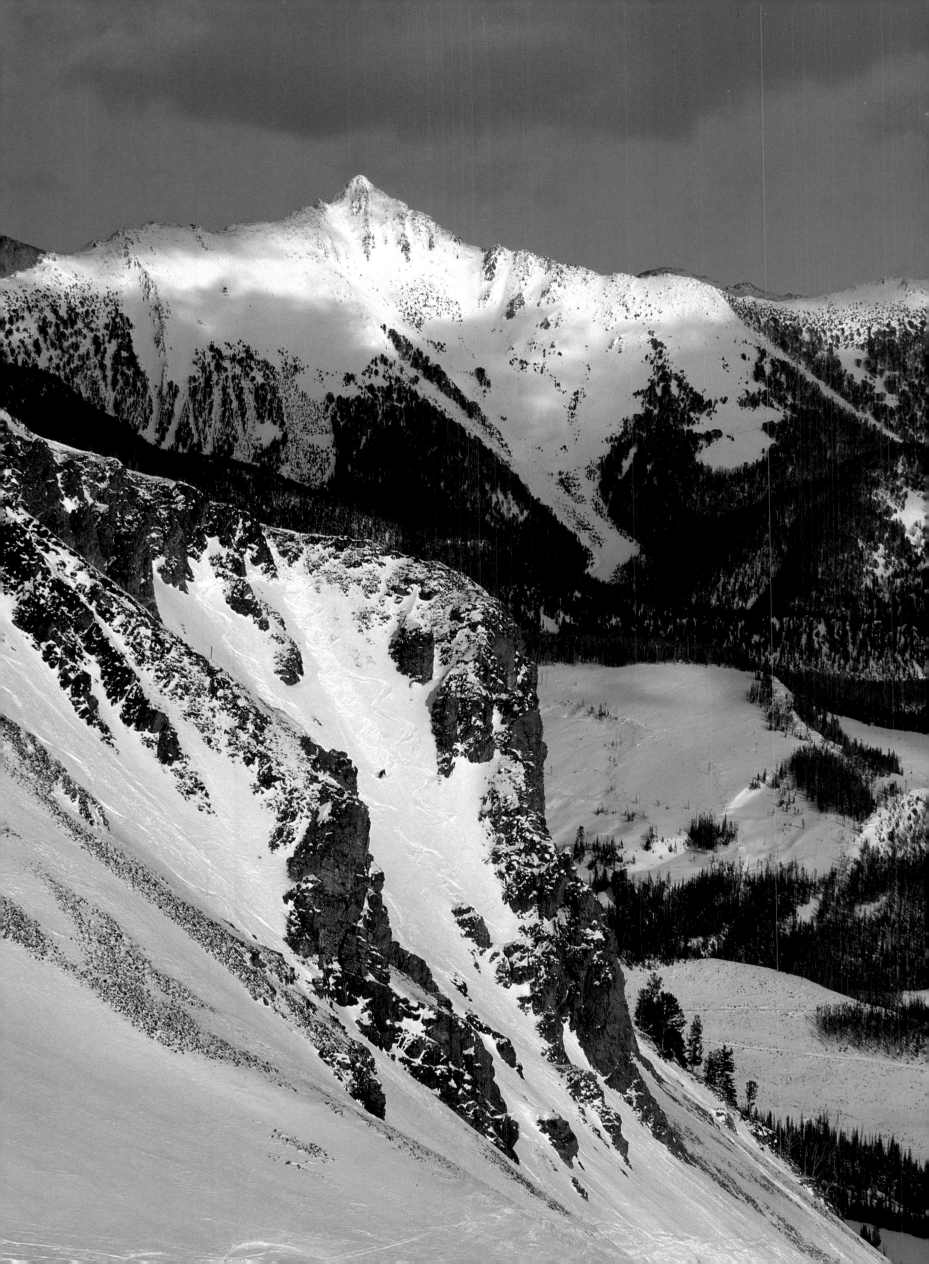

118 \ The lifts stop a thousand feet short

of the summit, but you can climb Lone

Mountain when conditions are deemed safe.

119 \ Most skiers are content to ride the color-

ful bubble gondola to the gentler pitches that

cut across the forested flanks of the peak.

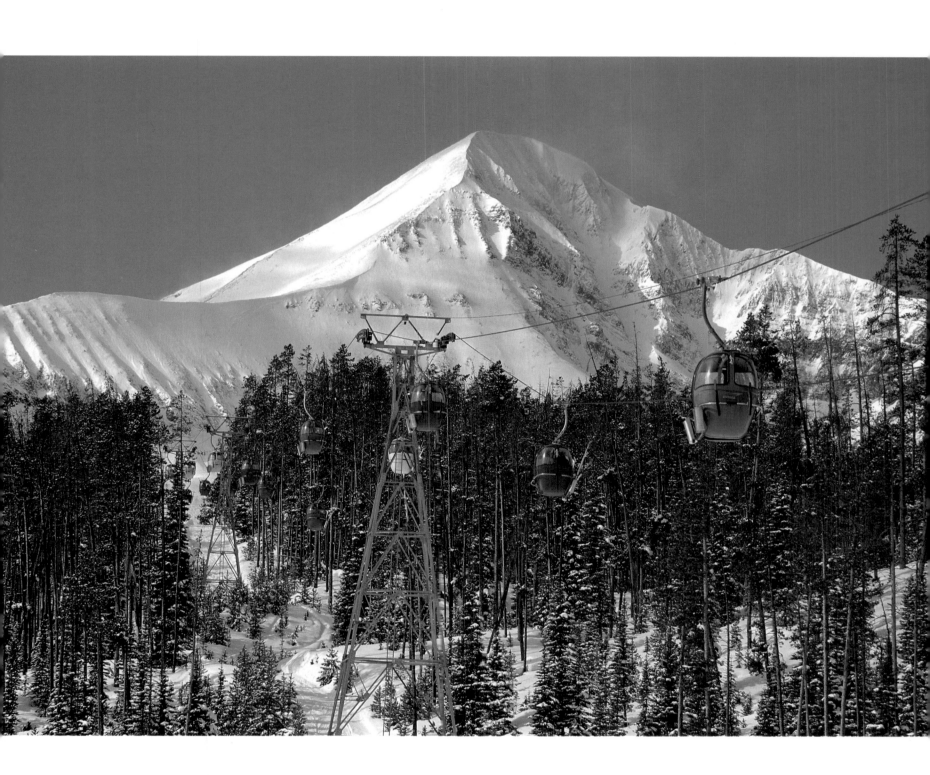

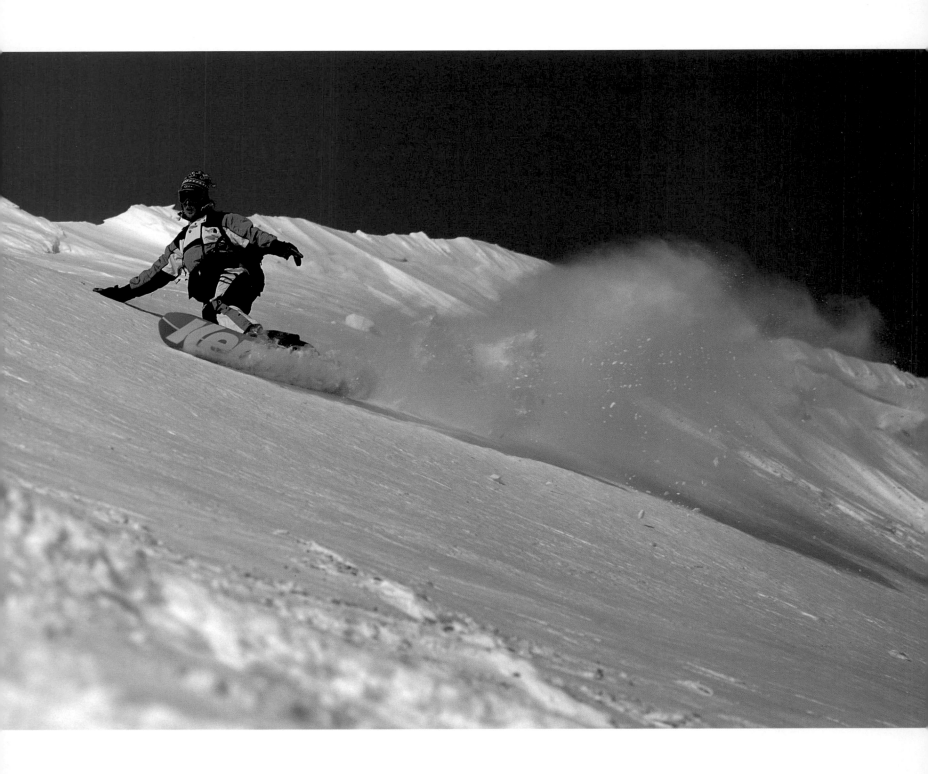

120 \ Bridger Bowl, outside the

cow-and-university town of Bozeman,

Montana, is a snowboarder's paradise.

121 \ The best sliding at Bridger requires a

steep, 400-foot climb to the Ridge, where "ridge

hippies" launch into myriad chutes and powder fields.

VERTICAL VALHALLA

Flying back up in the helicopter after our first run of the day, our guide spotted two sets of mountain goats on the ridge lines. Solid and woolly and starkly white against the blue sky, they tiptoed with deceptive speed over the cornices, frozen waves of snow suspended over the abyss. "They always walk directly over the rock," he said with admiration, "never on the overhanging part of the cornice. How do they know? And they always come out when the avalanche cycle is over. We can safely say it's very safe out here today."

Someone from the back of the ship, one of the ten skiers sitting shoulder to shoulder in the Bell Jet's cabin, wanted to know *why* the goats were up here with us, so far above food and water and the shelter of the valleys. "They like it up here," the guide replied, the lines at the corners of his mouth curling in a nearly perpetual grin. "They come up and go down every day. Maybe five thousand feet each way. They love to get up high and look around."

I could not tell if our guide was passing on a scientific fact, or if he was projecting his own joy onto the beasts' inscrutable behavior. It didn't really matter. All of us, goats and heliskiers, were spending the day way above treeline with nothing better to do than look around. And, in our case, ski powder snow 'til our legs cried for mercy.

A mere handful of outfitters in the Canadian Rockies have created, over thirty years, a new kind of skiing, a highly evolved form, like some odd Galapagos bird perfectly adapted to the sport's ultimate fantasy: endless snow, endless turns. The first man to use helicopters for ski mountaineering was an Austrian émigré named Hans Gmoser who came to Canada as a climbing guide in 1951.

In the late 1950s, he started using fixed-wing airplanes to land skiers high in the Rockies and called his fledgling business Canadian Mountain Holidays. By 1963, helicopters replaced the ski planes, and in 1965, he flew the first commercial group into an old lumber camp at the foot of the Bugaboo Spires. The next year, he had 70 skiers willing to pay for the rides up the glaciers, the year after 150. In 1968, the Bugaboo Lodge opened for business, establishing the CMH tradition of heliskiing out of self-sufficient, wilderness lodges. Now they have nine heli bases spread throughout the mountains. They have flown more than 70,000 customers for a total of 3.5 million runs and something like 7.75 billion vertical feet skied.

Mike Wiegele, another of these pioneer outfitters, has himself skied something over thirty-three million vertical feet. His permit area includes thirty-five hundred square miles, slightly less than the area of Connecticut. You could fit 640 Vails inside it. The CMH permits encompass considerably more.

All this happens in the variegated ranges of eastern British Columbia. They run roughly north-west to south-east and parallel to one another. Thus, the Purcell Mountains run just west of the continental divide; the Selkirks west of the Purcells; then the Monashees, the Columbias, and finally the Cariboo Mountains. Deep river valleys separate them as the Kootenay and the North Thompson and the mighty Columbia rivers switchback their way to the Pacific.

The east escarpment of the Rockies, like the Front Range in Colorado, swoops down sharply to the plains, to Calgary and Edmonton. This is where most of the people are, and the big national parks and the well-known ski areas at Jasper and Banff. Heliskiing, a shy bird, developed in the vast, almost unpopulated reaches to the west, out where there are few roads and town might consist of a post office, two bars, and three chainsaw shops. To be fair, the town of Blue River, where Wiegele's operation is headquartered also has a VFW post where you can play shuffleboard and throw darts and drink that good Canadian beer.

And for this, powder lovers from around the world shell out three to five thousand dollars (not counting airfare to Calgary) for a week's holiday? Yes they do. And a good many of them come back year after year after year, avowed addicts in one-piece suits.

So what do you get for your money here in skiers' Valhalla? The six-day package at most of the heli-outfits is basically this: you ski for six days, weather permitting. Mostly, the weather does permit. On many stormy days, helicopters can still fly to lower-elevation landings where you ski in the trees. On nice days, you soar up to the glaciers that drape the shoulders of many a peak over nine thousand feet. Usually, the glaciers provide the gentler pitches; the really steep stuff is in the trees.

You are guaranteed a hundred thousand vertical feet for your week. Most weeks, this is a snap. Some very hungry, very physical groups have done three hundred thousand. If you do not reach the hundred-thousand-foot mark, they refund a portion of your money. If you go over, you pay extra. Some weeks, there is barely disguised competition between groups to see who can ski the most vertical. Daily totals are posted in the lobby. Greed is not a pretty thing. But here, it is so good natured, it is infectious.

Along with your hundred thousand feet of lift, you get a pilot. He may or may not have flown in Vietnam. I had a pilot one time named Lucky Chuck. He flew his ship with exhilarating precision over the tree tops, balanced on one skid to let us out on a bayonet-thin edge. "It's easy," he told me, "when nobody's

shootin' atcha." At times, I have wondered what is going on in the pilot's mind when he drops us off in two feet of eiderdown fluff, and we are all whooping and hollering, and he is sitting there in street shoes and headset, no chance to jump out and ski just one. "It is a little like being a window washer in a whorehouse," a stoic Canadian told me once. But then he grinned and lifted off, turned the ship on its ear and dove it fast and hawklike to the pick-up in the valley.

You get lunch out on the hill. The helicopter settles into a meadow, the rotos wind down and stop, and the guides break out modest banquets of hot soup, sandwiches, tea, cookies, fruit, chocolate bars. You cannot eat too much; you are burning it up faster than you can refuel. Back at the lodge at dinner time, the cuisine usually comes up a few notches, to just below Michelin stars. Wiegele's Swiss chef spoiled us with wild mushroom soup, Cornish game hens, lemon butter salmon cucumber sorbet, caramel flan. The tablecloth was linen, and there were fresh-cut flowers—flowers in the grip of a northern winter?—in the centerpiece. Before dinner, we had the option of a hot tub or a massage. You tell yourself these things are not decadent; they are necessities so you can get up in the morning and do it all again.

You will very likely ski among timberline trees that have been transformed by rime ice into gargoyles and zoo animals: giraffes, elands, dinosaurs, water buffaloes. You may zip back and forth across their wind-drift tails, ski under their arching necks.

You will meet, in middle elevations, snow "mushrooms," huge, eight-foot-thick accumulations of snow that cap big evergreens and bow little ones double. Watch out. Every once in a while, a mushroom lets go, plopping to the ground with a spectacular whomp. Your tracks will intersect the pedestrian sidewalks of lynx and elk and wolverine.

You will learn to use the buddy system. In the trees, cries for help do not carry worth a darn. You may not be able to see the guide. You may not be able to see the guy coursing the line next to you. So it is paramount that you buddy up and that the two of you keep each other in sight. Every once in a while, someone will fall head first in the deep and not be able to get up. Or fall into a tree well, the hollow space around a tree trunk, and not be able to extricate himself. People have suffocated this way in these pillows of snow. But it will not happen to you if your buddy is there to help.

You will learn never to ski below the place where the guide has stopped. Who knows why he stopped where he did? Ski below the guide, and you will get to buy the first bottle of wine at dinner.

If you are lucky and the weather is fine, you will ski on glaciers, around blocks of blue ice as big as house trailers, threading your way between crevasses that split the snow in dark, echoing slits. You will ski snow like margarine, snow like whipped cream, meringue snow, custard snow, soap flake snow as light as a bubble bath washing over your astonished mouth and your goggled, disbelieving eyes.

If you are extremely lucky, you will ski some places that have never been skied before. This happened to us the day we flew into Foster Creek and saw the mountain goats. It was brand new territory; we were the first. And because we were first, Mike let us name some of the runs we skied.

We called the first one Billy Goat. Another one we named Moonstrudle for the ambrosial poppy seed pastry in the bottom of our lunch bags that noon. And a third, a run we skied in the amber glow of later afternoon, we called Sweet Thang, after a Georgian in our group.

So what are the downsides to all this, aside from the fact that you are now ready to ransom the kids' education to feed your newfound bliss? There are none. Not if you have come

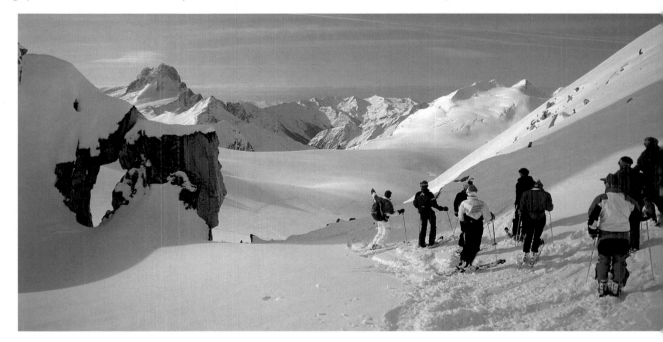

Heliskiing Pernicular Pass, the Bugaboos, British Columbia.

north with a spirit of adventure. I have had days when the temperature never got above minus 26 degrees Fahrenheit. I have seen fog and rain and "wind pressed" snow that was so hard it was impossible to poke it with your pole. But it never lasts. Nothing ever stays the same for very long in the mountains. The next day you will wake up and see those goats up a ridge line. A very good omen. And then your guide comes by, ready once more to lead you into paradise.

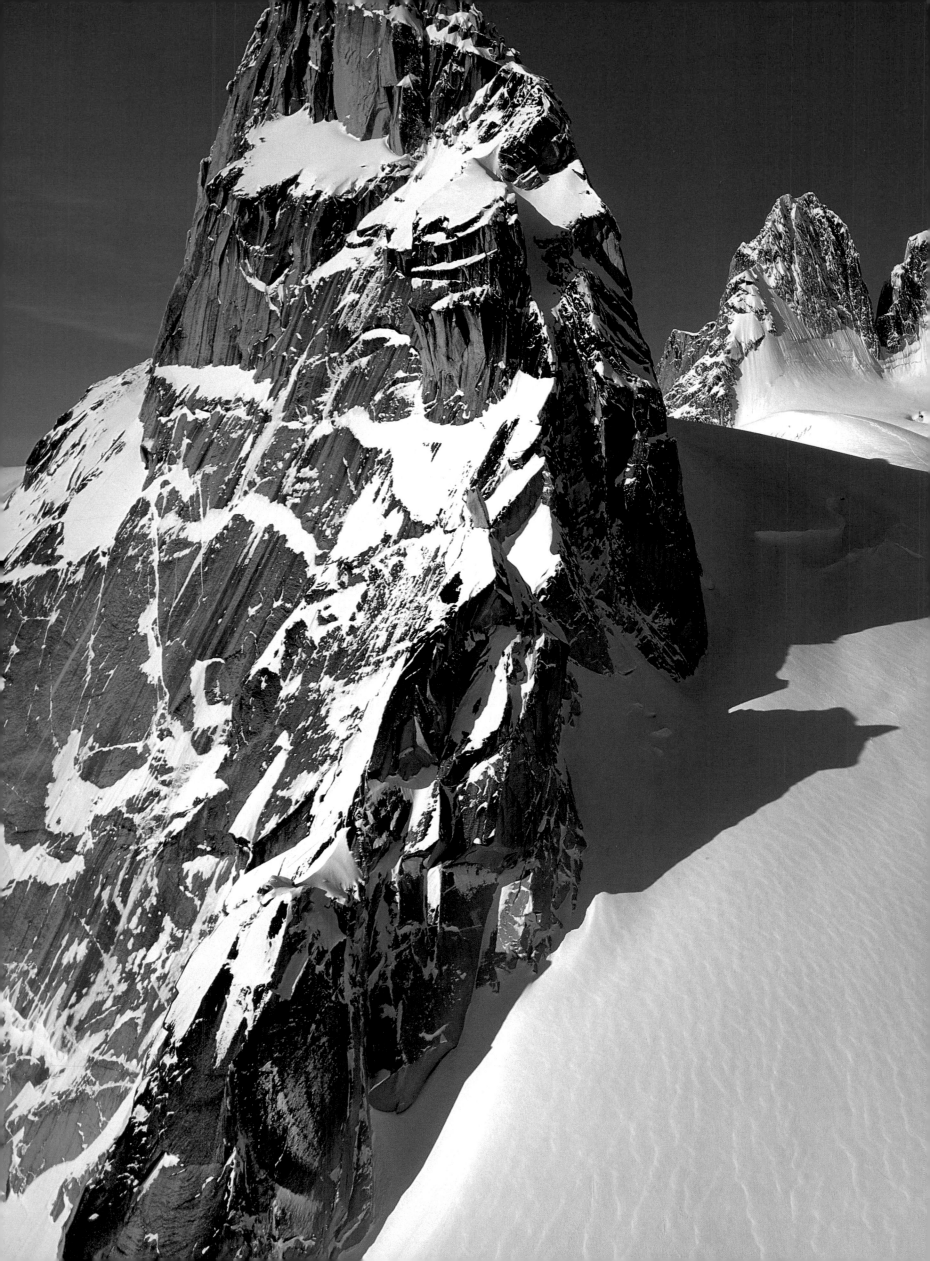

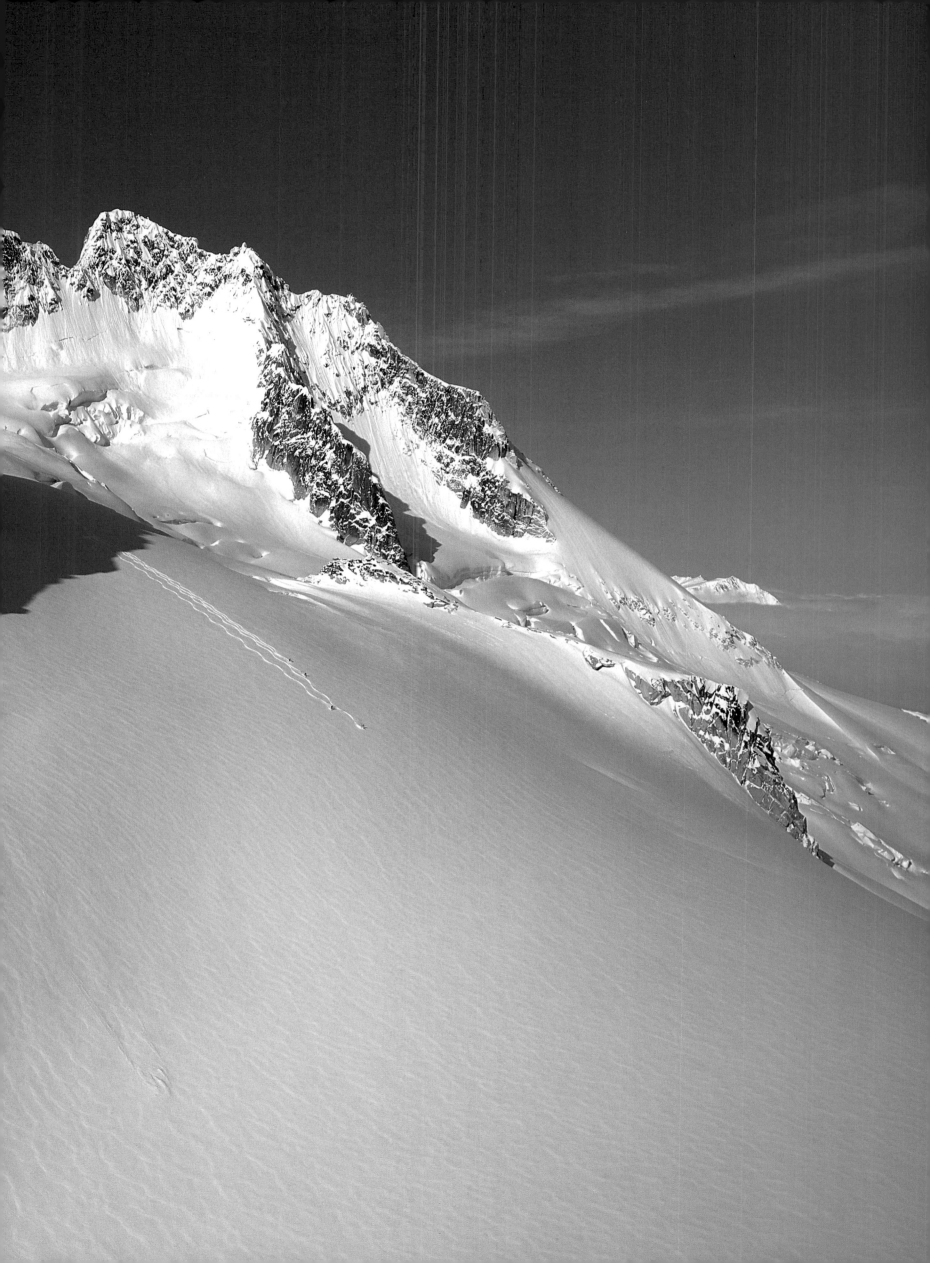

124-125 \ The Bugaboo Spires and

Vowell Glacier dwarf heliskiers on

the snowy roof of British Columbia.

126 \ For pick-up in the valley, skiers

huddle together, allowing the ship to

settle in a fury of its own blowing snow.

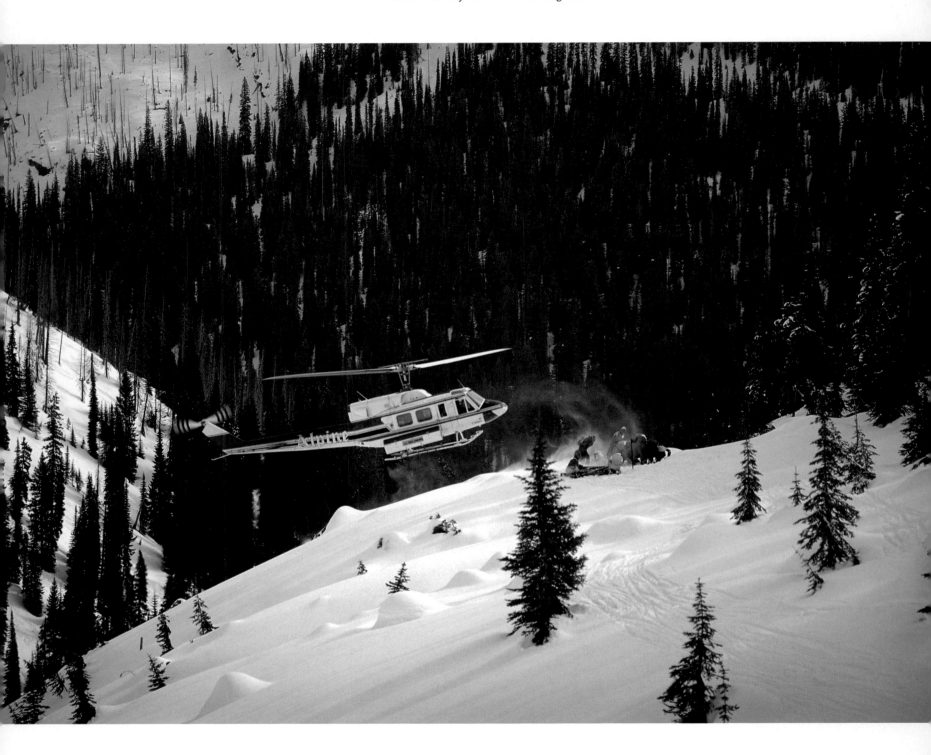

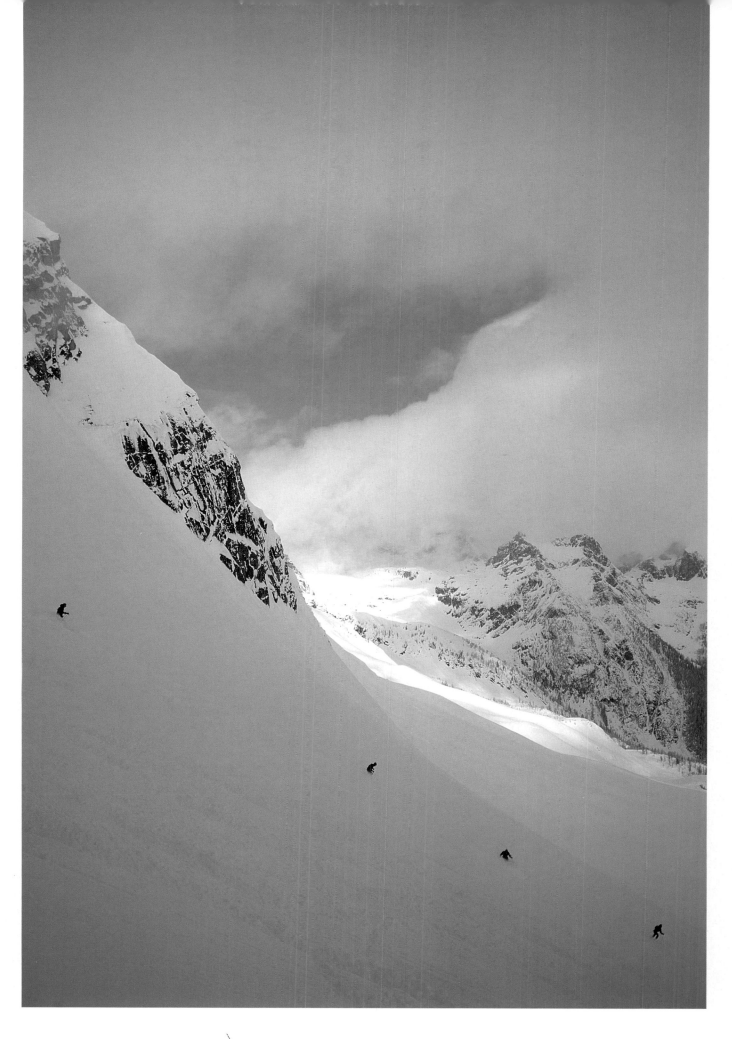

127 \ *Way out beyond the lifts and*

grooming machines, the allure of heliskiing

has a lot to do with original skiing: that is,

wild snow untouched by man or machine, the

majesty of nature and a blank white canvas.

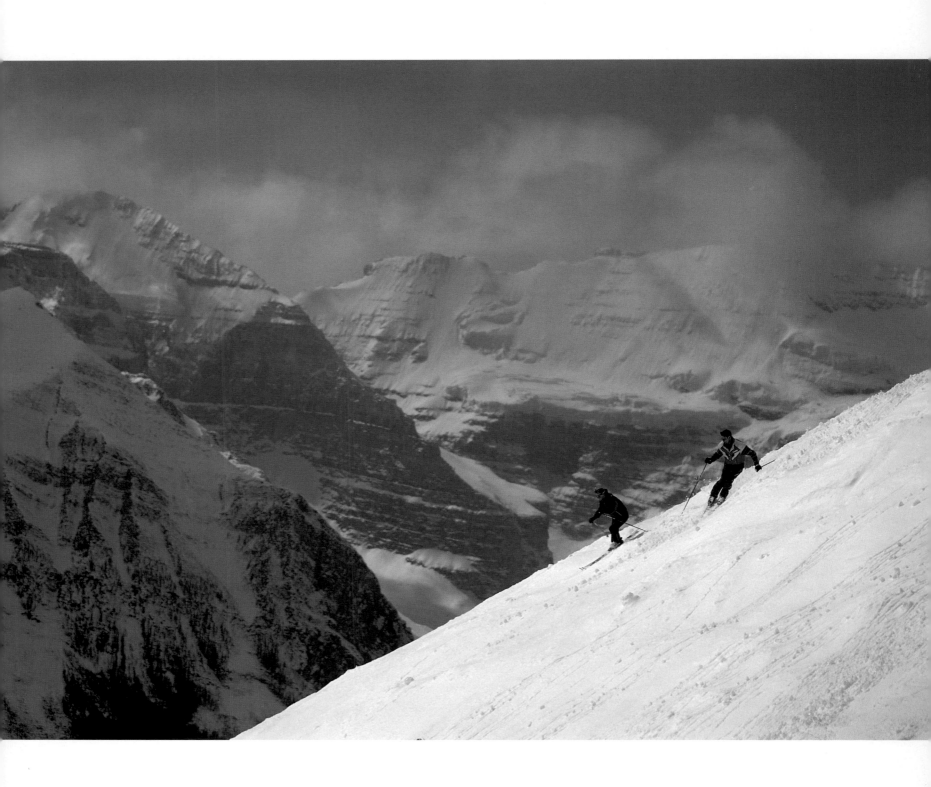

128 \ *On the continental divide and*

the provincial border with Alberta, Lake

Louise offers spectacular scenery and

some of the best lift-served skiing in Canada.

129 \ *At Lake Louise's Paradise Bowl, the*

fellow in red looks as if he is dropping into heaven.

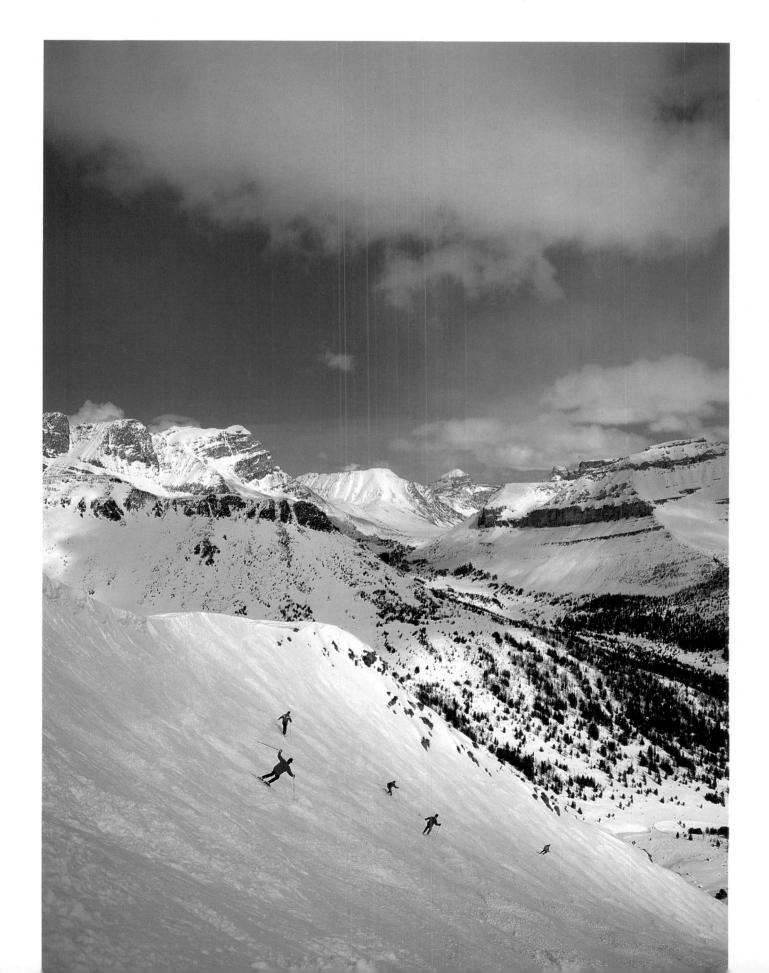

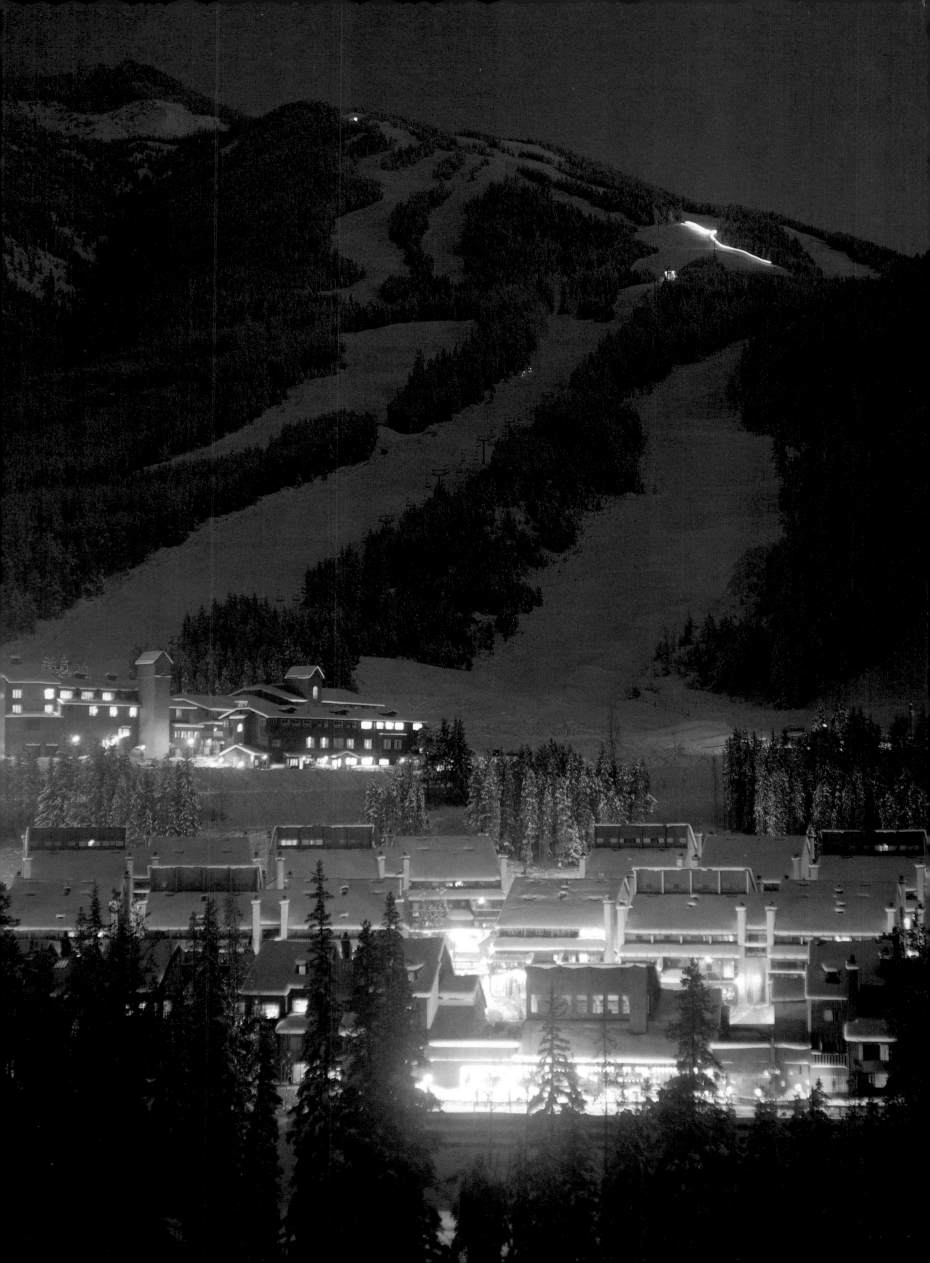

130 \ The new purpose-built

resort of Panorama lights up the night

in the Purcell Range of British Columbia.

131 \ Quintessential Panorama: Rollercoaster

run wends its polished way down thirty-eight

hundred vertical feet over two and one-half miles.

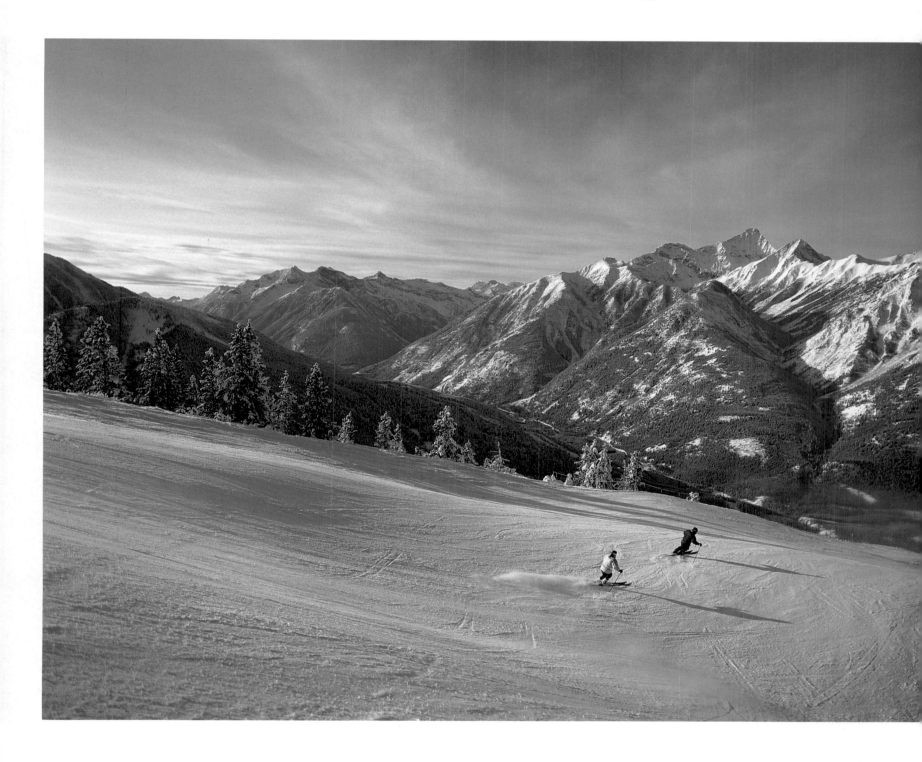

132 \ On clear days, guides lead the

way on high-elevation glaciers, careful

to skirt the gaping, blue-ice cravasses.

133 \ One helicopter may serve three or

four groups, dropping one off, then swooping

down to ferry the next from pick-up to ridgeline.

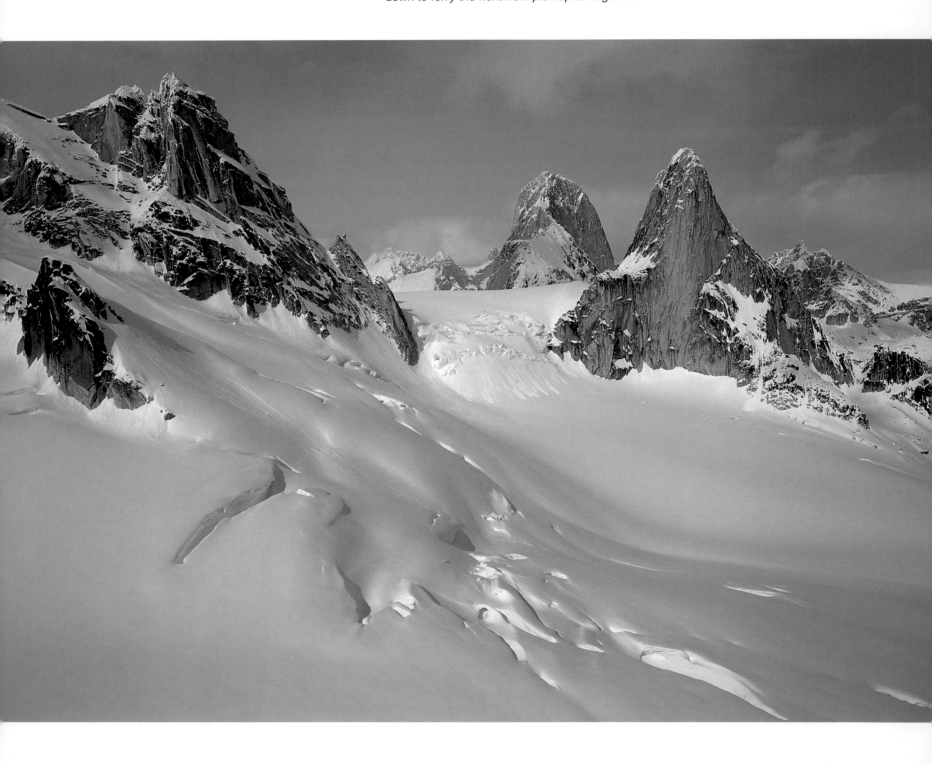

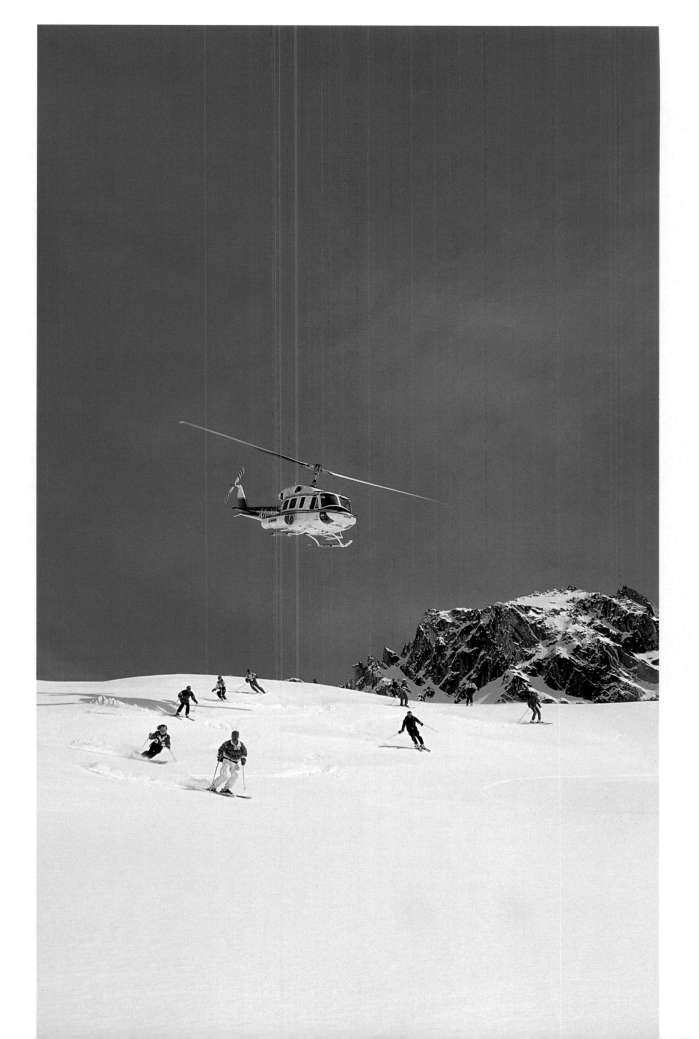

134 \ *On storm days, most of the skiing will*

be in the trees, here on a run called Route 66.

135 \ *"Bugaboo Bob" Geber displays the classic*

Austrian style that was developed in his twenty

years as a guide for Canadian Mountain Holidays,

which is the granddaddy of all the heliski outfits.

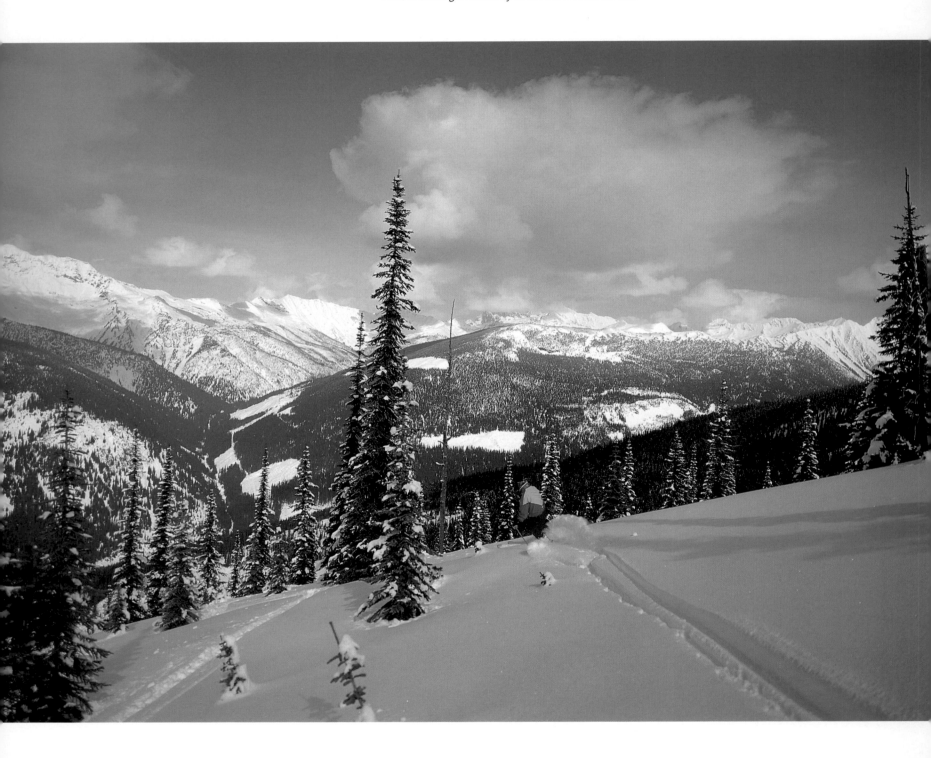

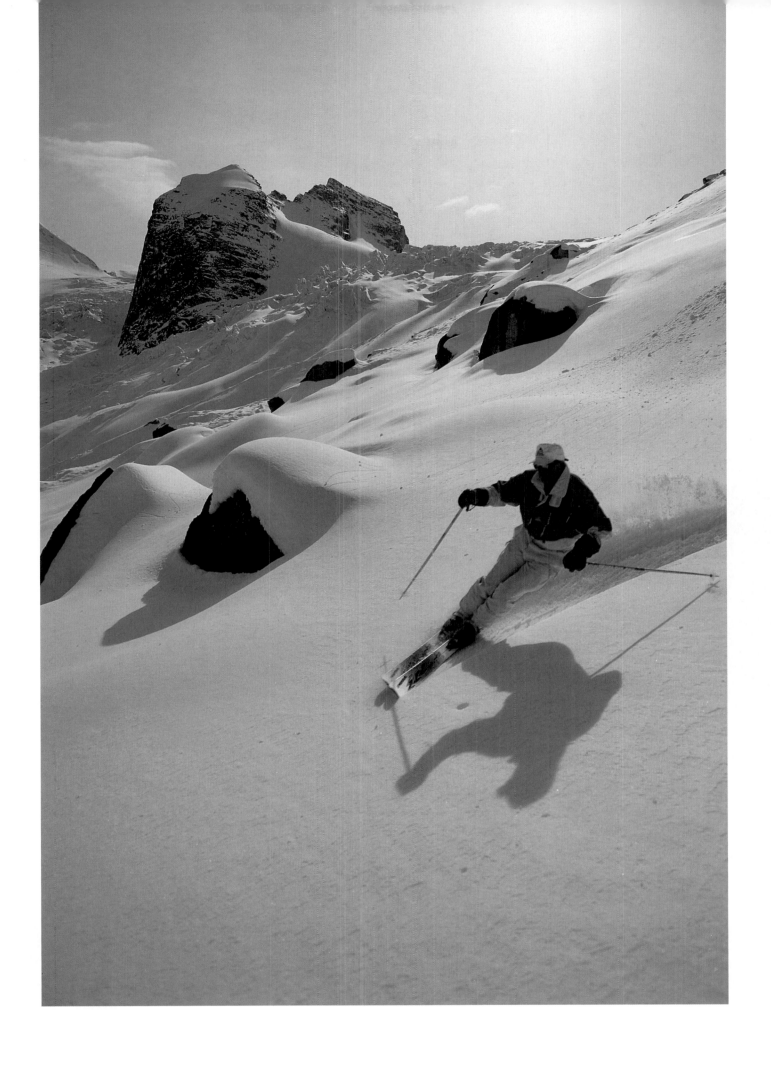

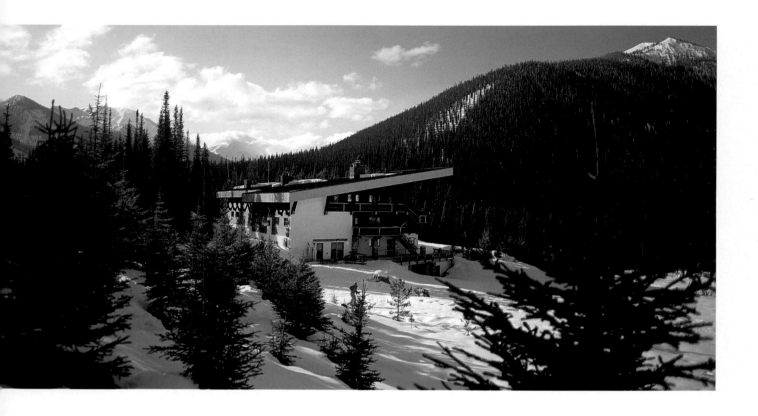

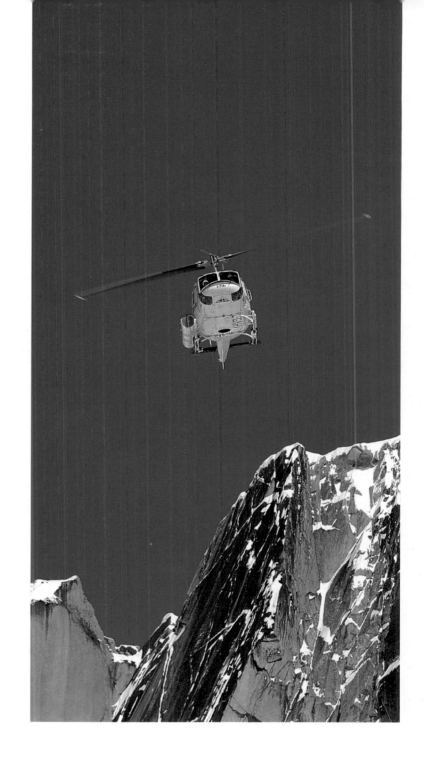

136A \ In 1968, Austrian Hans

Gmoser opened the first heliski lodge,

Bugaboo, in the Purcell Wilderness.

136B \ Lunch time, the rotors shut

down, out come sandwiches and hot

tea, and even the pilot kicks back.

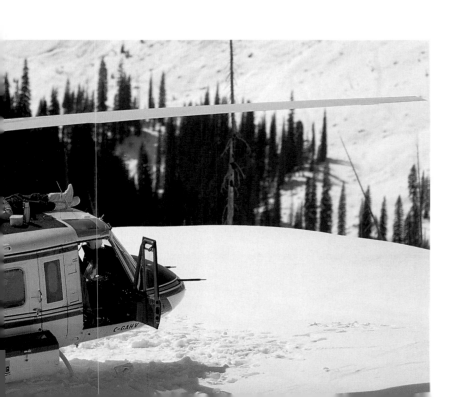

138 \ Heliskiers sometimes feel a mis-

guided pity for the pilots, who never

join the group for a powder run. But

pilots are not envious; they are eagles

riding the big air above the Rockies.

138 \ *Heliskiing shines in the spring*

when the sun-warmed snow—here

at McCarthy Glacier—turns to "corn."

139 \ *Powder turns, like alpha waves,*

weave an addiction many heliskiers cannot

shake, returning again and again to bliss.

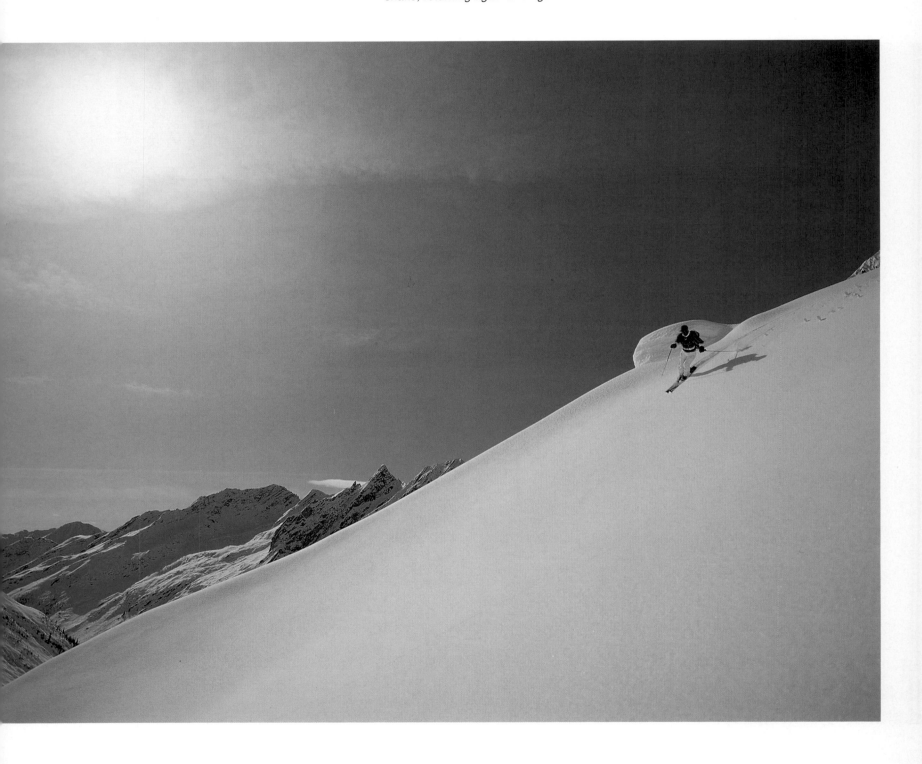

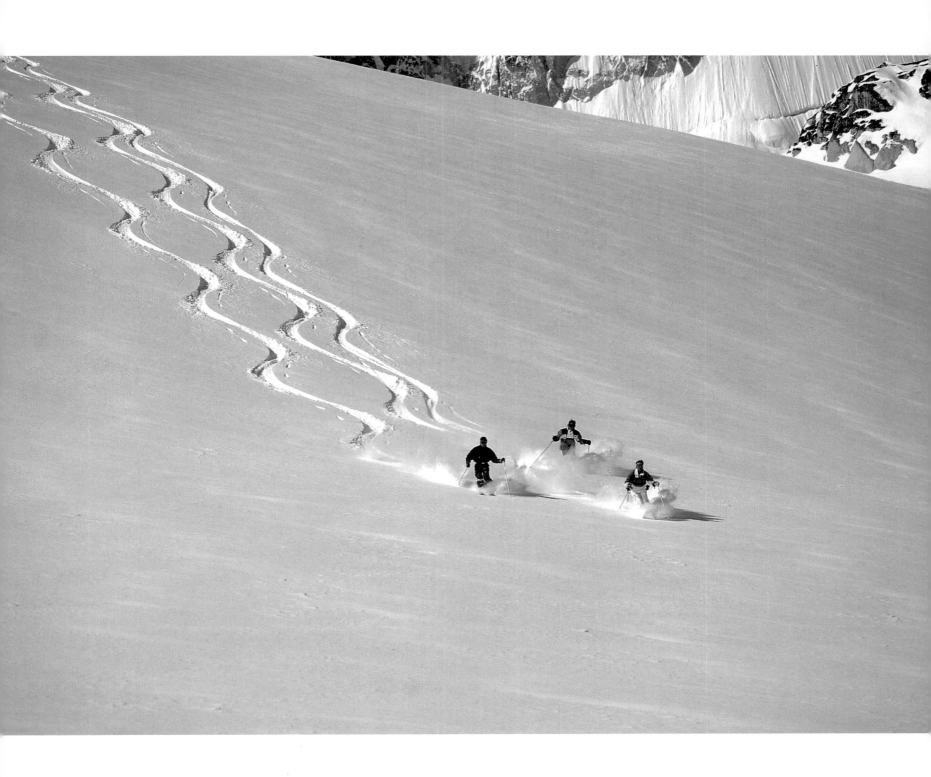

A SPECIAL THANKS TO

ALLAIRE TIMBERS INN
9511 Highway 9
Breckenridge, CO 80424
303-453-7530

RIO HONDO CONDOMINIUMS
P.O. Box 81
Taos Ski Valley, NM 87525
505-776-2646

SUN VALLEY LODGE
One Sun Valley Road
Sun Valley, ID 83353
208-622-4111

SNOWMASS LODGE
P.O. Box G-2
Snowmass Village, CO 81615
303-923-5600

THE CLIFF LODGE
Resort Entry #4
Snowbird, UT 84092
801-521-6040

THE INN AT JACKSON HOLE
Best Western
P.O. Box 328
Teton Village, WY 83025
307-733-2311

ALTA LODGE
P.O. Box 8040
Alta, UT 84092-8040
801-742-3500

BIG SKY
One Lone Mountain Trail
P.O. Box 1
Big Sky, MT 59716
406-995-4211

PANORAMA

Panorama, B.C.

Canada VOA 1T0

604-342-6941

HELI-TRAX

P.O. Box 1560

Telluride, CO 81435

303-728-4904

CMH HELI SKIING

217 Bearst

Banf, Alberta

Canada TOL 0C0

800-661-0252

COLORADO HELI SKIING

P.O. Box 64

Frisco, CO 80443

303-468-1551

HIGH MOUNTAIN HELI SKIING

P.O. Box 173

Teton Village, WY 83025

307-733-3274

THE NORTH FACE

and

BLACK DIAMOND

for providing equipment

SKIERS AND SNOWBOARDERS

Tracey Allen
Garret Bartelt
Duncan Brown
Jim Conway
Dave Cranz
Lee Cruzan
Julie Faure
Mark Felter
Tom Ferris
Holly Fuller
Amy Fustanio
Bob Geber
Scott Gough
Rick Hall

Sam Howard
Tor Jensen
Bruce Johnston
Jos Lang
Jonathan Marcus
George Marsh
Minot Maser
Viju Mathew
Kurt Mohler
Ben Myers
Jeffery Olesen
Rick Olson
Tim Swanson
Ken Wilder

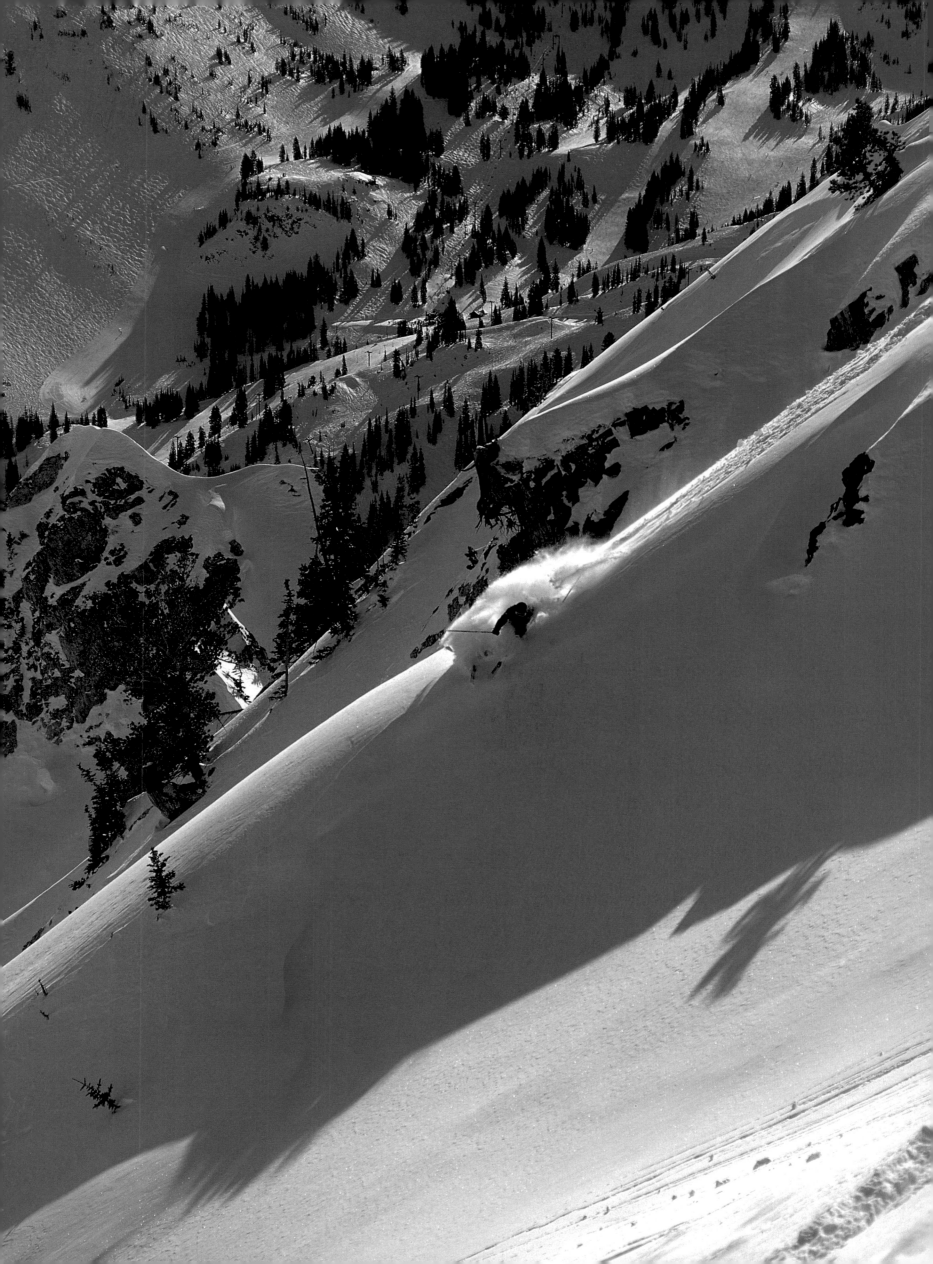

Chasing winter storms across the Rocky Mountains West became a seasonal ritual for me for three years. I drove with high anticipations of placing myself in the right locations at the right time. Rain turned to sleet and sleet to snow. Soon the welcome sight of signs glaring in the darkness would read "Chains or snow tires required by law."

It is really no secret that the best time to photograph skiing is right after the three-foot storm clears. But for me, the most rewarding skiing is in white-out storms, when conditions filter out distractions, enabling me to focus on free skiing in its purest form. It is peaceful in the trees where noise is muffled by snowflakes, and the only sound is my own heart. As the storm clears and the clouds lift, my concentration turns to photography, when the sun glistens off snow crystals and all around lie acres of untracked terrain.

Hundreds of photographic possibilities flood my imagination, but a few turns in waist-deep powder usually calm my senses, and I begin to focus. Without focusing, I have learned, I take snapshots with no relative interpretation of landscape. Finding a satisfying image through the creative process adds dimension to a place that becomes unforgettable.

This project was a way for me, as a photographer, to express my own philosophy about the landscape, as I created a relationship between the skier and his environment. Showing the unique identity of so many ski areas became a rewarding experience. I found patterns in the immaculately groomed runs of Sun Valley, Idaho, that European skiers dream of; mogul runs at Telluride, Colorado, that go on forever; and steep challenging couloirs at Jackson Hole, Wyoming. Within eight minutes, I can be pulled by tram up twenty-nine hundred feet to the top of Hidden Peak at Snowbird, Utah, where views of European-style alpine terrain surround me. I remember scrambling along a high traverse, carrying my skis, going into Albion Basin at Alta, Utah, with twenty-five powder-hungry skiers at my heels.

Crowds are a part of the powder chase, but there really is nothing in skiing compared to standing atop a three-thousand-vertical-foot untracked run in the wilderness. Two ways of fulfilling such a dream are hiking or heliskiing. My experience in CMH Heli Skiing in Canada was unsurpassed when the guide nudged my shoulder and pointed to the Bugaboos that had just emerged from the clouds at a landing spot. The run below dropped thousands of feet, the smooth snow broken only by crevasses in the glacier. These moments came spontaneously—typical of mountain weather. The only way to increase your odds of encountering such perfect weather conditions is to prepare, prepare, prepare—then get lucky!

Going from ski area to ski area, I attempted to calculate rhythms of nature, but luck always played a part. I spent six days skiing in dense thick fog at Steamboat, but a subconscious hope kept me there. On the seventh day, the skies broke and the snow was dry and deep. I remember the last light from the setting sun striking the flocked pines, turning their cold rime-covered branches warm. Experiencing such a variety of places has influenced me immensely. Since meeting so many interesting, wonderful people who live and work within these ski areas, from New Mexico to Canada, I have gained a deep respect for them and for the land with its dramatic changes when the snow begins to fall.

Photographer's equipment: I carry a Pentax 6 x 7 and three lenses (300 F4) (135 F.4) (45 F.4). I use Fuji Velvia ASA 50 and carry a few rolls of ASA 400 film for low light. To capture the skiers up close surrounded by powder, I used a Canon EOS1 with a 20-35mm zoom F 2.8 or 80-200 F 2.8 zoom because of its fast auto focus feature.

Marc Muench

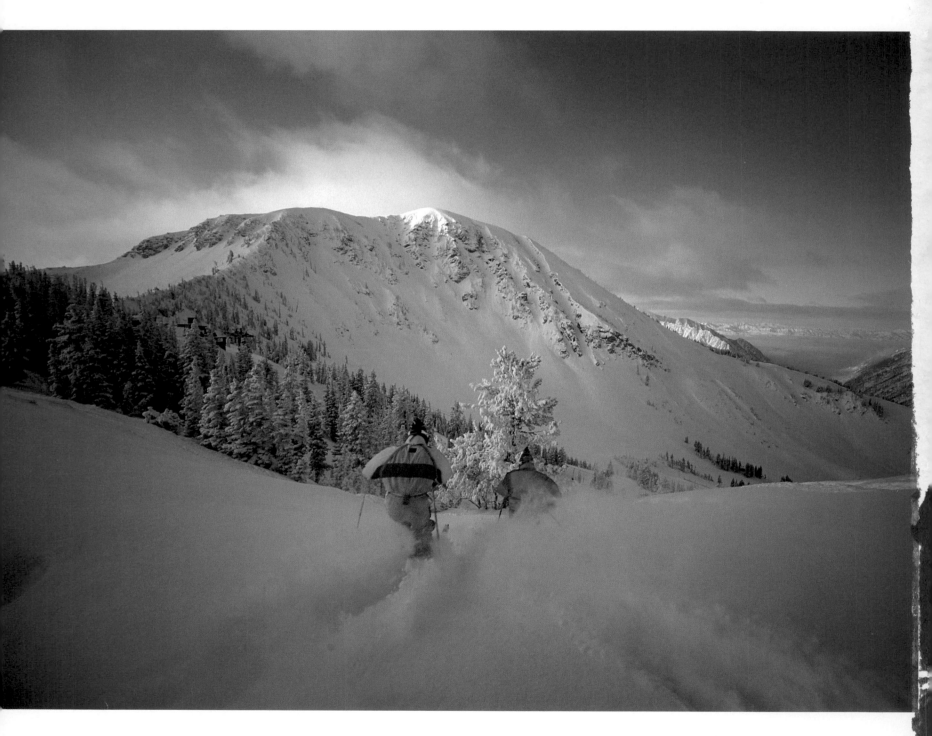

At Alta's Germania Pass, Mount

Baldy catches the first light of dawn. A

foot of new snow is under your skis, and

crystalline cloud matter floats you, drawing

you down the perfect flanks of the Rockies.